700.92 $60.00
Kelton Kelton, Elmer
Copy 1 The art of James Bama

KELTON, ELMER
THE ART OF JAMES BAMA /

C1993.
36363001108661 ROUN

COVELO, CA 95428

DEMCO

THE
ART OF
JAMES BAMA

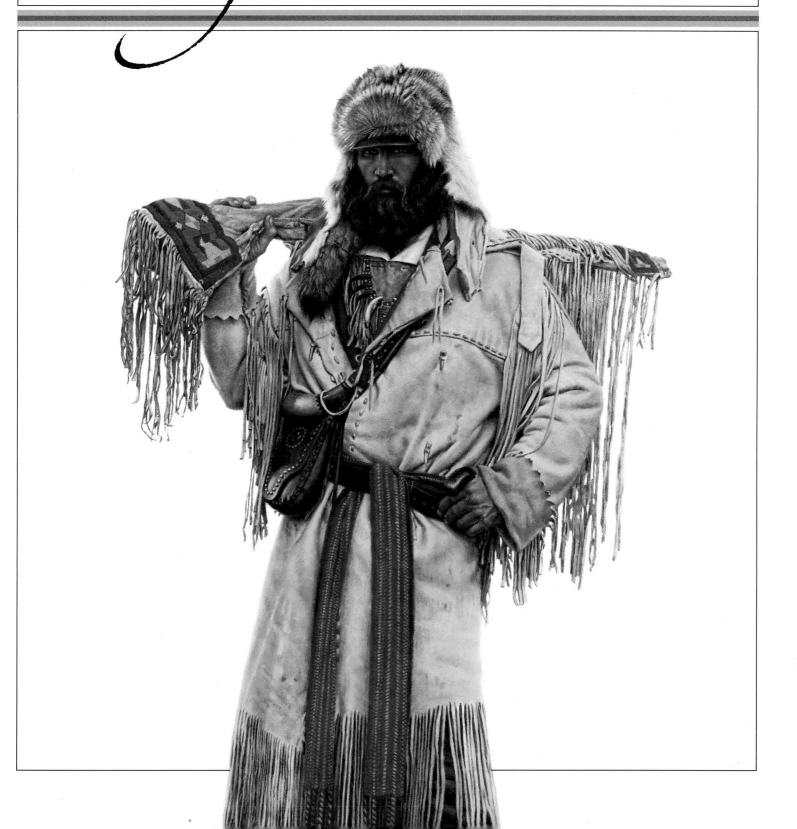

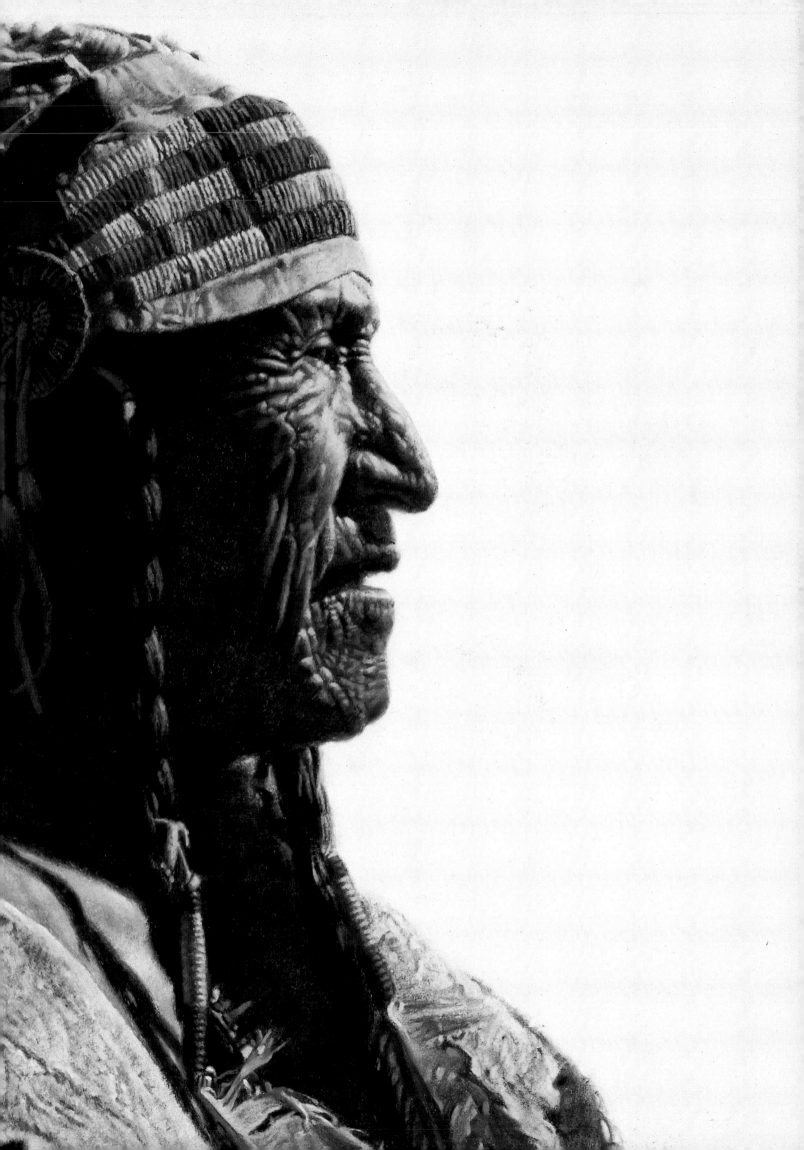

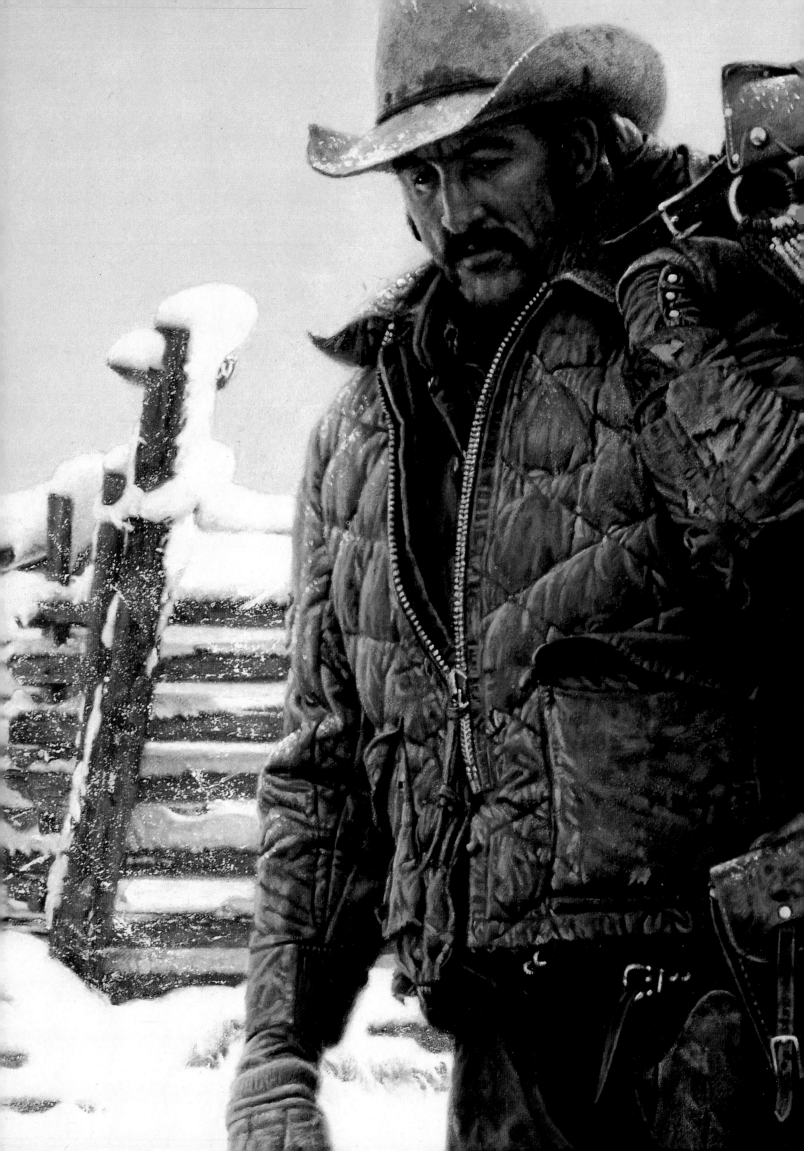

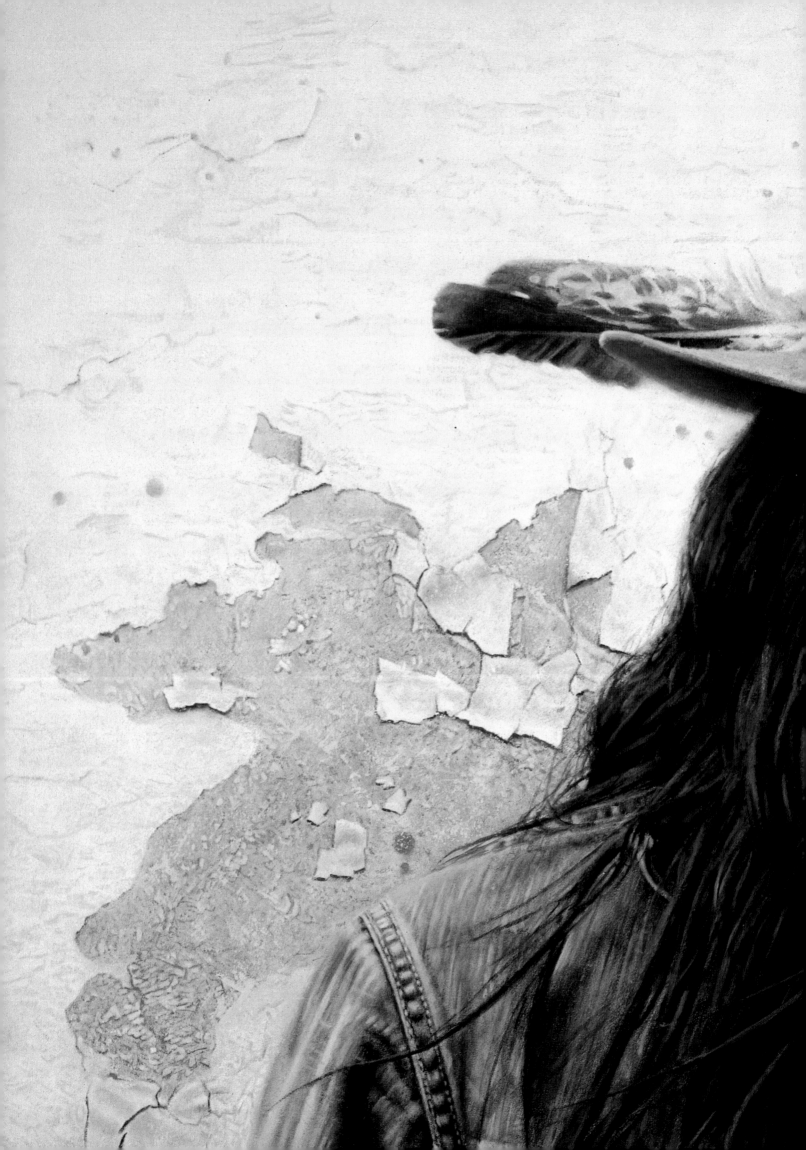

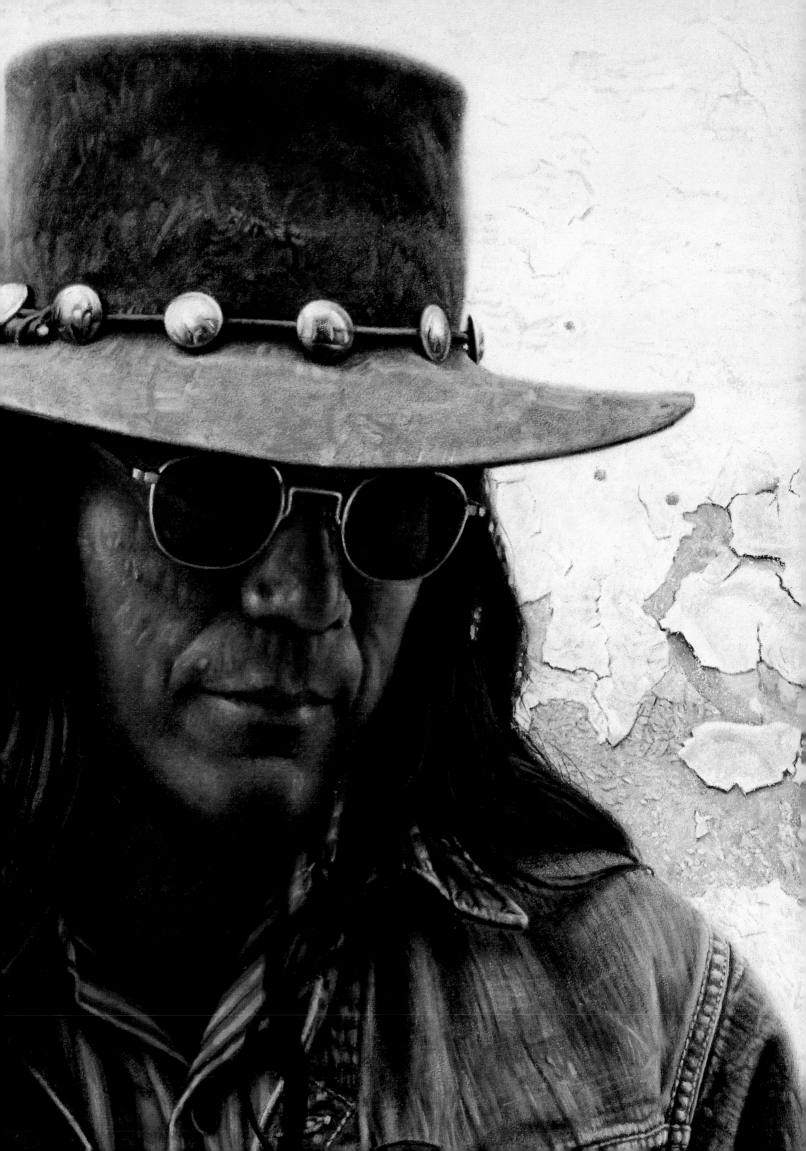

CROW INDIAN FROM LODGE GRASS—Henry Bright Wings *(See pages 2-3, 8, 30.)*
TIMBER JACK JOE, MOUNTAIN MAN—*(See pages 34-35.)*
LITTLE FAWN, CREE INDIAN GIRL—Rhesa Campbell *(See pages 142-143.)*
79-YEAR-OLD COWBOY—Al Smith, "Mountain Man of Cody" *(See page 33.)*

THE ART OF

THE GREENWICH WORKSHOP
TRUMBULL, CONNECTICUT

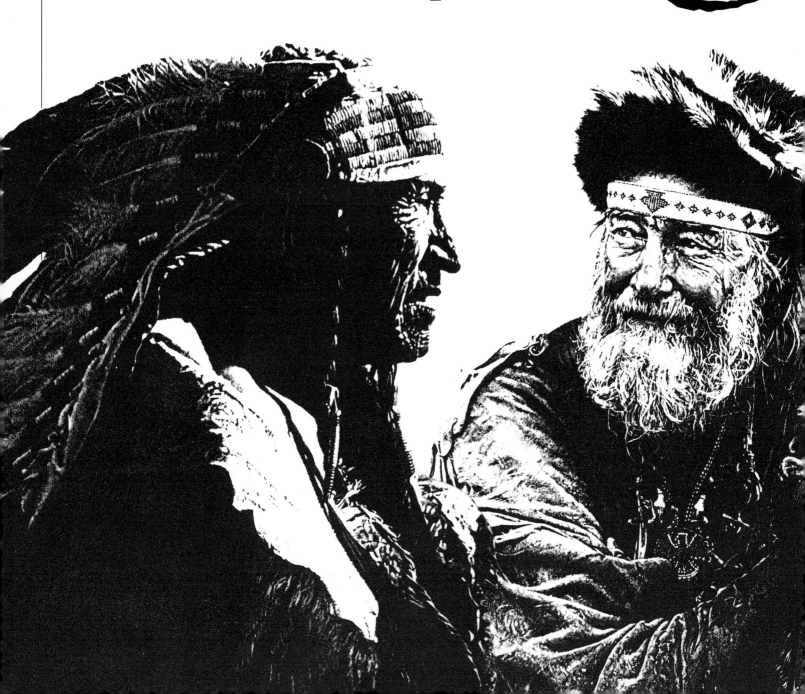

JAMES BAMA

TEXT BY ELMER KELTON
INTRODUCTION BY PETER H. HASSRICK

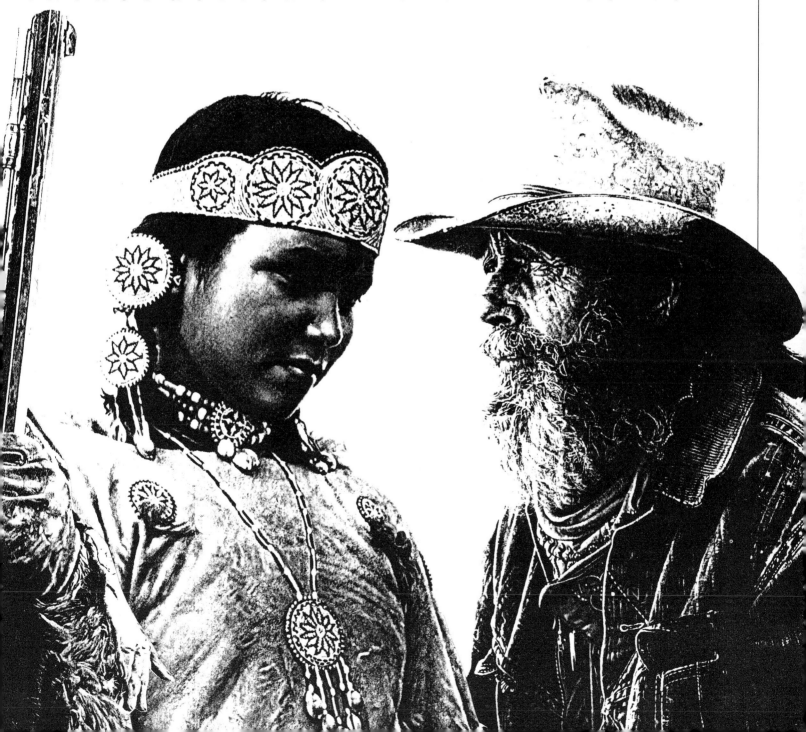

TO MY WIFE LYNNE,
WHO HAS ALWAYS ENCOURAGED
ME TO KEEP GROWING
AS AN ARTIST

CAPTIONS FOR FRONTIS PAINTINGS:
Page 1: READY TO RENDEZVOUS—Dan Deuter, Mountain Man *(See pages 52-53.)*
Pages 2-3: CROW INDIAN FROM LODGE GRASS—Henry Bright Wings *(See page 8.)*
Pages 4-5: HUNTING OUTFITTER—Don Smaltz of Cody, Wyoming *(See other art on pages 100-101.)*
Pages 6-7: CONTEMPORARY NAVAJO INDIAN—Len Foster was among a young Indian group James Bama met
and photographed at a basketball and soccer tournament in Denver. Foster had the contemporary militant
look of so many, the long hair, the hat and feather and dark glasses. Yet his demeanor and conversation
were pleasant. The artist painted a decaying, peeling wall behind him to represent the deteriorating conditions
on today's Indian reservations and the economic and emotional hardships of the people who remain there.

A GREENWICH WORKSHOP BOOK

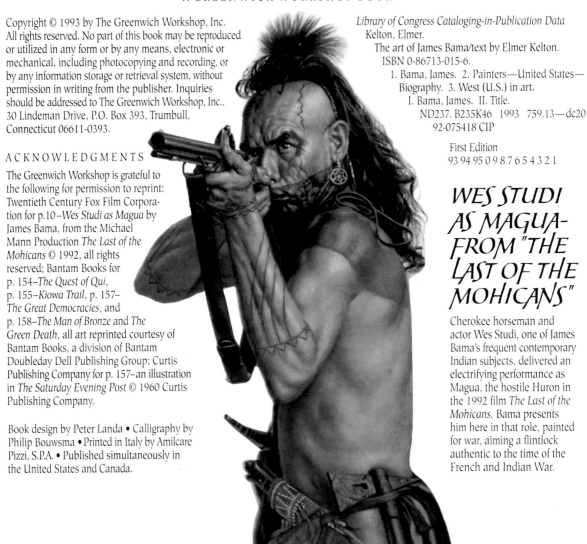

ACKNOWLEDGMENTS

The Greenwich Workshop is grateful to
the following for permission to reprint:
Twentieth Century Fox Film Corpora-
tion for p.10–*Wes Studi as Magua* by
James Bama, from the Michael
Mann Production *The Last of the
Mohicans* © 1992, all rights
reserved; Bantam Books for
p. 154–*The Quest of Qui*,
p. 155–*Kiowa Trail*, p. 157–
The Great Democracies, and
p. 158–*The Man of Bronze* and *The
Green Death*, all art reprinted courtesy of
Bantam Books, a division of Bantam
Doubleday Dell Publishing Group; Curtis
Publishing Company for p. 157–an illustration
in *The Saturday Evening Post* © 1960 Curtis
Publishing Company.

Book design by Peter Landa • Calligraphy by
Philip Bouwsma • Printed in Italy by Amilcare
Pizzi, S.P.A. • Published simultaneously in
the United States and Canada.

Library of Congress Cataloging-in-Publication Data
Kelton, Elmer.
The art of James Bama/text by Elmer Kelton.
ISBN 0-86713-015-6.
1. Bama, James. 2. Painters—United States—
Biography. 3. West (U.S.) in art.
I. Bama, James. II. Title.
ND237. B235K46 1993 759.13—dc20
92-075418 CIP

First Edition
93 94 95 0 9 8 7 6 5 4 3 2 1

WES STUDI
AS MAGUA-
FROM "THE
LAST OF THE
MOHICANS"

Cherokee horseman and
actor Wes Studi, one of James
Bama's frequent contemporary
Indian subjects, delivered an
electrifying performance as
Magua, the hostile Huron in
the 1992 film *The Last of the
Mohicans*. Bama presents
him here in that role, painted
for war, aiming a flintlock
authentic to the time of the
French and Indian War.

CONTENTS

INTRODUCTION

No one shares a more fundamental role in the success of our figurative tradition in Western American art than the Wyoming painter James Bama. Resident of Wapiti, a diminutive town in the state which boasts (and I mean truly boasts) of the smallest population of any state in the union, Bama commands an extraordinary breadth of public presence. His following comes from all walks of life. They are local Wyoming dude ranchers and bronc riders as well as Houston oilmen and New York culturati. Some are pure philistines in matters of art and others abound in sophisticated taste. And they are all exceptionally demanding. For, despite their diversity, Bama's admirers call on him to produce an especially finite aesthetic formula—a concoction which blends realism and spirituality. His followers demand a precision of presentation, an uncompromisingly truthful definition of form. At the same time, those devoted Bama aficionados readily succumb to the aesthetic by requiring the artist to portray the pervasively spiritual essence in the people and scenes he paints.

Pulled accordingly by these forces of patronage and yet following his own true demand for intellectual freedom and artistic integrity, Bama pursues a wonderfully vibrant career. He has lived in the West for nearly a generation. Moving to Wyoming in 1968, he sought a new life after more than 22 years as a commercial illustrator in New York City. Here in the West he found an abundance of material for his fertile mind and uncommon, creative genius. Here in the West he also found *himself*, and he soon revealed that self as a reflection of the new people and scenes he encountered.

Wyoming became his living studio. His brushes, which had helped him create compelling covers for novels and magazines published in the Northeast, now relished in preserving simple but wonderfully transmuted portraits of his freshly discovered Western world. Bama quickly became one of the West's most sensitive and genuinely involved chroniclers.

What seems to have intrigued Bama most about the Western scene is its people. His is a celebration of a living, human presence rather than the mythic wake that is usually expected of more slender talents in Western art today. He resolves the normal tension between myth and reality by transcending narration and proposing the verity of life devoid of reliance on fictive inventiveness. It is the qualities of character and the blush of persona that invigorate Bama's work, making his paintings resonate with expectant life.

Bama is a painter of neither scenes past, nor great men and women, but of today's history, of the contemporary figures who move in and out of quasi-historic roles within our own time. His works are derived from a broad range of historical analogue: the cowboy, as vital in his image today as it is nostalgic of the past uniqueness of the Old West; the outfitters, present-day symbols of the trapper era; the Indians, some who are young and dynamic forces within their tribes and some old enough to be but one generation separated from the proud chiefs who defended a way of life now lost to history. Rodeo riders share his attentions with homesteaders, prospectors with Indian militants. The world he creates is filled with real people, each dominated by his or her own symbolic essence. It is a world of tangible forms set in intangible perspective, a world which awakens in us a dormant sense of longing to observe the West in a blend of human tradition and precise imagery.

Beyond Bama's penchant for enlivening his canvases with the people of his West, he is appreciated for his virtuoso accomplishments as a technician, despite a reticence on his part to acknowledge such. "Technique has never been a major factor...to me," he remarked in 1980. There is, nonetheless, an extraordinary facility that permeates his work. One is immediately absorbed in Bama's multifarious textures, his precision of line which supports softly contoured forms and his ivory-smooth surfaces. Compositions are powerfully and simply

THE TRAPPER

Doug Mikkelsen was trapping for the federal government when Bama portrayed him in a pair of handmade, horn-button, mountain-man leather britches which he was wearing in the course of his daily work. His traps slung over his shoulder, he presents what Bama calls "a symphony of reds," his rust-colored hair and beard blending nicely with the various shades of red in his shirt, his underwear, his suspenders and kerchief. The broad-brimmed, well-weathered Western hat went into Bama's collection. "It's my favorite of all I own," he declares.

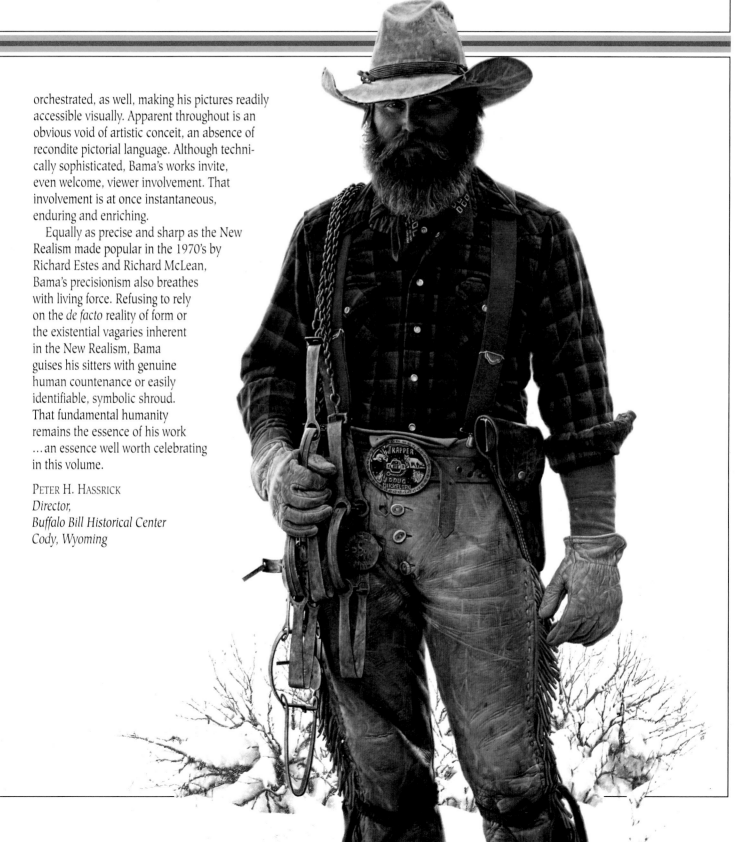

orchestrated, as well, making his pictures readily accessible visually. Apparent throughout is an obvious void of artistic conceit, an absence of recondite pictorial language. Although technically sophisticated, Bama's works invite, even welcome, viewer involvement. That involvement is at once instantaneous, enduring and enriching.

Equally as precise and sharp as the New Realism made popular in the 1970's by Richard Estes and Richard McLean, Bama's precisionism also breathes with living force. Refusing to rely on the *de facto* reality of form or the existential vagaries inherent in the New Realism, Bama guises his sitters with genuine human countenance or easily identifiable, symbolic shroud. That fundamental humanity remains the essence of his work ...an essence well worth celebrating in this volume.

PETER H. HASSRICK
Director,
Buffalo Bill Historical Center
Cody, Wyoming

OLD CROW WOMAN WITH MEDICINE HIDE—Cerise Stewart, Wife of Medicine Man
SHOSHONE CHIEF—Herman St. Clair, Respected Elder
PORTRAIT OF AL—Al Smith, Cowboy and Guide
OLD ARAPAHO STORY TELLER—Mike Brown, Keeper of Traditions

BRIDGES

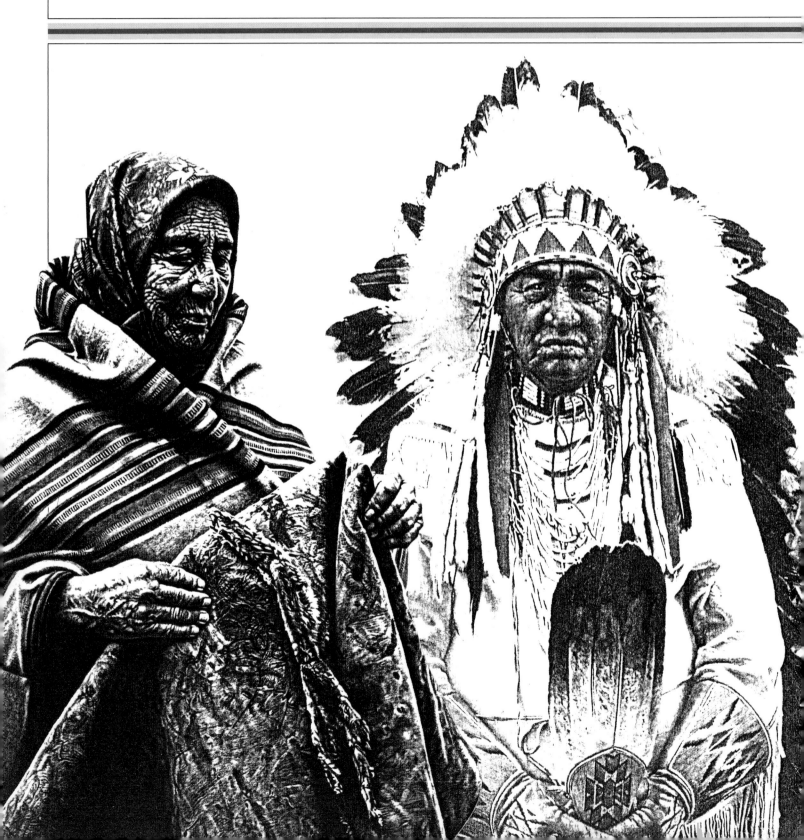

TO THE PAST

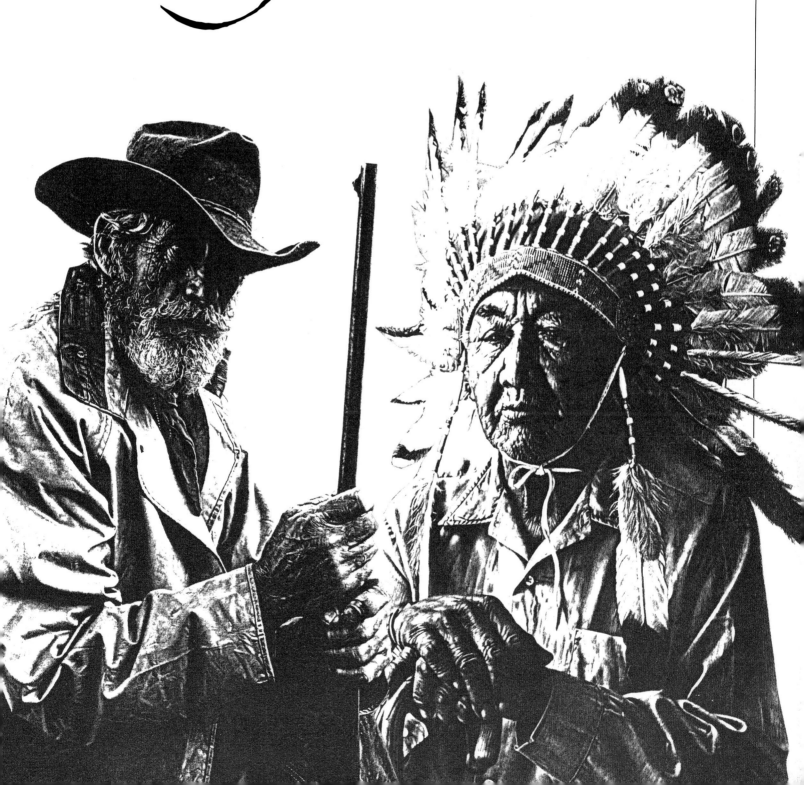

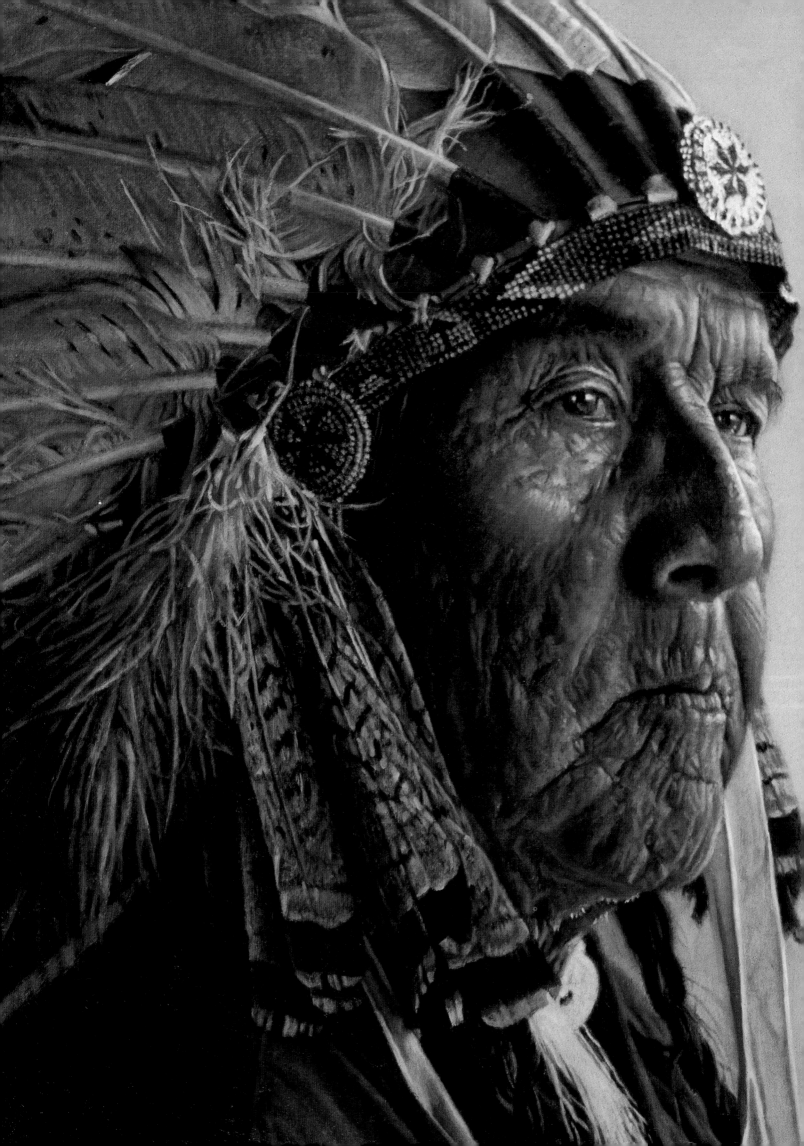

BRIDGES TO THE PAST

When James Bama gave up his successful New York career in commercial art, he had no intention of becoming known as a Western artist. On the contrary, he had seriously considered moving to New England, to Norman Rockwell country, and painting native New Englanders in their own natural element. The artist in him had always been fascinated by "old people with wrinkles." He knew he would find plenty of them in Maine or New Hampshire, Vermont or wherever he decided to go.

But first he wanted to visit a friend, artist Bob Meyers, with whom he had worked and shared a common interest in sports for about ten years while they had painted illustrations and advertising art in the same New York studio. Meyers had retired from illustration in 1960 and fulfilled a longtime ambition to find a home in the West. He had bought a guest ranch on the North Fork of the Shoshone River west of Cody, Wyoming. In 1966 Bama and Lynne, his wife of two years, accepted Meyers' invitation.

"I hadn't seen him in seven years, since he had moved out West," Bama recalls. "I wasn't interested in horses or riding; I just wanted to see Bob. We came out as dudes, simply to visit. We were thirty-six miles from town. Even though I had been all over the world, this was the first place I had not had access to a Coke machine or a bank or American Express. We rode in the mountains. We were alone and had to rely on our own resources. It was great."

The following year the Bamas decided to move to the West, to live amid the rugged beauty of Wyoming that had impressed them so much.

The artist was fascinated by everything he saw in the Western environment. At first he did a great many still lifes: old log buildings, wagons, corral fences. Of particular interest were animal skulls he found lying about on the range. "People would ask me, 'What's the big deal about old skulls? We see them all the time.' But *I* hadn't seen them, coming from New York."

Gradually he became aware that compared to the Eastern states he had known, Wyoming had a relatively short history. "It had not occurred to me that there were people still living who were older than the state of Wyoming. I began to find out there were people alive who had come here in covered wagons, who had homesteaded here." He began to notice oldtimers in Cody, in particular three old fellows who hung out together on a street corner. They piqued his interest, but he was shy about intruding upon their privacy.

"I got to know John Thevenow, who owned a saddleshop. He loved the oldtimers, and he finally introduced me to Slim Warren. Slim was the most wonderful-looking old cowboy. He lived in a little stucco apartment…had his saddle on a barrel. They said he would always train a horse so that when you put your foot in the stirrup it would take off at a mile a minute. He would talk about horses, not girls. But he was too old and busted up to do ranch work anymore.

"Slim took me over to meet Roy Bezona, who called himself Old Man Wyoming. Then John Thevenow introduced me to George Washington Brown, who was more than ninety years old. He was the last living stagecoach driver who had driven twenty-four-horse teams. So I finally got to know these three people I had wanted to paint in the worst way. I think Norman Rockwell would have been envious."

As the acquaintanceships deepened he began to recognize that these men and others of their age group were a living link to Wyoming history; they had witnessed much of it in the making. He also realized, to his sorrow, that to a large extent time had passed them by. Changing conditions in the world around them forced them, however reluctantly, to adjust to lifestyles alien to so much they had known. Moreover, they were lonely, having outlived most of their peers. They were largely ignored by younger people busy with the challenges of their own daily lives.

"All they wanted was a little attention, a little recognition for what they had done and been." Given that, they warmed up

[17]

*"It had not occurred to me
that there were people still living
who were older than the state of Wyoming.
I began to find out there were people alive
who had come here in covered wagons,
who had homesteaded here."*

very quickly. These old men offered their friendship, and Bama was glad to have it.

He had always known that the West was home to many diverse Indian tribes, but they had never particularly intruded upon his consciousness until he began to see them. Suddenly they were very real, very relevant. Ironically, the first Indians he saw in Cody were at a parade—not in it but standing on the curb watching white men dressed and painted to portray Indians.

"God knows what they were thinking," Bama says.

*A*gain, John Thevenow opened a crucial door. He introduced Bama to a Crow woman named Rose Plenty Good, who made moccasins to sell in his saddleshop. "She was the first Indian I had ever spoken to out here," the artist recalls. After posing for him herself, she soon began bringing other Crow Indians down from the reservation 180 miles away. One of them, to Bama's delight, was a son of the noted Medicine Crow.

"Meeting Chester Medicine Crow was the most exciting thing that had happened in my professional life up to then. He was the son of a famous chief, and there he sat right in our living room with his father's headdress and peace pipe and a peace medal that had been given to him by Woodrow Wilson. And he had his father's 1890's American flag with forty-six stars in it. He looked great. The thing I really liked most was that he was half today and half history. He had all the accoutrements of the old frontier Indian, and yet he was wearing a contemporary shirt. I didn't paint him as I would have painted his father. I painted him as a living example of the transition between yesterday and today."

Bama became acquainted with people at the St. Stephens Catholic Mission on the Arapaho and Shoshone Reservation near Riverton, Wyoming. Pius Moss ("He was one of the biggest and strongest Indians I ever saw; he could lift a car by himself.") introduced him to Francis Setting Eagle, at 94 1/2 the oldest living Arapaho, a man who once had performed before Queen Victoria. "Boy, was I excited about that! He was just what I had been looking for, this very old Indian with all those wrinkles, and an old black reservation hat and braids and cane. But I was afraid we were going to lose him, he looked so frail."

As an outsider experiencing them for the first time, the Indian reservations held great enchantment for him. At the same time, visiting them was a sobering experience. It revealed the depths of poverty and despair so many Indians endured. Though in his younger days he had seen much of the outside world, old Francis Setting Eagle lived in a small government house with little furniture beyond a chair and a television set.

Bama visited an elderly tribal council chief of the Northern Cheyenne who once had recited a traditional Indian prayer in Washington for President Lyndon B. Johnson. The old man pointed out to Bama with considerable pride that he had an indoor toilet. So many of his friends and neighbors did not.

But there was magic as well. Bama sat in the tepee of a Crow medicine man and witnessed a prayer ritual. "He was a medicine man for the Whistle Water clan. Isn't that a great name? He had a medicine bundle that had last been photographed in 1935 by the Smithsonian. He explained the significance of it to me. This opened up a whole new world. I had read of such things but had never seen them.

"Everyone there was Indian except a friend and me, and even he was part Indian. We sat in the tepee cross-legged and smoked the peace pipe. I had never smoked. I didn't know how to inhale, so during the ceremony I accidentally put the pipe out. That was embarrassing."

*A*t this ceremony he received an entree to Indian mysticism. The participants made medicine with a small glass ball of a kind found in novelty shops. A tiny lead figure was embedded inside. Holding the glass to the light, they declared that the figure had changed form. "I didn't see it, but it was fascinating being there with those Indians who were convinced they saw the changes with their own eyes. You see

CHESTER MEDICINE CROW WITH HIS FATHER'S PEACE PIPE AND PEACE MEDAL

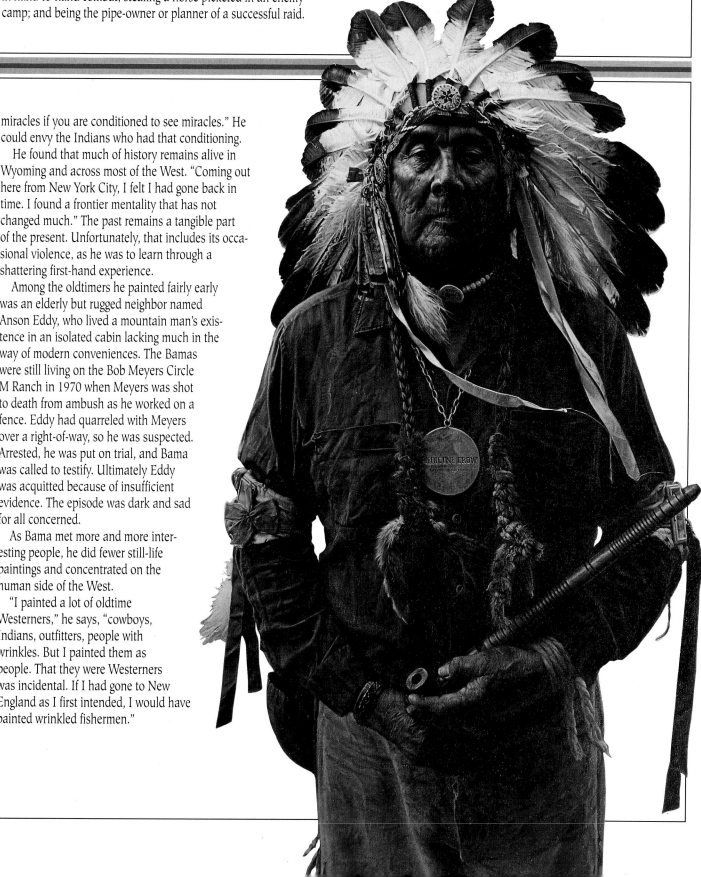

Chester Medicine Crow's visit to the Bama home was one of the highlights of the artist's early years in Wyoming. Son of one of his people's most distinguished leaders in the final years of Indian warfare, Chester Medicine Crow bore himself with the inherited dignity of a tribal chief. He wore his father's headdress and a peace medal given to the original Medicine Crow by President Woodrow Wilson, and he carried his father's peace pipe. His father was noted for having achieved all four of his tribe's standard deeds of valor: counting coup by touching an enemy; snatching away a bow or gun in hand-to-hand combat; stealing a horse picketed in an enemy camp; and being the pipe-owner or planner of a successful raid.

miracles if you are conditioned to see miracles." He could envy the Indians who had that conditioning.

He found that much of history remains alive in Wyoming and across most of the West. "Coming out here from New York City, I felt I had gone back in time. I found a frontier mentality that has not changed much." The past remains a tangible part of the present. Unfortunately, that includes its occasional violence, as he was to learn through a shattering first-hand experience.

Among the oldtimers he painted fairly early was an elderly but rugged neighbor named Anson Eddy, who lived a mountain man's existence in an isolated cabin lacking much in the way of modern conveniences. The Bamas were still living on the Bob Meyers Circle M Ranch in 1970 when Meyers was shot to death from ambush as he worked on a fence. Eddy had quarreled with Meyers over a right-of-way, so he was suspected. Arrested, he was put on trial, and Bama was called to testify. Ultimately Eddy was acquitted because of insufficient evidence. The episode was dark and sad for all concerned.

As Bama met more and more interesting people, he did fewer still-life paintings and concentrated on the human side of the West.

"I painted a lot of oldtime Westerners," he says, "cowboys, Indians, outfitters, people with wrinkles. But I painted them as people. That they were Westerners was incidental. If I had gone to New England as I first intended, I would have painted wrinkled fishermen."

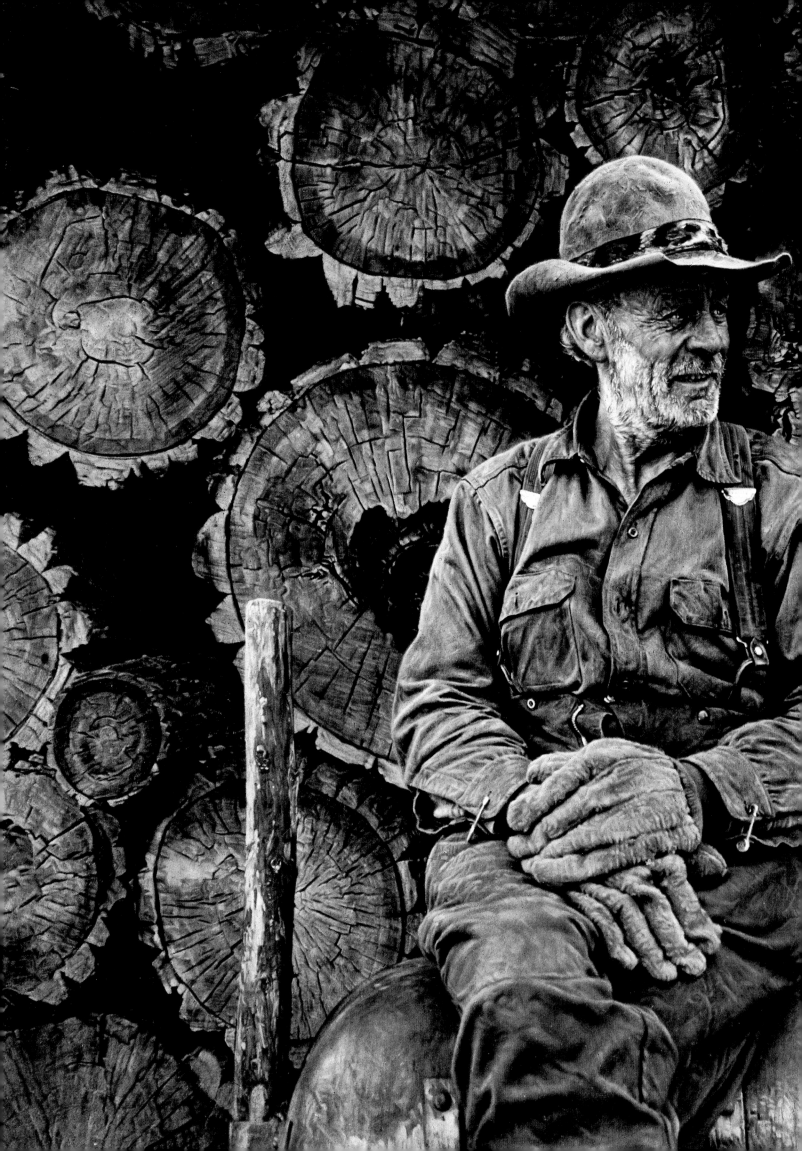

ANSON EDDY, MOUNTAIN MAN

PORTRAIT OF A SIOUX

Meeting a colorful local character like Anson Eddy was a stimulating experience for artist James Bama soon after he and his wife Lynne moved from New York to a ranch west of Cody, Wyoming. Eddy lived in a mountain cabin with forty cats, about that many rifles, and a wood-burning stove. A true mountain man, he had been a hunting guide in his younger days and worked with the U. S. Forest Service. Every Saturday he would walk the two and a half miles down to the road to pick up his mail, always carrying a rifle in case he should see a rabbit to feed his cats. He did not own a vehicle, so a friend hauled hay for Eddy's horses. Eventually Eddy was accused in the ambush murder of a neighbor, tried and acquitted. "He was a tough old bird, the real McCoy," Bama says. He pictured Eddy seated upon a wheelbarrow upturned against a stack of wood the rugged mountain man had cut for his own use. The logs reminded film-buff Bama of the cogs and gears in Charlie Chaplin's classic *Modern Times*. Because of the fine detail in the wood, the painting required five-and-a-half months of work. "I could have built a house with the logs faster than I painted them," he says.

The artist saw Frank Sotonoma Salsedo in a slow-moving parade at a Crow Fair on the Wind River Reservation in 1979. Though Salsedo was actually a Klamath Indian from the West Coast, he was wearing a Sioux outfit for a role in a television movie, *The Legend of Walks Far Woman*, being filmed nearby. Bama found him a very convincing Sioux with a choker around his neck and two necklaces, one beaded and one of elk teeth. The Crow Fair is the largest powwow in its part of the country and invites participation by Indians of all tribes. Its grand entries feature hundreds of horseback riders in all manner of traditional and nontraditional outfits.

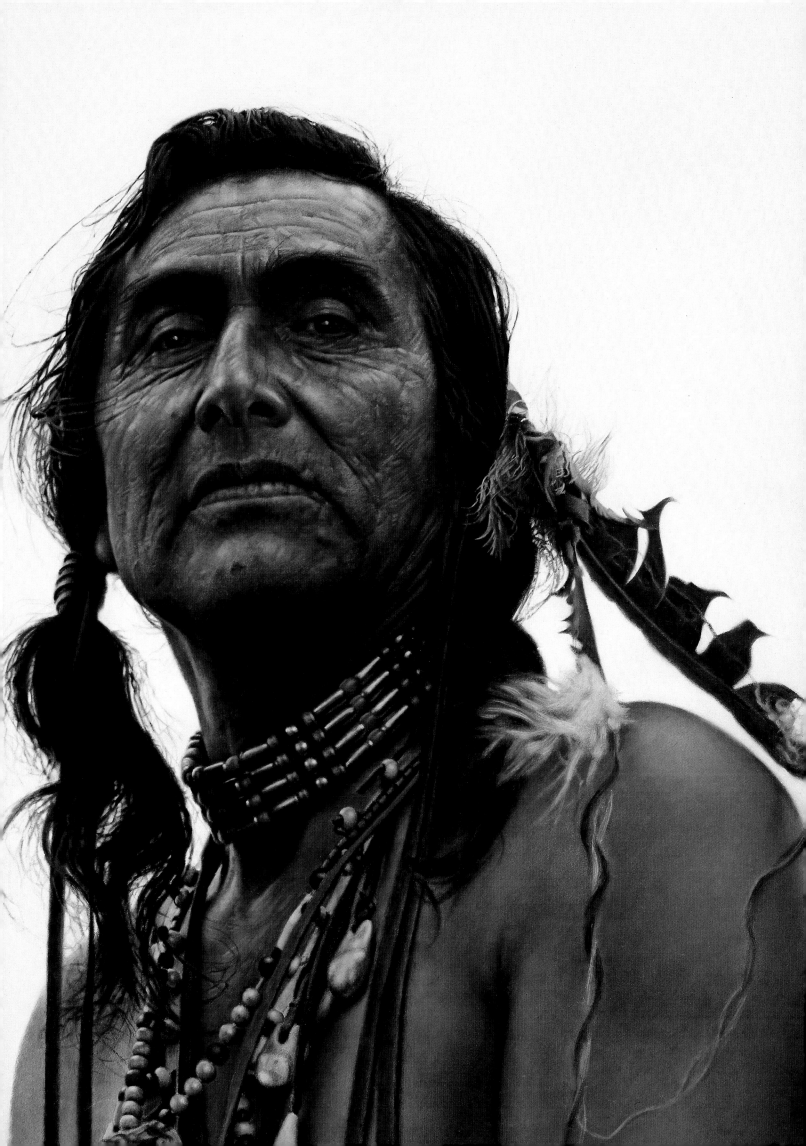

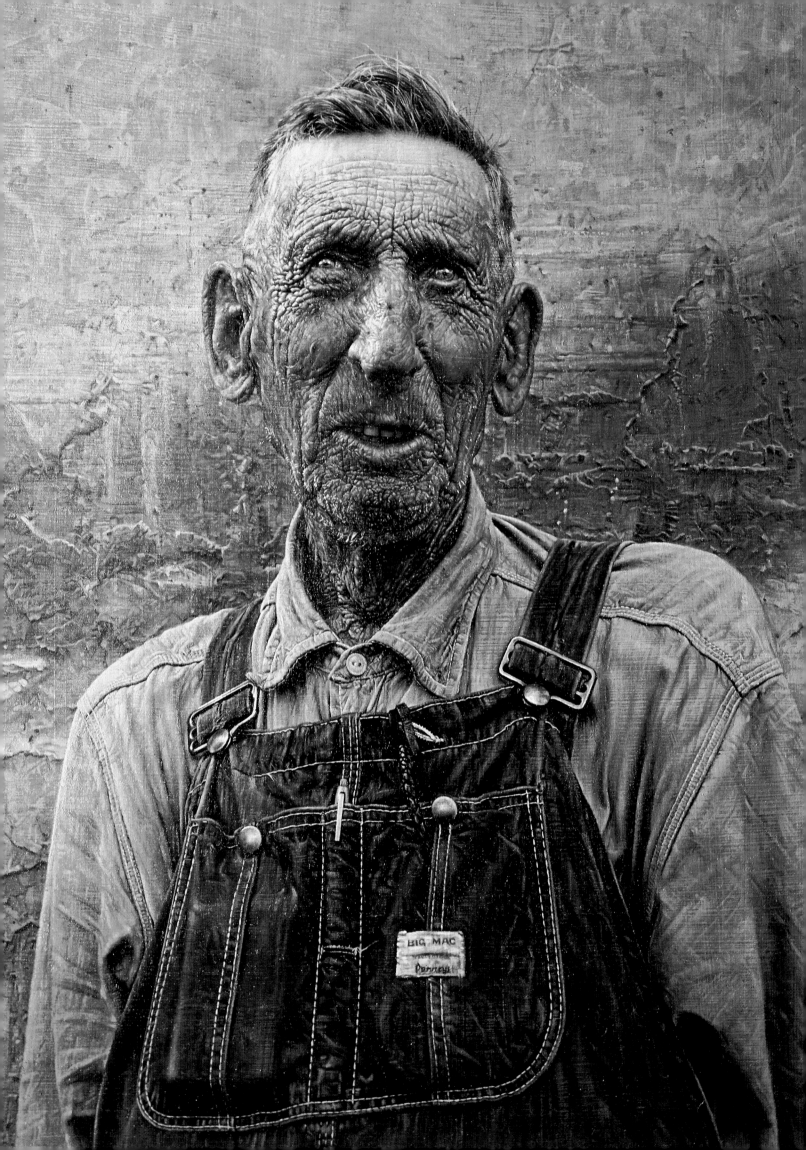

ROY BEZONA, OLD MAN WYOMING

Roy Bezona was one of Cody's colorful local characters with whom Bama became acquainted. Bama always liked to paint wrinkled faces, and Bezona's was about as wrinkled as he ever saw. Bezona himself declared, "My face is like a baseball team; it's got nine hairs on each side." He was born July 10, 1890, the same day Wyoming became a state. He told the artist, "If you paint my picture, call it 'Old Man Wyoming.'" Bezona was born in Missouri but left at age twelve, seeking work to help support his family. He labored on the road into Yellowstone National Park, herded sheep, hired as a freighter and homesteaded land near Cody. Self-taught, he had a keen and inquiring mind that made him knowledgeable about a wide range of subjects. He was something of a cynic, especially about politics. Nobody impressed him. His friendship had to be earned; it could not be bought. Yet he sought that friendship and became like family to Lynne and James Bama. "We had a birthday party for him, and Lynne baked him a cake," Bama recalls. "He almost cried." Bezona did indeed have a sentimental side. A nephew and his family lived with him several years. After they moved away, Bezona never removed the towels from the bathroom the children had used, or took their toys from his mantle. He died in his sleep at 83, an age attained despite his eating a hearty breakfast of bacon and eggs every day and consuming a big pot of black coffee. *(Small painting at right is entitled ROY BEZONA, PORTRAIT.)*

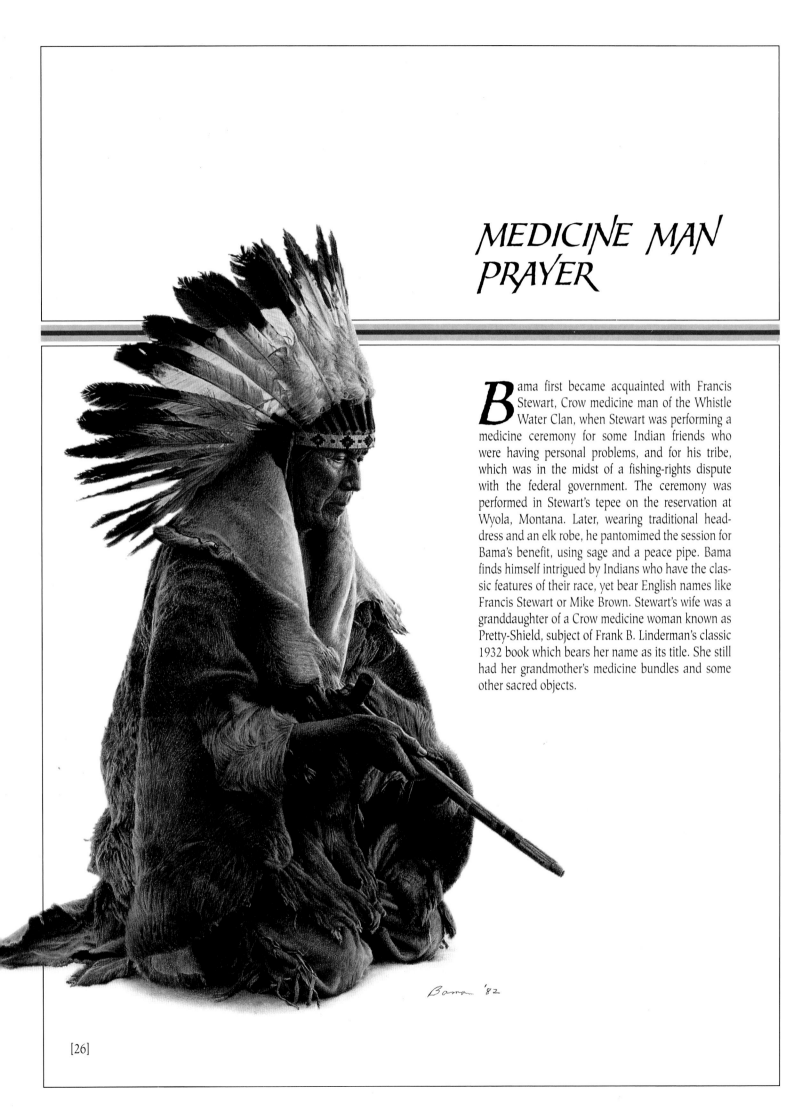

MEDICINE MAN PRAYER

Bama first became acquainted with Francis Stewart, Crow medicine man of the Whistle Water Clan, when Stewart was performing a medicine ceremony for some Indian friends who were having personal problems, and for his tribe, which was in the midst of a fishing-rights dispute with the federal government. The ceremony was performed in Stewart's tepee on the reservation at Wyola, Montana. Later, wearing traditional headdress and an elk robe, he pantomimed the session for Bama's benefit, using sage and a peace pipe. Bama finds himself intrigued by Indians who have the classic features of their race, yet bear English names like Francis Stewart or Mike Brown. Stewart's wife was a granddaughter of a Crow medicine woman known as Pretty-Shield, subject of Frank B. Linderman's classic 1932 book which bears her name as its title. She still had her grandmother's medicine bundles and some other sacred objects.

Bama '82

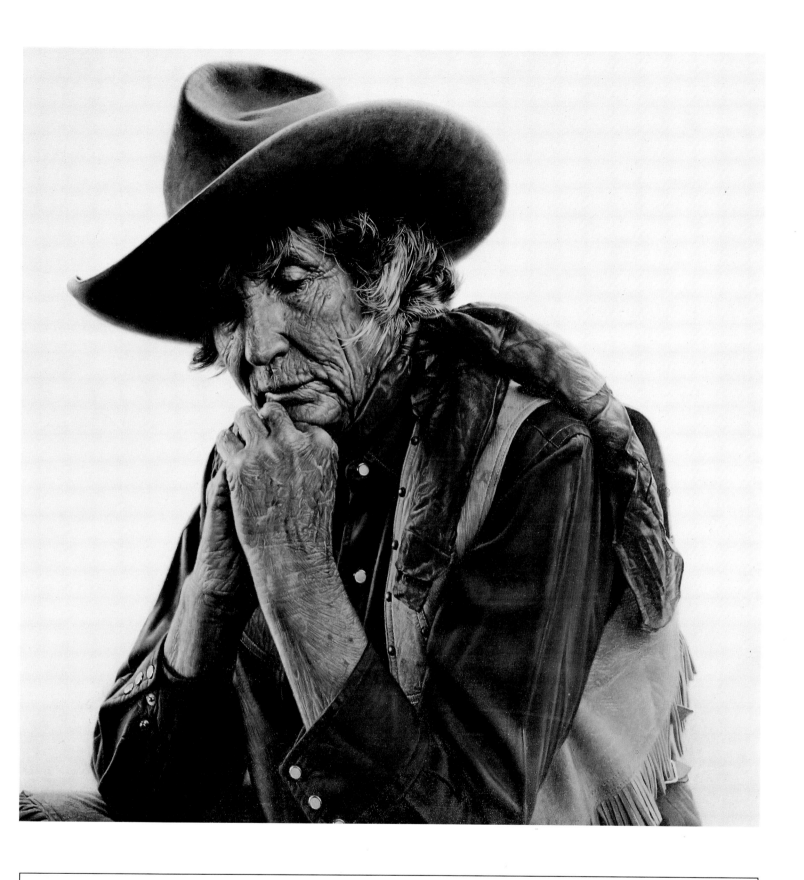

A PORTRAIT OF LUCYLLE MOON HALL

The first time Bama saw Lucylle Moon Hall, the college-educated ranchwoman was dressed in her mother's old-fashioned black dress and riding sidesaddle in a rodeo parade. When she came to the Bama studio to pose, she drove up in a truck and began shoveling dry cow manure on the front lawn as her visiting present. A rugged, large-boned woman, she was still irrigating her own land until fairly recent times. Now in her 80's, she still lives on a ranch north of Cody, Wyoming. For this portrait she dressed in her old cowgirl clothes, with a big red silk kerchief and a pinched-crown hat of 1920's vintage. Bama says of her, "She is a very colorful woman, of a kind they just don't make anymore."

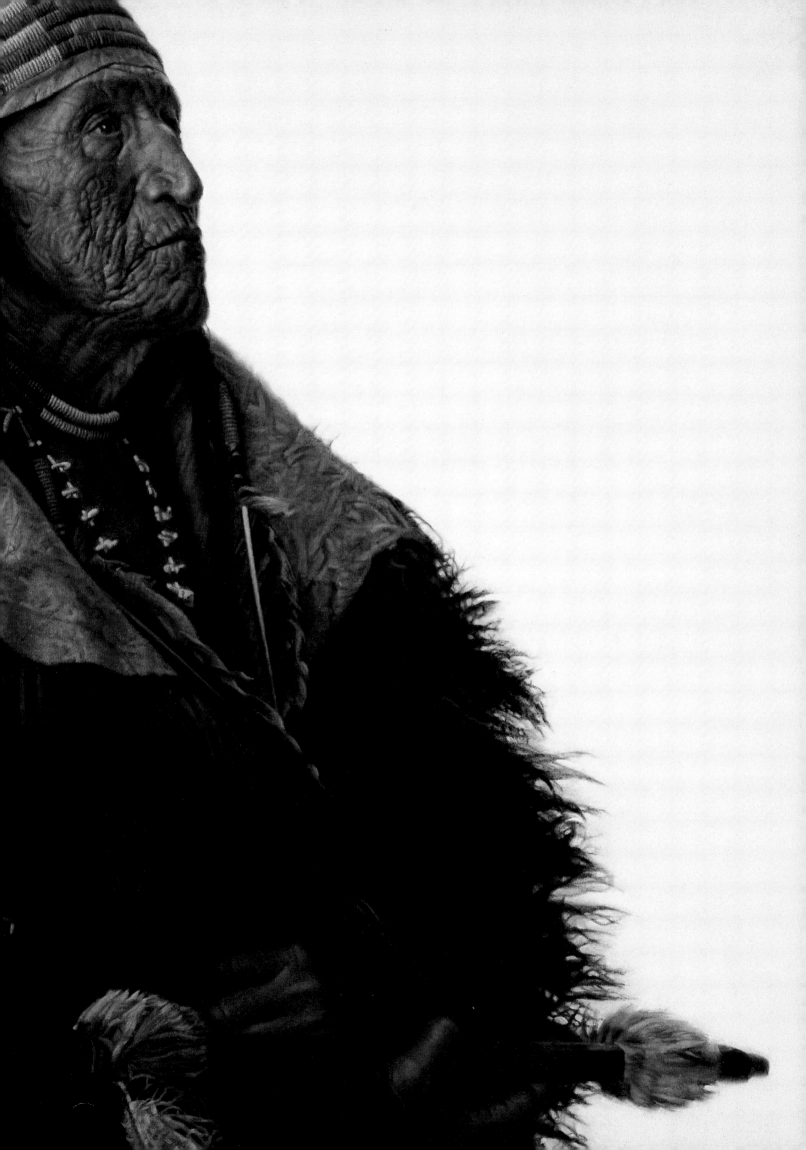

CHESTER MEDICINE CROW WITH HIS FATHER'S FLAG

Chester Medicine Crow offered Bama a direct link with fighting Indians of the frontier, for he was a son of the noted chief Medicine Crow. He posed in his father's Crow headdress and against his father's 1890's flag with forty-six stars. "He was the first male Indian I painted," says Bama. "He was part yesterday and part today." Chester Medicine Crow was stone deaf, so Bama was unable to communicate the way he wanted him to pose. The dignified old gentleman seemed to feel he was expected to sit stiffly and formally, so that is the way Bama painted him. The artist found irony in the fact that Indians often use the American flag as a motif in their arts and crafts despite many wrongs done to them by the white man's government.

The Crows were a branch of the Hidatsa, almost always in conflict with the tribes who neighbored them because of fierce competition for their favored hunting grounds. They were originally given an extensive Montana reservation in return for their help to the military against hostile tribes such as the Sioux and Cheyenne, but this reservation was eventually whittled down substantially under pressure of white interests. The Custer battlefield, near Garryowen, Montana, is on Crow lands.

CROW INDIAN WITH PEACE PIPE

Bama met Henry Bright Wings during a medicine ceremony performed in the tepee of a Crow medicine man at Wyola, Montana. Bright Wings, then 68, had his hair cut short and was wearing white-man shirt and trousers, but Bama liked his classic face, which he thought would have been appropriate on a buffalo nickel. When Bright Wings visited Old Trail Town in Cody several years later, Bama dressed him in historical costume including a pre-1900 headdress and a very old buffalo robe from the Old Trail Town Museum in Cody.

In earlier times the right to wear a headdress had to be earned, usually in battle. Today even women and children sometimes wear a showy nontraditional warbonnet for powwow dances, parades and celebrations. Many men feel that their age is entitlement enough, but others will not wear a headdress because they do not consider it their right. Bama met a Pine Ridge Reservation Indian who would not pose in a headdress though he was 45 years old and certainly looked venerable enough. In the Indian wars of the post-Civil War years, Bright Wings' people, the Crows, frequently allied themselves with the military against such traditional enemies as the Sioux and Cheyenne. Crow scouts rode to their deaths with Custer.

Bam

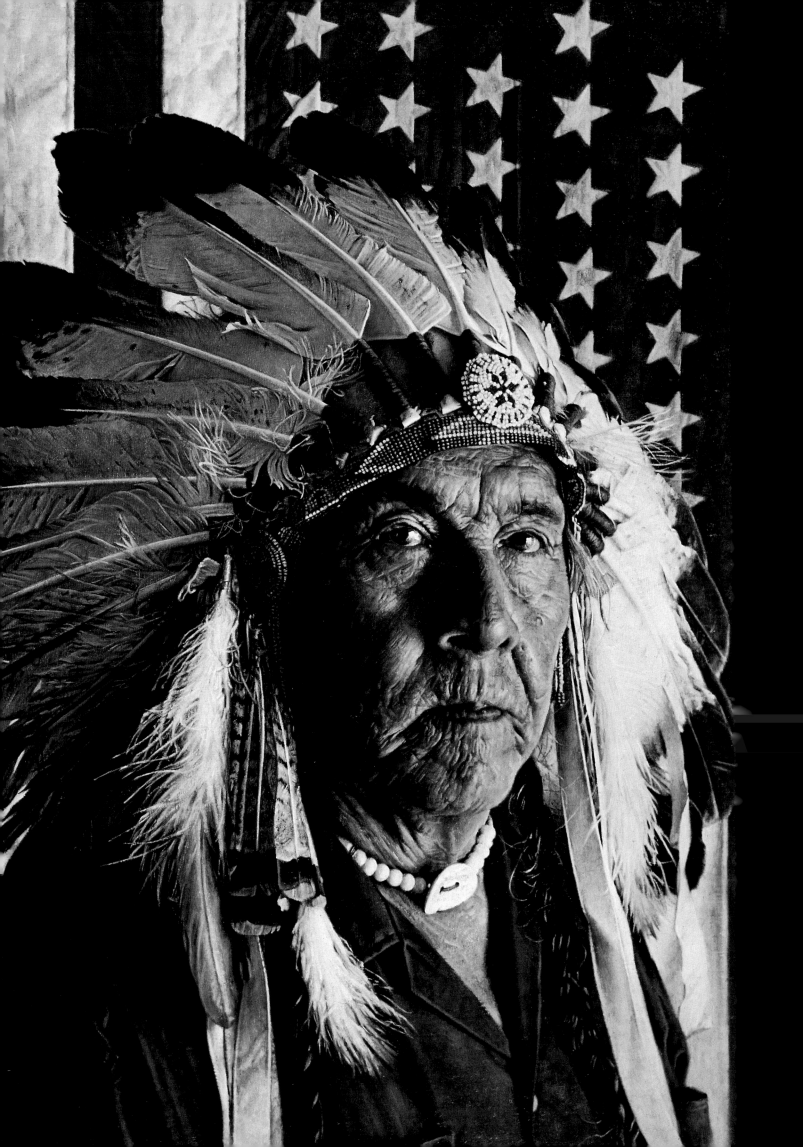

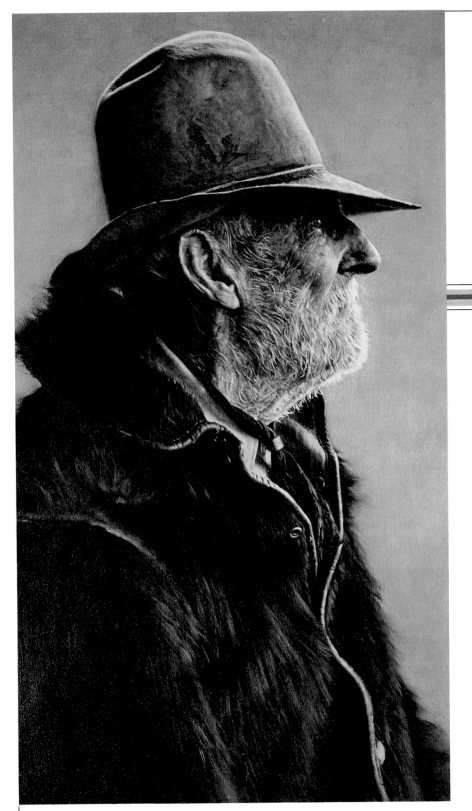

GEORGE WASHINGTON BROWN

George Washington Brown was 92 when Bama first met him, Wyoming's oldest living stagecoach driver of twenty-four-horse teams. Even at that age he still had a strong grip. After his wife's death he had moved into a mobile-home court but alarmed its owner when he tripped and fell. Refusing to enter a nursing home, he took a room in a Cody hotel and remained there until his death at 95. A tall man with big, bony hands, he used to hang out on a street corner with a couple of other Cody oldtimers, often bickering with them over particulars of events in the distant past. Bama found these veterans of the Old West fascinating and mourns their passing. "Once you talked to these people they opened up, and they were wonderful. I loved to visit with these guys on the street corner and just make small talk. They were so typical of a small Western town like Cody, and now they are all gone. This was our heritage, people like this. Now we have Wal-Mart and K-Mart instead of oldtimers. It has changed so much here, it is starting to become Anytown, U.S.A." He finds some comfort in the fact that the old cowtown Meeteetse, some thirty miles down the road, still retains much of its original flavor.

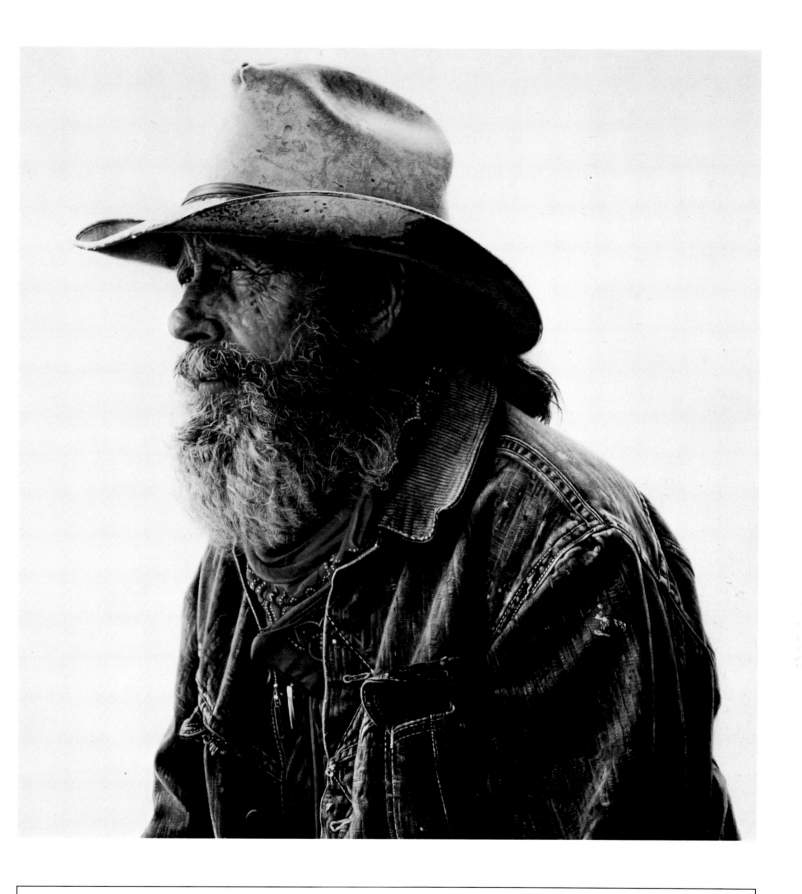

79-YEAR-OLD COWBOY

*A*cowboy, camp cook, hunting guide, coal miner and former deputy sheriff, Al Smith was one of many colorful oldtimers Bama found when he moved to Cody, Wyoming. At 79, Smith took the artist into the mountains, trapping. He continued to trap well into his 80's. At age 16 he had worked in the coal mines, surviving an explosion that killed forty-eight of his co-workers but eventually giving up the work after developing black lung disease. He served for a time as a deputy sheriff in Wyoming's Sweetwater and Lincoln counties. In his late years he tried to recreate his past by wearing his cowboy outfit, complete with red neckerchief, blue-jean jumper, pistol and chaps, to charm tourists with stories of early days in Wyoming. He handed out cards describing himself as "The Mountain Man of Cody."

SIMON SNYDER, RETIRED RANCHER

TIMBER JACK JOE, MOUNTAIN MAN

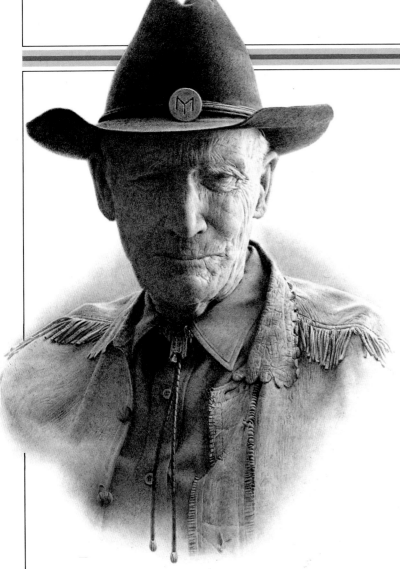

Timber Jack Joe, real name Joseph Ernest Lynde, gave Bama his introduction to a present-day phenomenon, the modern mountain man. At one time or another Joe had been a sheepherder, farmer, rancher, miner and a timber contractor for the U. S. Forest Service. He was a man who seemed to have been born out of his natural time. When Bama first met him, he was living out a fantasy of the past in the mountains, trapping, venturing down in beard, beads, colorful buckskins and skunk cap for fairs and parades. He often lectured schoolchildren on the lives of the original mountain men who were the first whites to leave their moccasin prints in many hidden parts of the Rockies. His constant companions were his Appaloosa horse, Papoosie, and a shepherd dog, Tuffy, which rode behind Joe's saddle in countless parades. When Tuffy finally died at the age of 18, he was given a fitting mountain-man funeral. Of Lynde, Western actor Slim Pickens declared, "I believe the good Lord played an awful trick on Timber Jack Joe by putting him here in this day and age, but thank God he did, 'cause now the rest of us know how a real mountain man looked, dressed, and smelled." Joe's exuberant portrayal of his spiritual forebears occasionally went overboard. He was expelled from a museum in Cody after startling tourists with a tremendous war whoop. His sons are definitely products of today, however. One is a minister, the other a stockbroker.

Simon Snyder was the oldest living registered voter in Park County when Bama got to know him in Cody, Wyoming. "When I met him he was probably 90," Bama relates. "He sat in an armchair in the old Irma Hotel. They put up a sign over it that said, 'Simon Snyder's Office.' He spent his later years just sitting there and observing life." He had come to Cody as a boy in 1898, when the new town had but three permanent buildings. In his youth he broke horses for Buffalo Bill's TE Ranch. He was for a time a forest ranger, a homesteader, a hunting guide and ultimately operated one of the earliest and most successful dude ranches in the West. He was kindly and well liked. It was said of him that when he was younger he could outwalk anyone around him. Asked once if he had ever been lost in the mountains, he replied, "You bet. Show me a man who has never been lost and I'll show you one who has never guided very much. The trick is, if you get lost, to get yourself out of trouble without involving a lot of other people who might also get in trouble." Here he wears a soft buckskin jacket and has his old cattle brand attached to his hatband. The famous Irma Hotel, built in 1902 by Buffalo Bill, still maintains the sign where Snyder sat for so long and has named one of its rooms the Simon Snyder Suite in his memory.

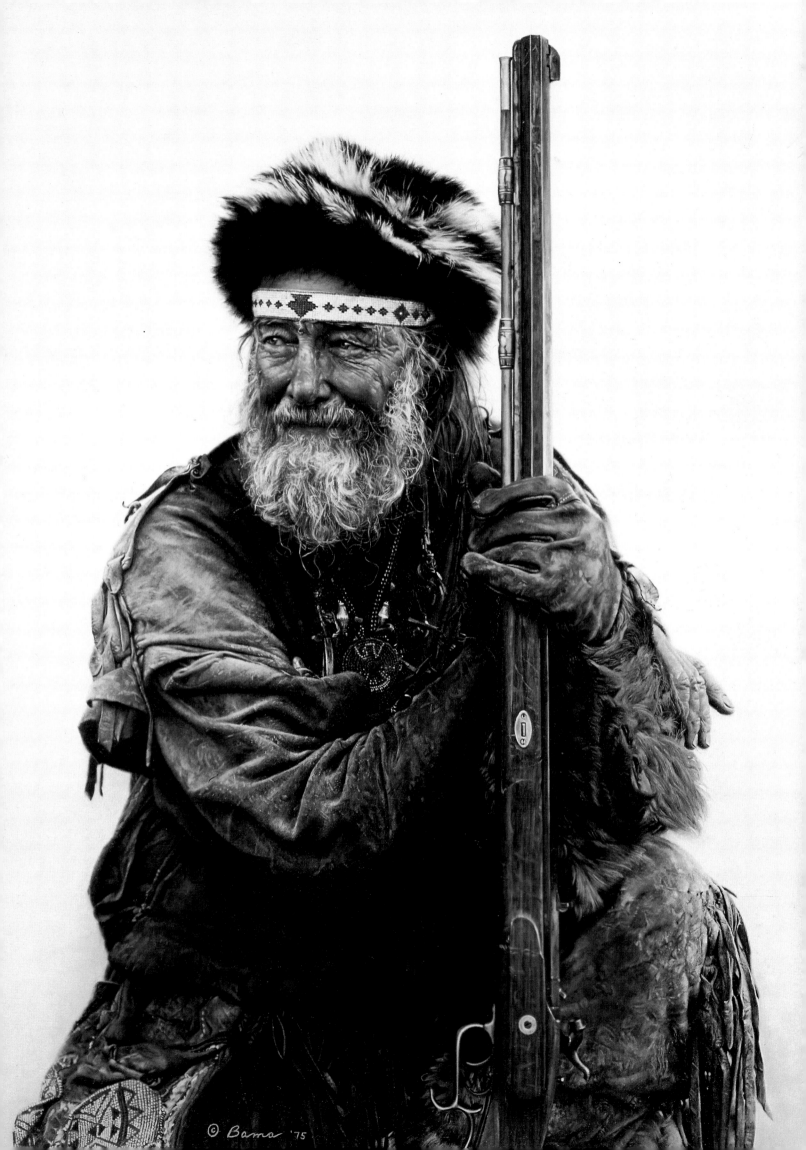

Bama '76

OLD SOD HOUSE

When the Bamas moved to the Bob Meyers Circle M Ranch west of Cody, Wyoming, in 1968, this old log house with sod roof still stood at the headquarters. The outfit was both a guest ranch and a working cattle operation. To Bama's sorrow the structure was eventually removed, replaced by a recreational facility for dancing and movies. To the ranch owner the deteriorating old house no longer had any useful purpose. To Bama it was a remnant of the region's history, a wonderful bit of Western atmosphere.

OLD ARMY COLT STILL LIFE

The six-shooter is a major icon of the Old West. Samuel Colt's initial 1836 model was tried by the Texas Rangers against Comanche Indians, and the weapon became known on the frontier as "the great equalizer." One of Bama's early still-life paintings centers around a single-action Army Colt .45, a hand-tooled leather holster and cartridge belt, an old cartridge case and cartridges, resting upon an aging plank door. All of these historic artifacts are from Bob Edgar's collection in Old Trail Town.

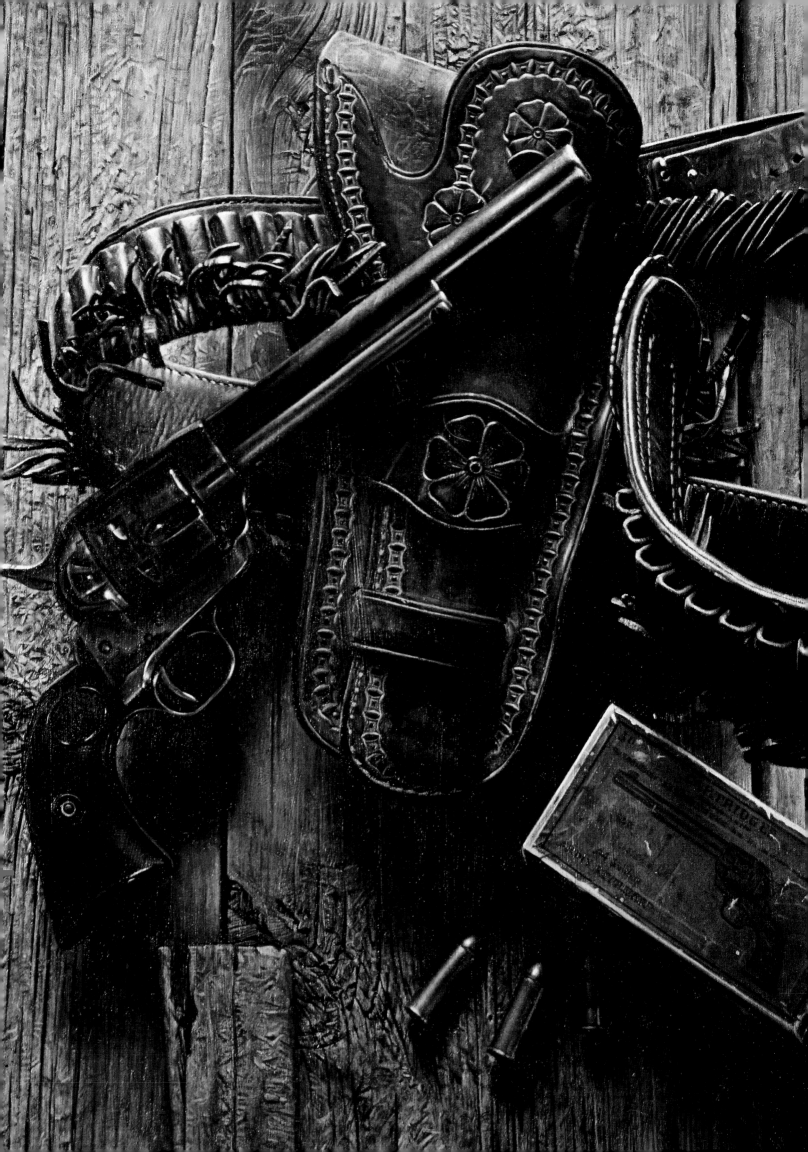

HARLEY KINKADE

Harley Kinkade was sheriff of Park County, Wyoming, more than twenty years and never fired his gun. He was well liked for an unquenchable sense of humor. A big, gentle man, he operated heavy equipment but refused to wear a hard hat. He preferred his own cowboy hats, like the one here, a diamond-shaped hole cut in its crown for ventilation. His passion was wagons and teams. He gave chuckwagon breakfasts for friends and neighbors, setting up a genuine old chuckwagon of his own, serving pancakes, bacon, ham, eggs and black coffee. Kinkade dabbled in real estate, even at odd times. Once while investigating a fatal shooting he tried to sell Bama a piece of land while Bama helped him search for a stray bullet. "He was always doing a little business on the side," Bama says. "I teased him about that for years, and he would say, 'You should have bought it. It was a good buy.' " Bama used to admire Kinkade's huge hands, which he thought would look great in a painting. Kinkade would declare, "That's just my arthritis." His two sons, John and Jerry, are wagon-and-team men, too. At the time of his death the old horseman was out in the country, breaking a new team to the harness.

NINA BIG BACK, A NORTHERN CHEYENNE

OLDEST LIVING CROW

*N*ina Big Back of Lame Deer, Montana, was known as an excellent quilt maker, seamstress and bead worker, though her clothing here is plain and simple, much as Bama found the lady herself to be. He remembers her as very meek and quiet. She was strongly devoted to family and church. The Indian penchant for descriptive names ran strongly in her family. She was a daughter of Eugene and Susan Bull Sheep Standing Elk. She lived to be 78, surviving by two years her husband, John Big Back.

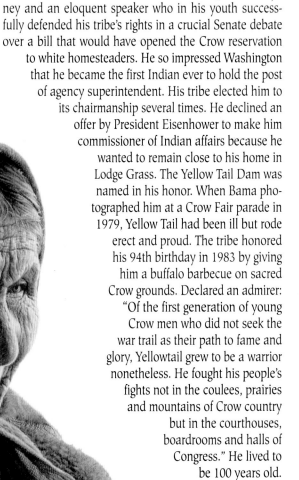

*R*obert Summers Yellow Tail was one of the most highly respected elders in the Crow tribe when Bama met him. He was an accomplished attorney and an eloquent speaker who in his youth successfully defended his tribe's rights in a crucial Senate debate over a bill that would have opened the Crow reservation to white homesteaders. He so impressed Washington that he became the first Indian ever to hold the post of agency superintendent. His tribe elected him to its chairmanship several times. He declined an offer by President Eisenhower to make him commissioner of Indian affairs because he wanted to remain close to his home in Lodge Grass. The Yellow Tail Dam was named in his honor. When Bama photographed him at a Crow Fair parade in 1979, Yellow Tail had been ill but rode erect and proud. The tribe honored his 94th birthday in 1983 by giving him a buffalo barbecue on sacred Crow grounds. Declared an admirer: "Of the first generation of young Crow men who did not seek the war trail as their path to fame and glory, Yellowtail grew to be a warrior nonetheless. He fought his people's fights not in the coulees, prairies and mountains of Crow country but in the courthouses, boardrooms and halls of Congress." He lived to be 100 years old.

BEN MARROWBONE

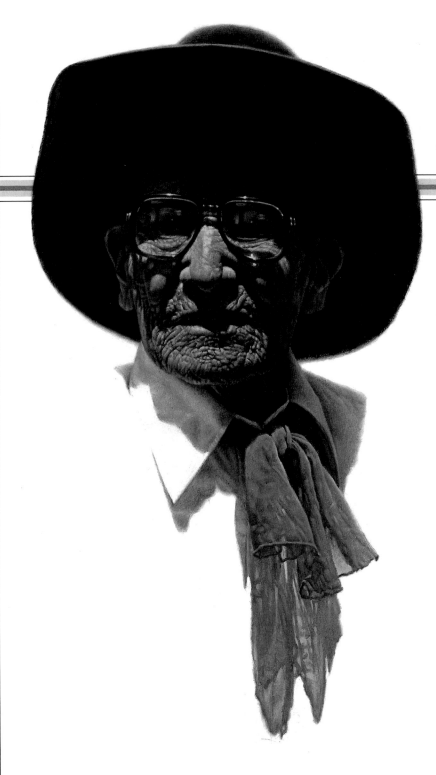

*A*s a young man, Ben Marrowbone rode in the latter days of Buffalo Bill's Wild West Show with all the trappings of his Arapaho heritage. When a recreation of the show was staged in Cody on the hundredth anniversary of its inception, Marrowbone and a white cowboy, Fred Webb, were the only known surviving veterans of the original. They were invited to be guests of honor. Both were 95, and Marrowbone had to be helped into the arena with his walking cane. Nevertheless, the two danced a little jig for an appreciative crowd and seemed to enjoy the show tremendously. Bama found Marrowbone still a handsome man, his skin firm, his jaw square, his brown eyes aglow with pleasure over the recognition.

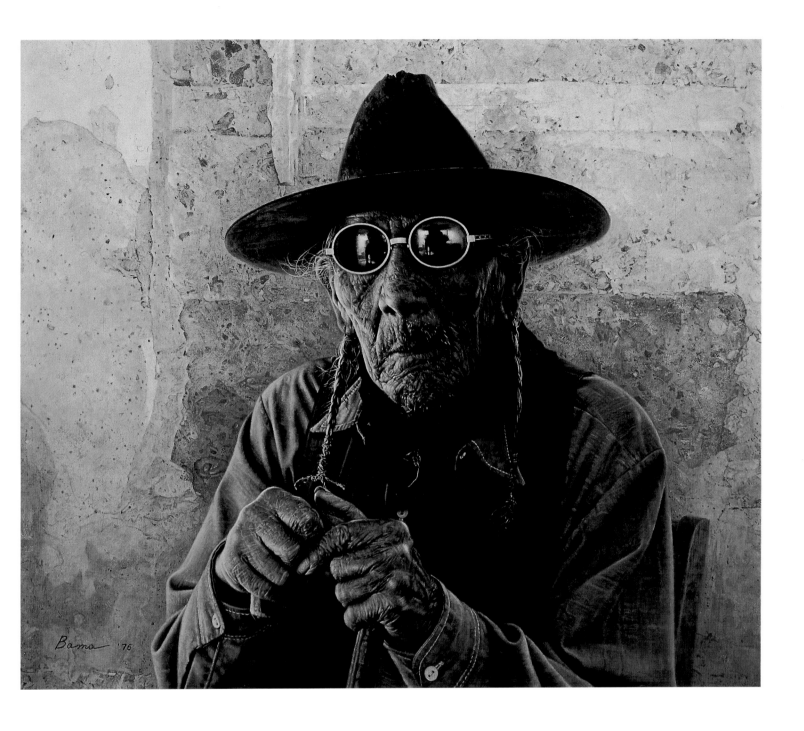

FRANCIS SETTING EAGLE

Francis Setting Eagle was 94 1/2 years old, alert but so frail that Bama feared he might not survive the posing session. He found that Setting Eagle was not only the oldest living Arapaho at that time but a most revered tribal elder, a solid link with the frontier past. He had been born outside the military post at Fort Washakie in Wyoming Territory in the spring of 1882, barely six years after the Custer fight. He was seven when the Ghost Dance began its sweep through the plains tribes, climaxing in the terrible shootings among the Sioux at Wounded Knee. In 1892 he became the first pupil of the Franciscan Sisters in the Catholic school at St. Stephen's. He herded cattle on the reservation, appeared in the silent film *The Covered Wagon* and began a lifelong friendship with Colonel Tim McCoy, who served as interpreter for the Indians working on that picture. He traveled with McCoy's company to New York, London and Paris and appeared in several of McCoy's later films. As early as 1903, he was chosen by the Keeper of the Drum to perform with the Eagles, official drum unit for Arapaho tribal ceremonies. The rest of his life he participated, offering songs of blessing for the departure and safe return of Arapaho servicemen in the world wars, Korea and Vietnam.

His last public act was to sing at the funeral of an old friend. The drum-chant of his *Eagle Song* was presented at his own funeral. His ancient black reservation hat and his drum shield were buried with him, six months after he posed for Bama's painting.

A GUNFIGHTER—Scott McKinley, Cody Rancher
MOUNTAIN MAN, 1820-1840—Charlie Golden of Pinedale, Wyoming
GARY "PACKRAT" BRADAK—Outfitted for Rendezvous
THE BUCKSKINNER—Richard Briggs, Professional Trapper

BUCKSKINS AND

MUZZLE-LOADERS

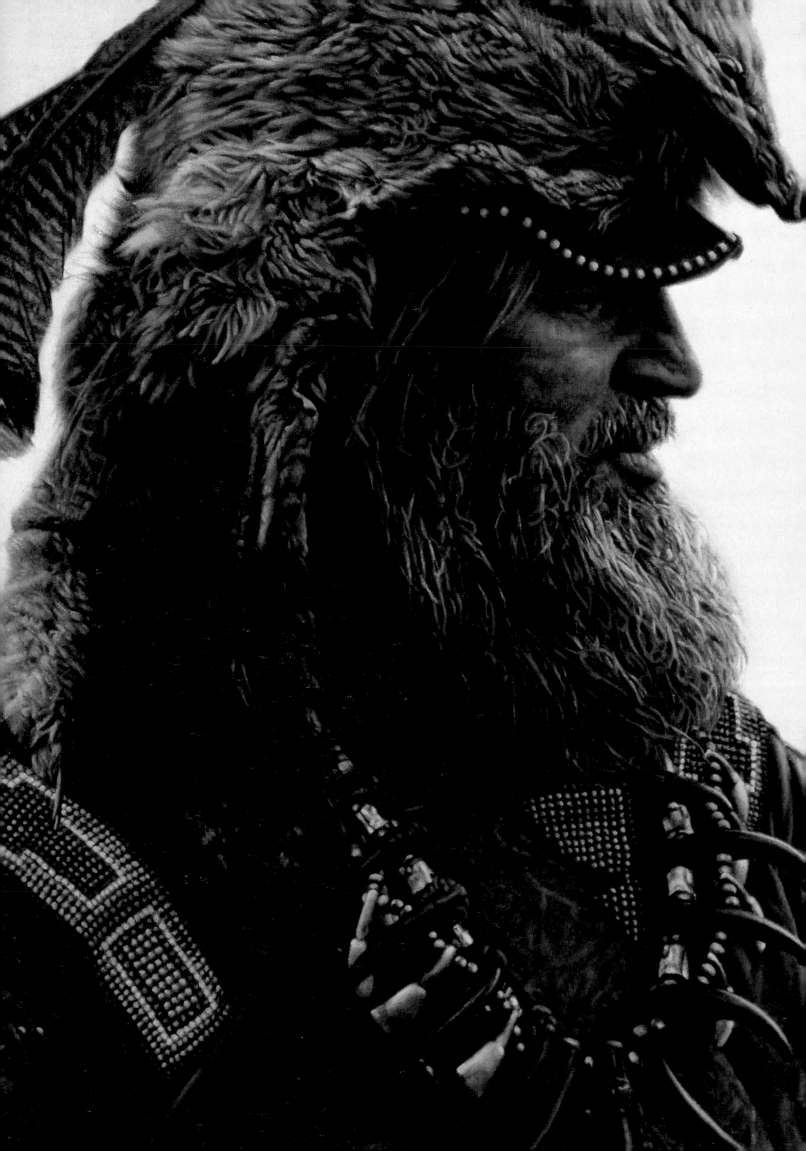

BUCKSKINS AND MUZZLE-LOADERS

As a newcomer from the East, one thing that quickly became clear to James Bama after his arrival in Wyoming was that many Westerners have a passion for their history. They often express that passion by recreating its images and trying to relive, if sometimes briefly, the lives and times of their forebears. One of the strongest examples is the modern-day mountain-man rendezvous, conducted annually in many Western towns.

Bama's association with Bob Edgar helped him become acquainted with the mountain-man phenomenon. Edgar is a combination of cowboy, artist and professional archeologist. In 1967 he and his wife Terry began collecting historic old log buildings from around Wyoming and moving them to a location they call Old Trail Town in the western edge of Cody, at a site where Buffalo Bill in 1895 began surveying the town that was to bear his name. They have disassembled more than twenty old buildings of historic interest that were about to fall either to the bulldozer or to the ravages of time and have reassembled them piece by piece for preservation. Edgar took the Bamas to historic places, showed ancient Indian petroglyphs to Lynne and introduced Bama to many interesting oldtimers he subsequently painted.

The original mountain men were the beaver trappers who penetrated the vast Western wilderness on the heels of the Lewis and Clark expedition. Though preceded in some areas by French and English fur trappers operating from Canada, the Americans blazed new trails and enjoyed their heyday for about twenty-five or thirty years in the first half of the nineteenth century. Eventually most of the beaver streams were trapped out, and introduction of the silk hat in Europe left the beaver-pelt market in ruins. But while it lasted, the mountain man's reign was, in the imagination of later generations at least, one of glory and high adventure.

The real mountain men were a highly varied group, a few well educated but most barely literate if at all. Some went west to seek new experiences and escape boredom, some to escape the law. Most probably saw it primarily as a way to make a living, if a highly dangerous one. Often they were required to operate clandestinely in the midst of hostile territory, setting their beaver traps under the noses of Indians eager and willing to lift their scalps. Life expectancy was short. Those who survived lived in severe privation, eating whatever the land provided or going hungry, wading in half-frozen rivers and streams to set the beaver traps, enduring the bitterest of winter weather because that was when the pelts were prime.

Isolated from others of their race, the mountain men often took up the lifestyles of the Indians, dressing like them, eating like them, accepting many of their beliefs. They commonly allied themselves with one tribe or another, gaining that tribe's protection but also acquiring its enemies. Frequently they took Indian wives to share the daily burdens of camp and to cement alliances with their in-laws' tribes. In effect, they became Indians by adoption.

If they made it through winter blizzards and past the watchful eyes of those who sought to put them under, they could look forward to the highlight of the year, the annual fur-trading rendezvous. There the company men collected their wages and the "free" trappers sold or traded the past season's catch for the next season's supplies. They let off their pent-up steam in a few rowdy weeks of revelry, indulging themselves in raw whiskey, gambling, horse-racing and Indian women before returning to the isolation of their scattered camps to start the cycle over again.

Washington Irving in 1837 described a Green River rendezvous like this: "Never did rival lawyers, after a wrangle at the bar, meet with more social good humor at a circuit dinner. The hunting season over, all past tricks and manoeuvres are forgotten, all feuds and bickerings buried in oblivion." He wrote that an occasional brawl would end "in cordial reconciliation and maudlin endearment."

When the beaver trapper's way of life ended in the 1840's, many mountain men became scouts for the military and guides for emigrant wagon trains. Their explorations had made them familiar with the great Western spaces the general public

regarded as a trackless wilderness. Others founded trading posts which in some cases became the foundation for later towns and cities. Some never adjusted to the new "civilization" and lived out their remaining years in a futile search for their lost yesterdays. Their world had changed, and they—like the Indians—became strangers in a land they had regarded as their own.

Today, many communities throughout the mountain West sponsor a rendezvous at which modern-day mountain men may spend a weekend or sometimes a week, reliving at least the surface lifestyle of their real-life forebears. They dress in outfits constructed as authentically as possible, usually buckskins and fur caps, moccasins and beads. These men carry muzzle-loading rifles copied closely after the handmade, long-barreled weaponry common in the 1820's and 1830's. Ornamentation is limited only by imagination and a penchant for remaining faithful to the period portrayed.

*T*heir replication of the mountain-man era has its practical limits, of course. Most of these celebrations take place in summer, when the weather is usually benevolent and sleeping in a tent or under the open sky is an enjoyable experience, the discomforts minor and easily overlooked. Meals are cooked over a campfire, though most of the makings come out of a store or a home freezer. Even with these agreeable compromises, the illusion of reality gives rendezvous participants a strong appreciation of their spiritual forebears' outdoor lifestyle.

Bama's artistic instincts responded quickly to the color and spirit in these reenactments. He found also that a few people lived out their mountain-man fantasies far beyond the few days of organized rendezvous. They became so steeped in history and lore that they submerged their own identities and in effect became the characters they portrayed. They lived a mountain-man existence the year around, or at least most of the year, shunning the town life, trapping or prospecting to earn the necessities.

He met and painted a man, John Bode of Colorado Springs, Colorado, who took on the persona of the historical Uncle Dick Wootton to the extent that he was reluctant to reveal his true name or talk about his own past. He had "dropped out of the rat race" and, in effect, had become Uncle Dick Wootton, reborn. In his buckskins, his fox headpiece and necklace of bearclaws and tiny bells, he was the personification of the historic Wootton he portrayed to schoolchildren and tourists.

One who became the subject of several Bama paintings invented a character, then took on that fictional character's name and trappings. Calling himself Timber Jack Joe, he traveled about from one rendezvous celebration and powwow to another with his horse, Papoosie, and his shepherd dog, Tuffy, living as nearly as possible under today's conditions the kind of life a real mountain man would have known. His buckskins were authentic not only in appearance but in aroma. Timber Jack Joe spent his winters high up in the mountains, trapping as his forebears had done. He allowed himself a modern touch, however: a snowmobile for greater mobility.

Charlie Golden is another of Bama's favorite mountain-man subjects. He finds him one of the most authentic looking. He particularly admires Golden's bearskin hat, a rare item. Committed to preserving as much of the Western heritage as possible, Golden is regionally noted for cutting off his long beard each year and auctioning it to raise money for a local historical society in Pinedale, Wyoming.

*A*nother of Bama's favorite mountain-man subjects lived in a primitive lean-to west of Cody. He found it difficult to conform to the requirements and lifestyles of modern society and felt he had been born in the wrong period of history. He emulated the real mountain men in the way he lived and the way he thought. He participated in long trail rides, recreating the routes of his spiritual forebears, and wrote philosophical letters which reflected his preference for the olden times, lost beyond retrieval. He died young, still wishing he had lived earlier.

For his paintings Bama picks modern-day mountain men for their authentic appearance. "I can tell you who they really

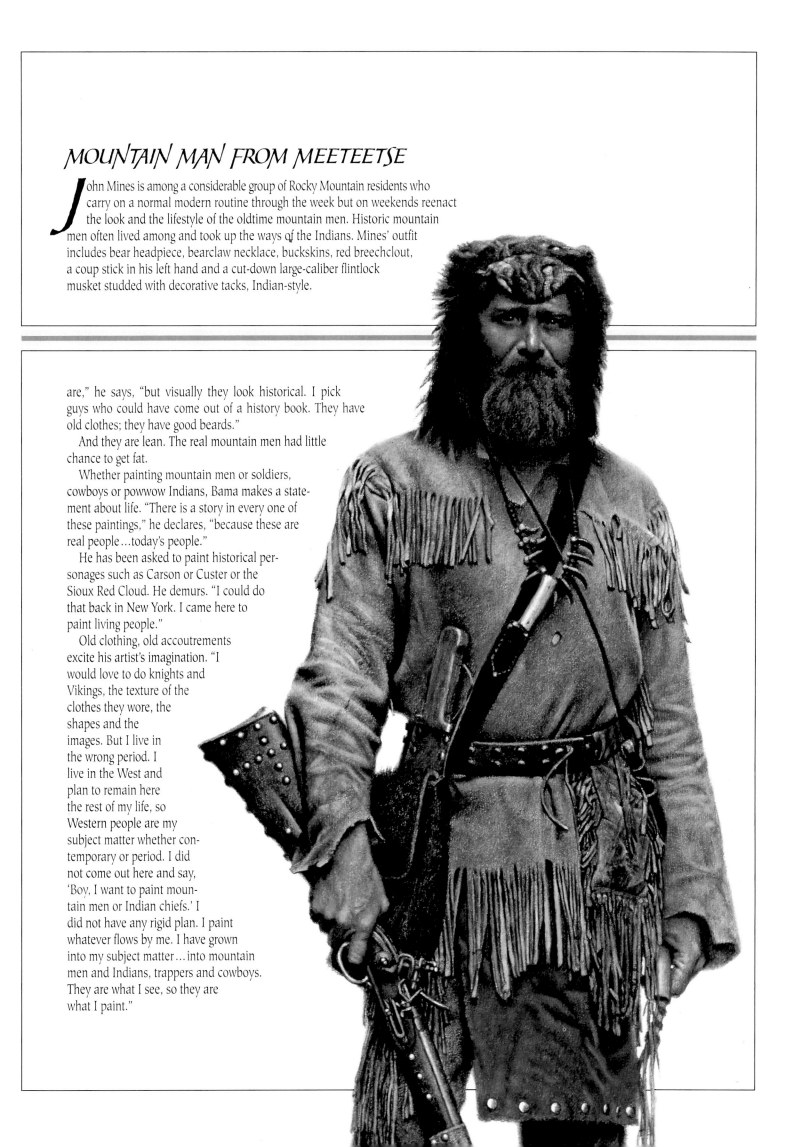

MOUNTAIN MAN FROM MEETEETSE

John Mines is among a considerable group of Rocky Mountain residents who carry on a normal modern routine through the week but on weekends reenact the look and the lifestyle of the oldtime mountain men. Historic mountain men often lived among and took up the ways of the Indians. Mines' outfit includes bear headpiece, bearclaw necklace, buckskins, red breechclout, a coup stick in his left hand and a cut-down large-caliber flintlock musket studded with decorative tacks, Indian-style.

are," he says, "but visually they look historical. I pick guys who could have come out of a history book. They have old clothes; they have good beards."

And they are lean. The real mountain men had little chance to get fat.

Whether painting mountain men or soldiers, cowboys or powwow Indians, Bama makes a statement about life. "There is a story in every one of these paintings," he declares, "because these are real people…today's people."

He has been asked to paint historical personages such as Carson or Custer or the Sioux Red Cloud. He demurs. "I could do that back in New York. I came here to paint living people."

Old clothing, old accoutrements excite his artist's imagination. "I would love to do knights and Vikings, the texture of the clothes they wore, the shapes and the images. But I live in the wrong period. I live in the West and plan to remain here the rest of my life, so Western people are my subject matter whether contemporary or period. I did not come out here and say, 'Boy, I want to paint mountain men or Indian chiefs.' I did not have any rigid plan. I paint whatever flows by me. I have grown into my subject matter…into mountain men and Indians, trappers and cowboys. They are what I see, so they are what I paint."

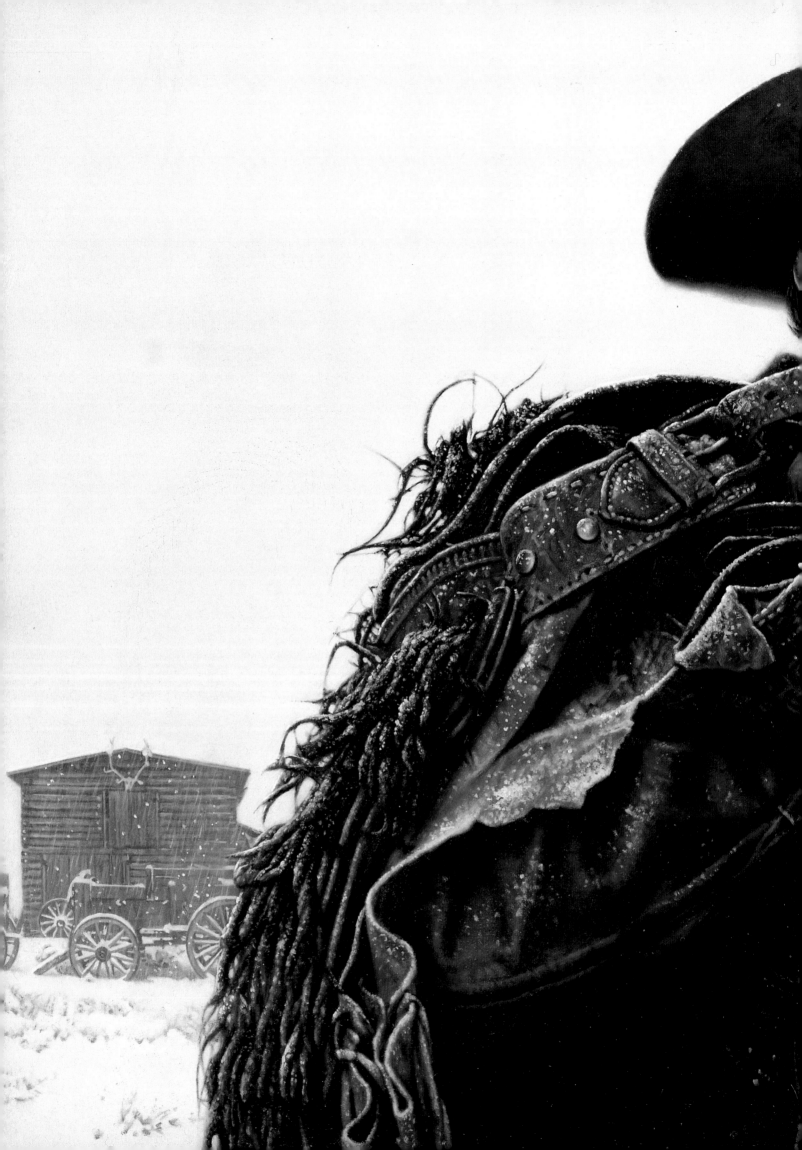

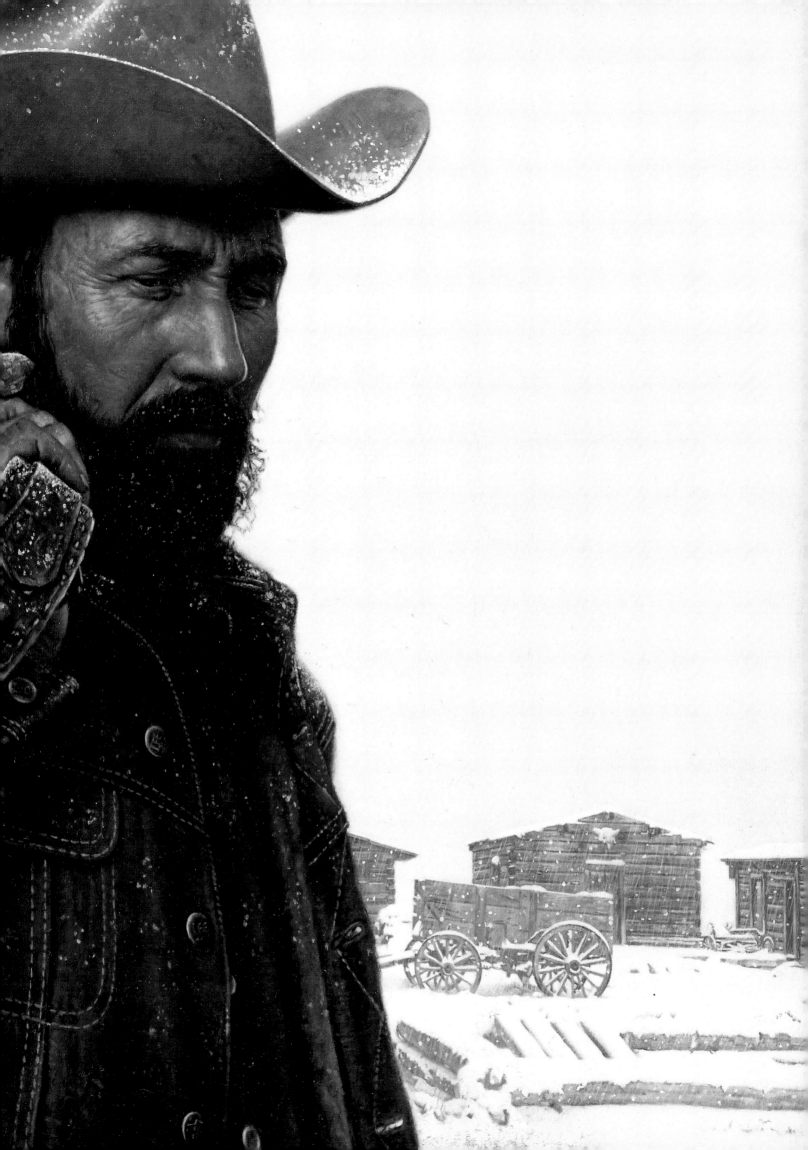

AT THE BURIAL OF GALLAGHER AND BLIND BILL

READY TO RENDEZVOUS

◄ A small cemetery in Old Trail Town has become a resting place for several Old West characters, including two cowboys legend says were murdered in 1894 because of a woman. W. A. Gallagher and Blind Bill were reburied with appropriate ceremony a few years ago. Afterward, Bama painted his friend Bob Edgar carrying a pair of Angora chaps which had been draped across Gallagher's grave. A special benefit print from this painting raised about $20,000 for the Old Trail Town Foundation. In background are some of the museum's collection of old wagons and historic frontier buildings, painstakingly dismantled, all their pieces numbered, then reconstructed in their original configurations. The buildings include such landmarks as a log cabin built for Custer's Crow scout Curly, who carried the news of Yellowhair's death to the outside world; an outlaws' cabin which once hosted Butch Cassidy, the Sundance Kid and others of the Hole-in-the-Wall gang; the bullet-marked Rivers Saloon from the mouth of Wood River; and a cabin built at the foot of the Big Horn Mountains in 1880 by buffalo hunters Jim White and Oliver Hanna. White was murdered at the cabin later that year. Hanna went on to found the town of Sheridan, Wyoming. Ironically, the woman blamed for the deaths of Gallagher and Blind Bill was killed four years later in a saloon fight.

B ama was impressed by mountain man Dan Deuter's long, luxurious buckskin coat. He had not seen another quite like it, the fringes generous in quantity and length, its light tan offset by red color in the dangling voyageur sash and intricate beading of the rifle case. In traditional mountain-man times, this would have represented many hours of meticulous handwork for an Indian woman, possibly a winter-long project done as a gift of love or to be swapped for white man's trade goods. Indians cherished finery for ceremonial occasions, and mountain men often modeled after the Indians among whom they lived. Deuter became curator of a recreated frontier landmark, old Fort Uncompahgre, established as a fur-trading post by Antoine Robidoux about 1826 near present-day Delta, Colorado. The fort is operated as a living museum where reenactors demonstrate the lifestyles and crafts of mountain-man days.

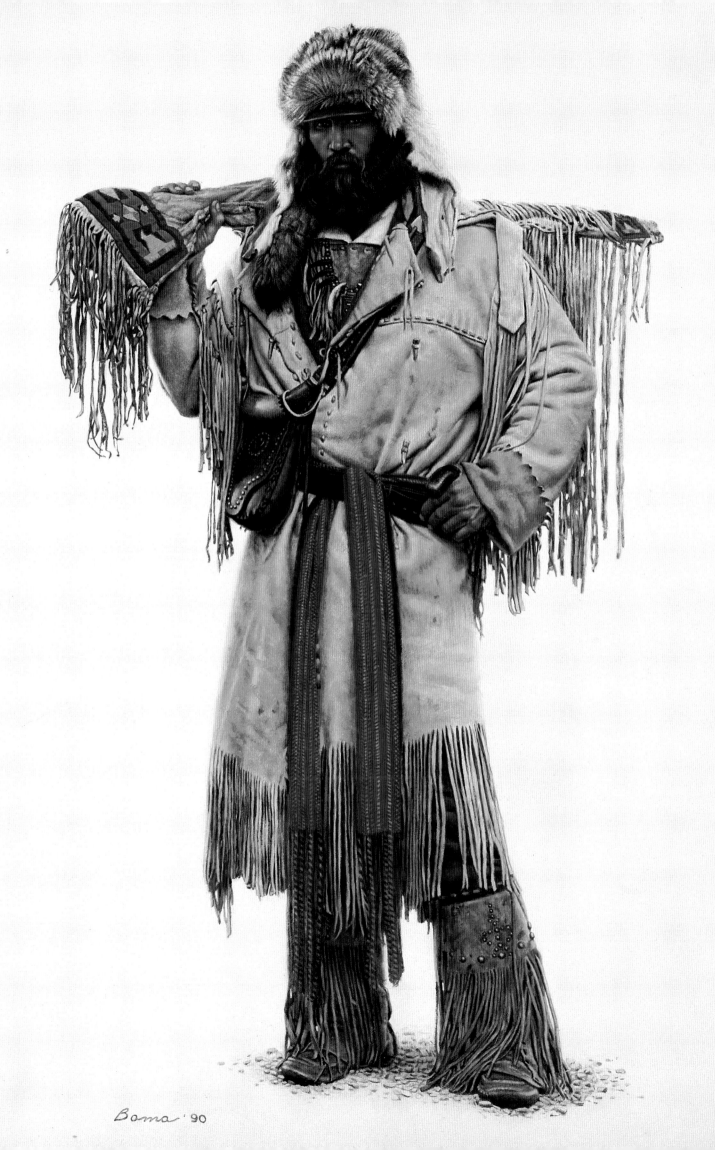

Bama '90

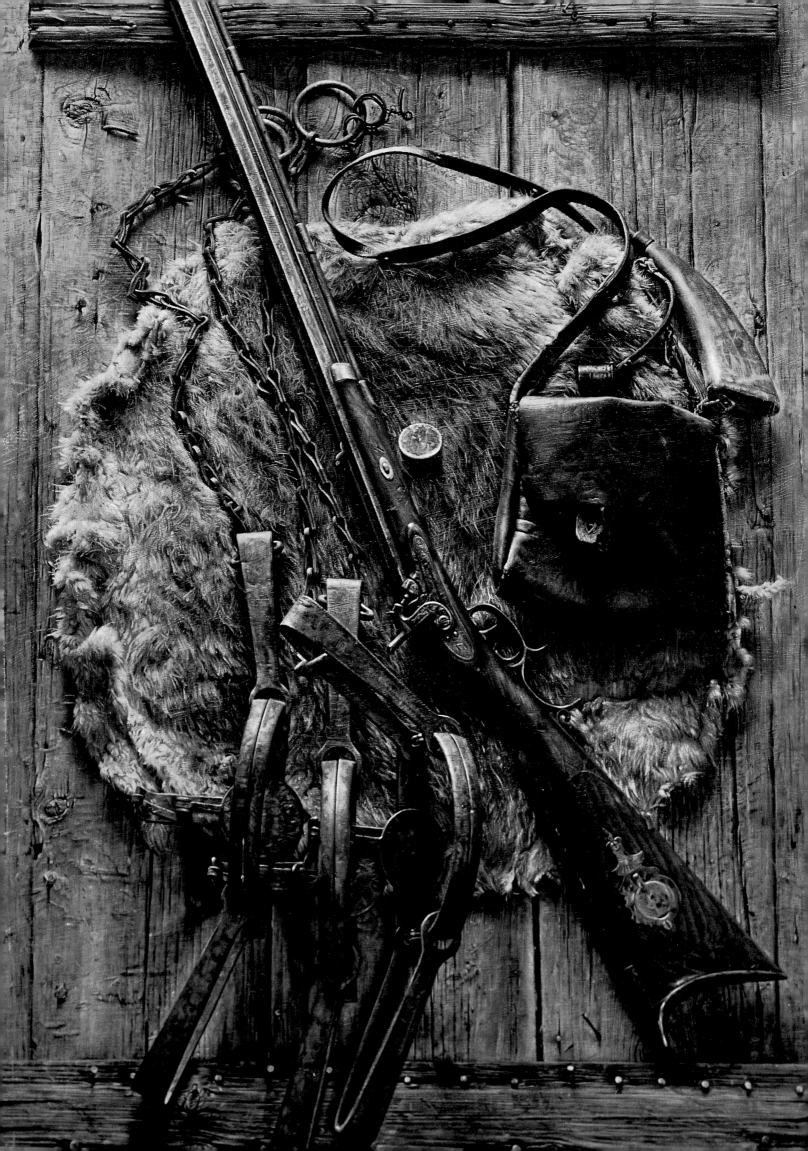

OLDTIME TRAPPINGS IN THE ROCKIES

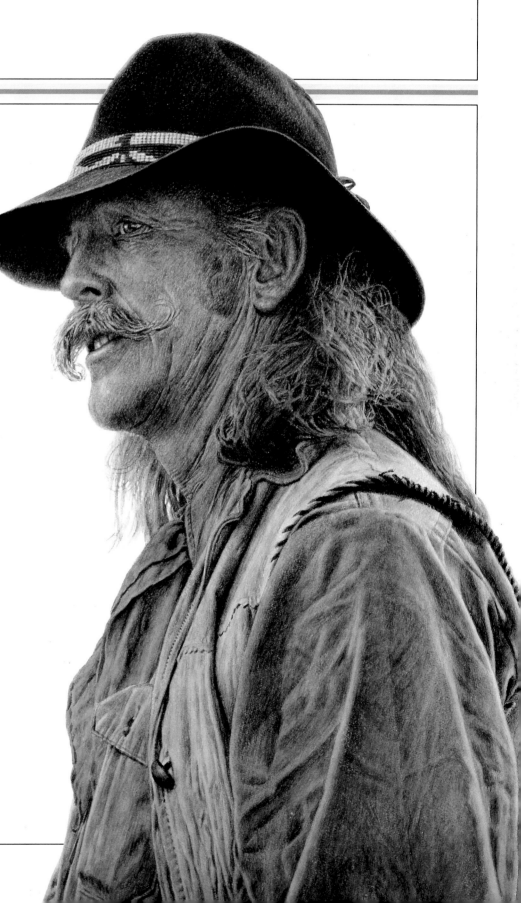

*T*his still life presents many essentials of an early mountain man's daily existence: a percussion rifle with a box of caps, powderhorn, a "possibles" bag, traps with the chains that anchored them down, and a stretched animal hide. Actually, he could not afford to possess a great deal more, limited to what he could carry on his back or pack on whatever horses or mules he owned.

THE TROOPER

*B*ama never got to know the name of this cowboy, who appeared in a parade at the Cheyenne Frontier Days. Dating back to 1897, it is one of the West's most famous rodeos. The artist saw a potential painting in the weathered face, the rusty moustache and shoulder-length hair, the beaded hatband and the weathered old clothing that bespoke an earlier time. For years Bama attended rodeos whenever he could, watching for photogenic types who might become the basis for paintings. He has literally hundreds of photos and sketches in his files, awaiting their turn to come to life beneath his brush.

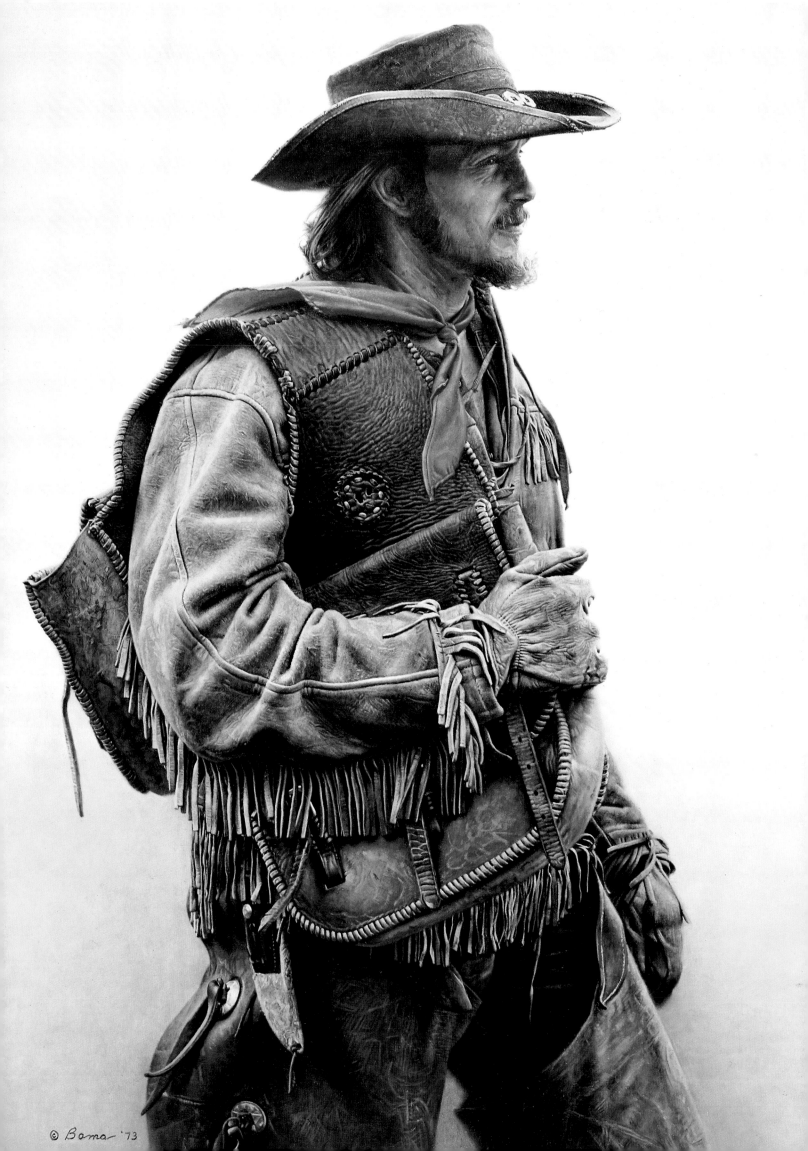

DEE SMITH
WITH SADDLEBAG

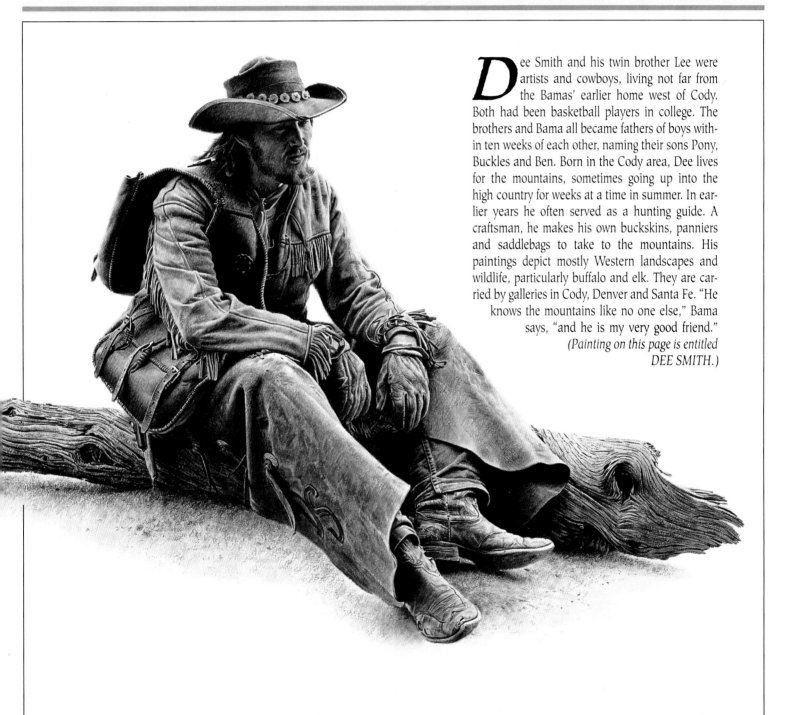

Dee Smith and his twin brother Lee were artists and cowboys, living not far from the Bamas' earlier home west of Cody. Both had been basketball players in college. The brothers and Bama all became fathers of boys within ten weeks of each other, naming their sons Pony, Buckles and Ben. Born in the Cody area, Dee lives for the mountains, sometimes going up into the high country for weeks at a time in summer. In earlier years he often served as a hunting guide. A craftsman, he makes his own buckskins, panniers and saddlebags to take to the mountains. His paintings depict mostly Western landscapes and wildlife, particularly buffalo and elk. They are carried by galleries in Cody, Denver and Santa Fe. "He knows the mountains like no one else," Bama says, "and he is my very good friend."
(Painting on this page is entitled DEE SMITH.)

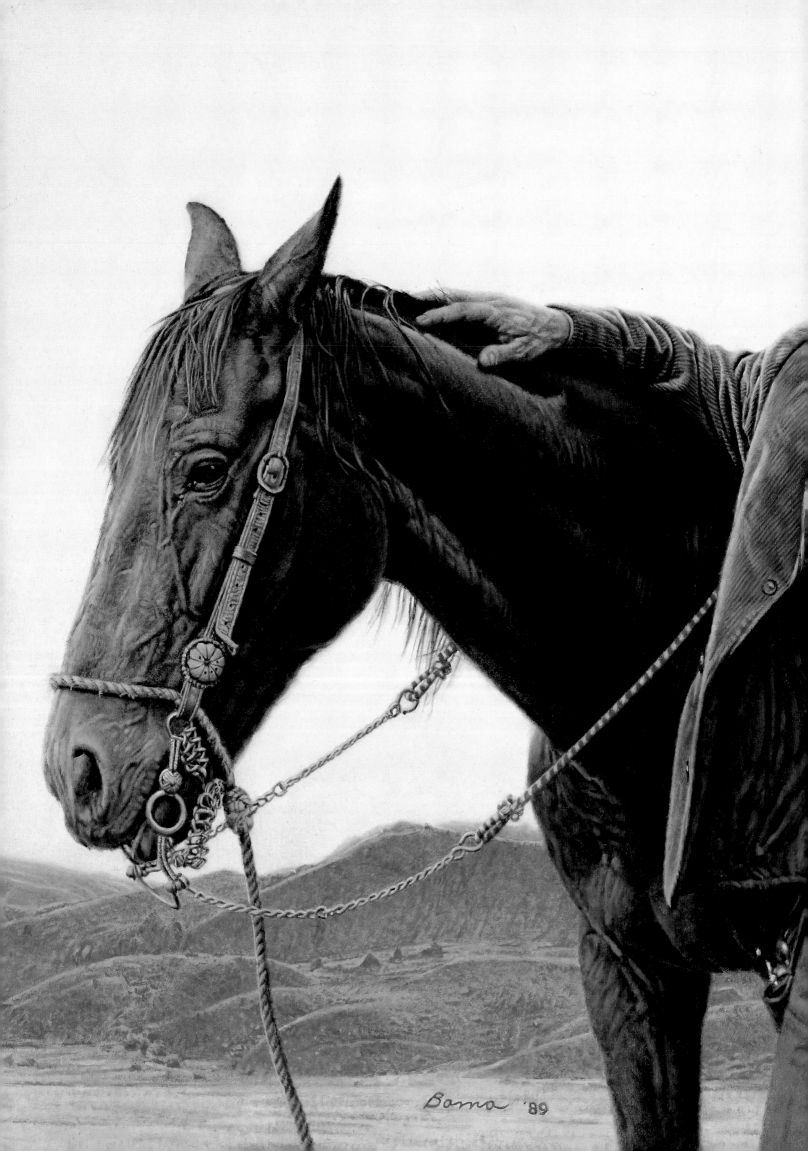

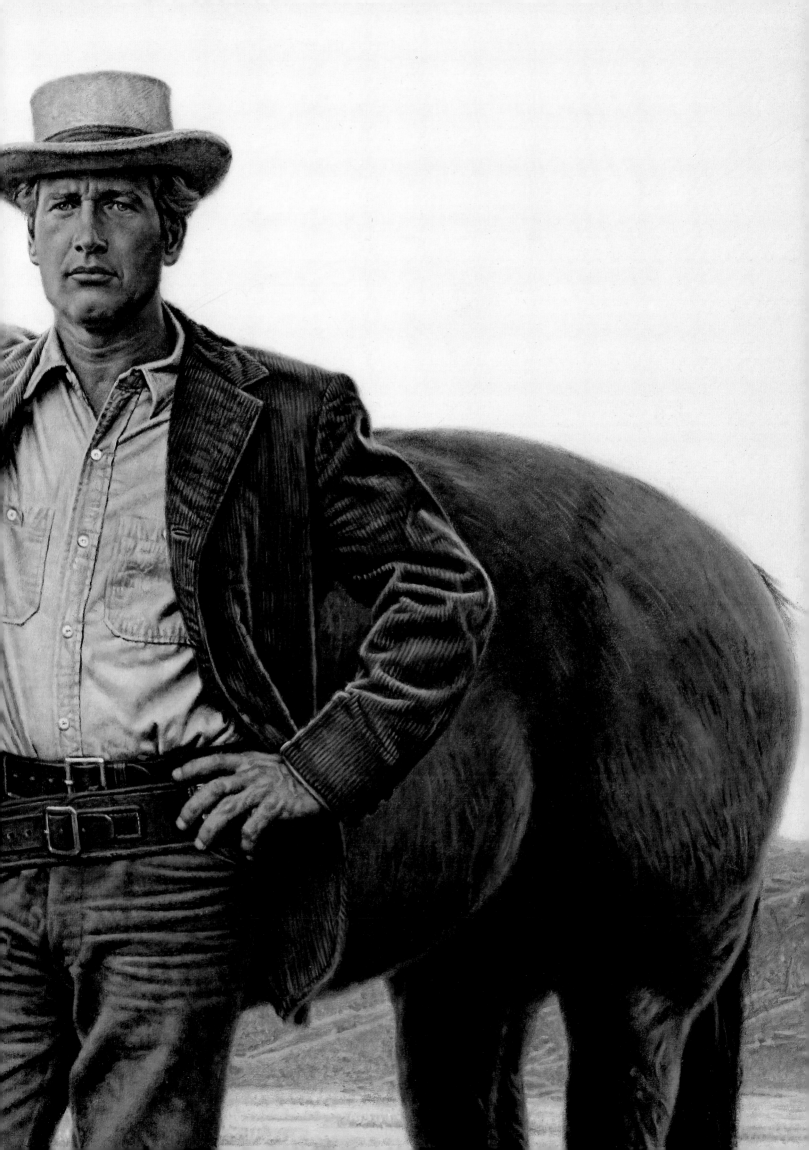

BOB EDGAR
WITH SHARPS RIFLE

Bob Edgar and his wife Terry founded Old Trail Town, an out-door-indoor museum at the western edge of Cody, Wyoming, and introduced Bama to many facets of Western life when he first moved to Wyoming. Through the years the artist has relied heavily upon Edgar's vast knowledge of both the old and the modern West to make his paintings accurate in their details. Here, wearing an old bearskin coat, Edgar holds an octagonal-barreled Sharps rifle of a type once used to kill buffalo. Bama declares that this was the toughest painting he ever did. It took him four months. The two old saddles alone required two weeks. "My enemies in art are wood, feathers, beads and fringe," he says. "They take forever to do, and wood is the worst." Giving the logs a three-dimensional look, and detailing their grain, was a major challenge and an exhausting one.

PAUL NEWMAN
AS BUTCH CASSIDY

This study of actor Paul Newman in his film role as Butch Cassidy is the only commissioned work Bama has painted since 1971, and it was done for a benefit. Proceeds from the print went to Newman's Western-style Hole-in-the-Wall Gang Camp, which he established in Connecticut to provide summer recreation for terminally ill children. Having watched his own brother die slowly of cancer at the relatively young age of 43 was a strong factor in Bama's decision to do the painting. He was an appropriate artist for this work inasmuch as his Wyoming home is west of the original Hole-in-the-Wall outlaw hideout where the real Butch Cassidy and his friends enjoyed their leisure in relative safety between bank- and train-robbing exploits.

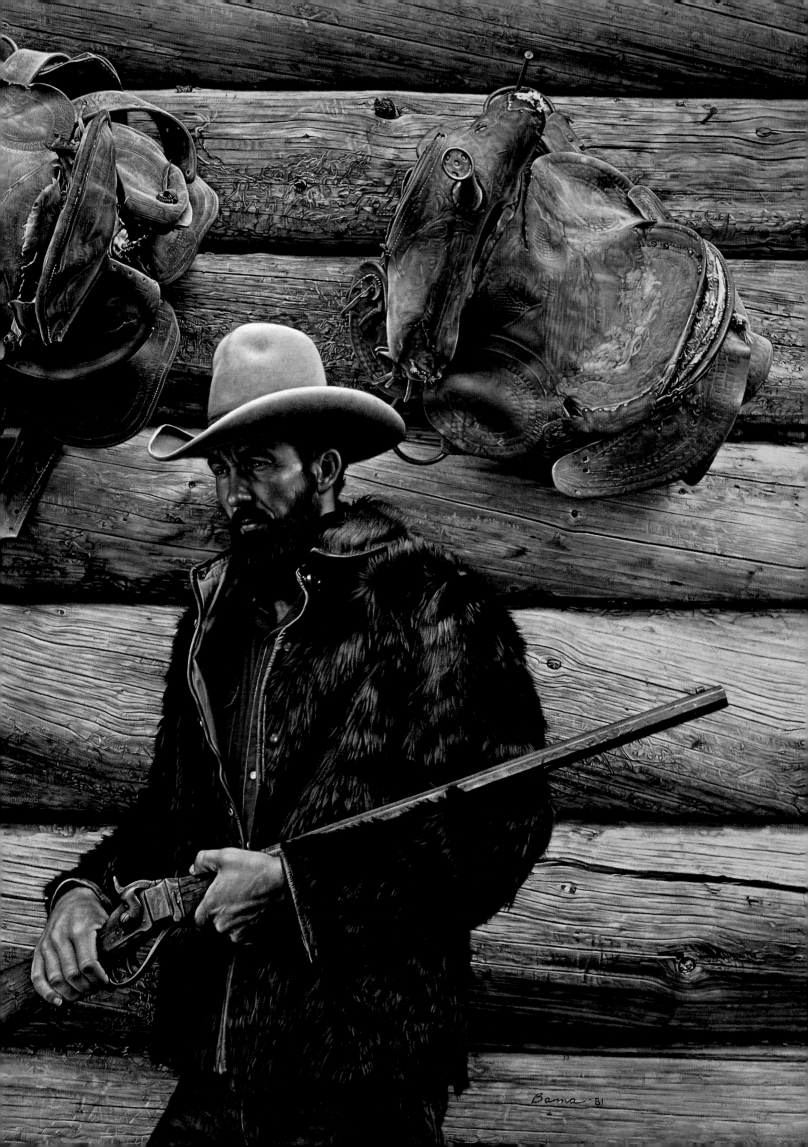

Bama '81

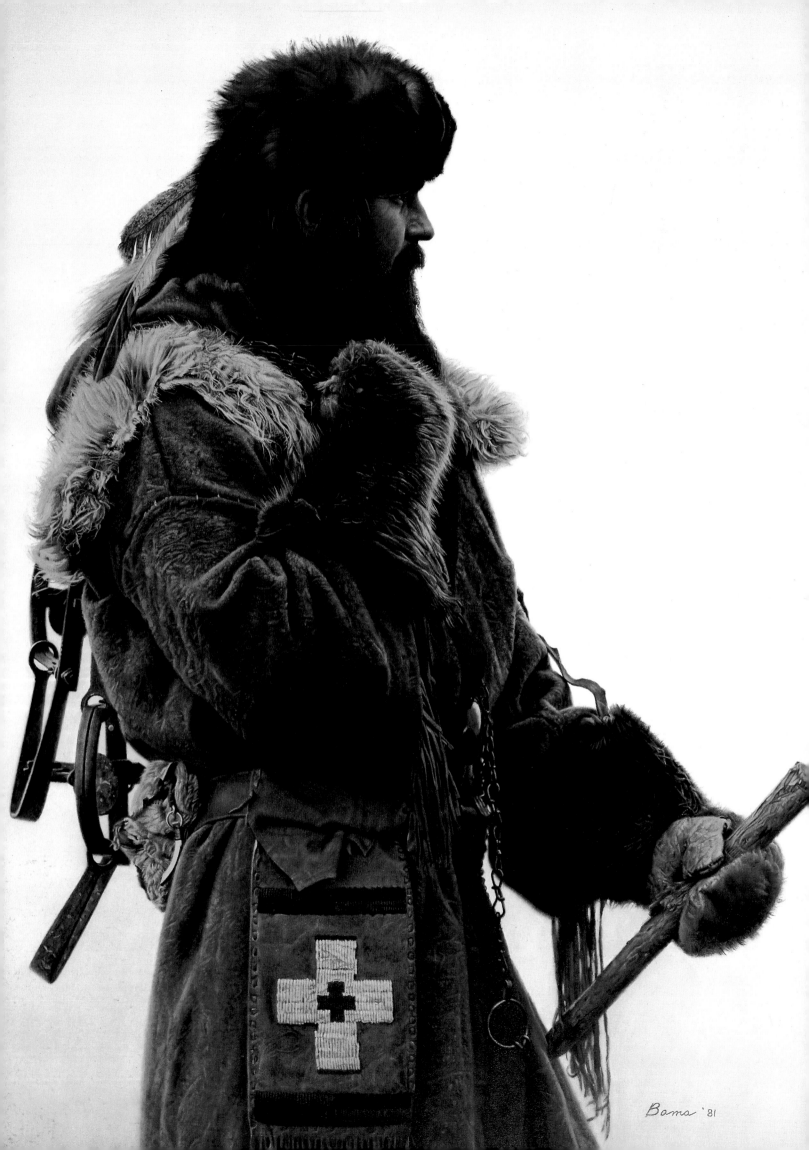

WINTER TRAPPING

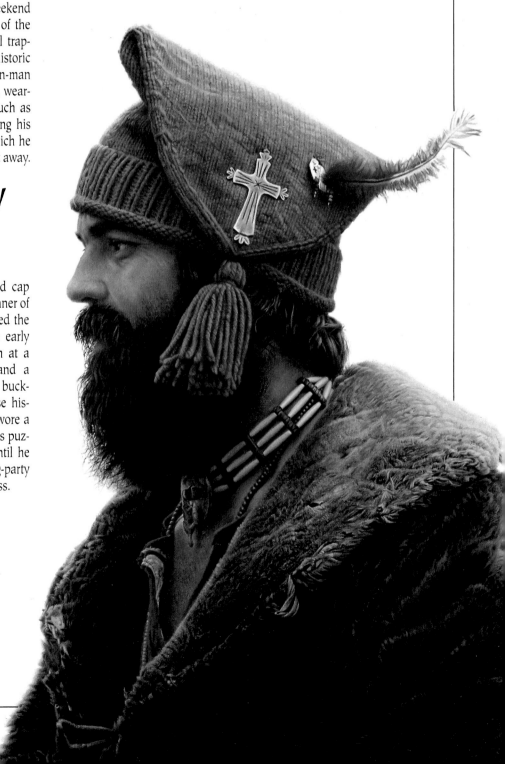

▶ **R**ichard Briggs of Cody is more than a weekend mountain man. He actually lives much of the mountain-man lifestyle as a professional trapper. Very serious about his reenactment of historic predecessors, he attends every annual mountain-man rendezvous and black-powder shoot that he can, wearing one of his several authentic period outfits such as this heavy red coat. Over his right shoulder hang his traps. In his left hand is a wooden stake with which he secures a trap so the caught animal will not drag it away.

AT A MOUNTAIN MAN WEDDING

Richard Briggs sports a voyageur-style red cap adorned with a Christian cross, in the manner of the French and *metis* trappers who worked the beaver streams of the northern Rockies in the early decades of the 1800's. Bama photographed him at a mountain-man wedding where bride, groom and a majority of the guests came dressed in authentic buckskins and other trappings representative of those historic characters they emulate. Even the minister wore a Santa Fe hat, appropriate to the period. Bama was puzzled about the red feather pinned to the cap until he found that the bride had given all the wedding-party members keepsake feathers from her wedding dress.

MOUNTAIN MAN PORTRAIT

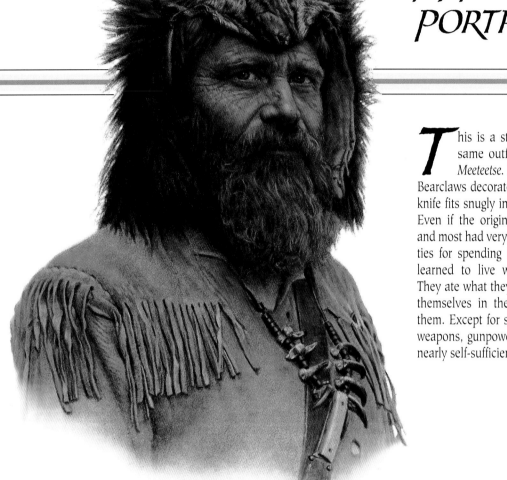

*T*his is a study of John Mines, wearing the same outfit worn in *Mountain Man From Meeteetse.* His headpiece is made of bearskin. Bearclaws decorate the bead necklace, and a small knife fits snugly into the strap around his shoulder. Even if the original mountain men had money—and most had very little—they found few opportunities for spending it. They copied the Indians and learned to live with whatever Nature provided. They ate what they could shoot or trap and clothed themselves in the skins of the animals that fed them. Except for such manufactured necessities as weapons, gunpowder and lead, they could be very nearly self-sufficient.

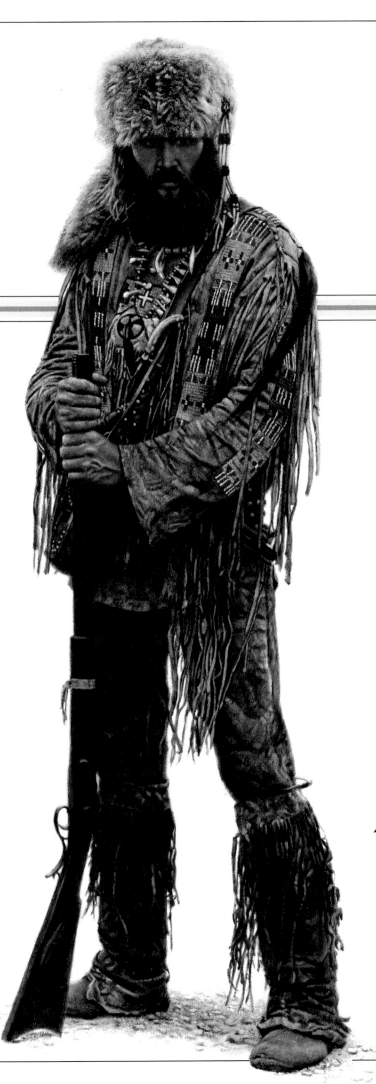

DAN, MOUNTAIN MAN

Dan Deuter and his wife Cat were both Western artists, living in Rapid City, South Dakota, and once were voted artists of the year in that state. Attending art shows and various annual rendezvous celebrations which glorify the mountain-man and Indian period in Western states, he would wear one of his buckskin outfits, and she would wear the ceremonial deerskin dress of an Indian woman. The painting reveals the intricate and colorful patterns of beadwork on Deuter's coat, work that in historic times might have been done by a mountain man's Indian wife. The weapon is a half-stock cap and ball rifle, circa 1840–1850.

1880'S STILL LIFE OF SADDLE AND RIFLE

After the painfully slow and tedious detail that went into this work, Bama swore, "I'll never paint grass again." But he has. This was another of his early still lifes representative of the pioneer period in Western history. The saddle is of an 1880's high-cantle style without the wide pommel that later came into popularity because it gave a rider a better chance to stay aboard a bucking bronc. The blanket is Indian-style, and the rifle is a Winchester model 1886.

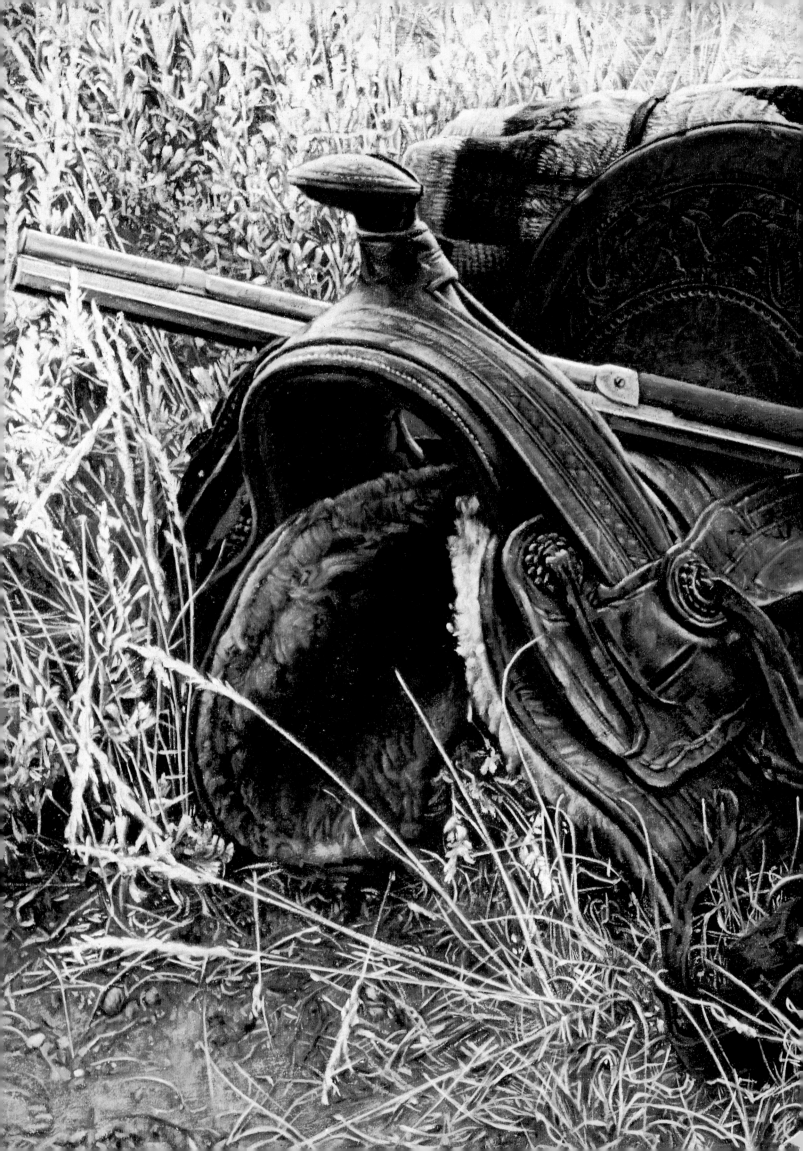

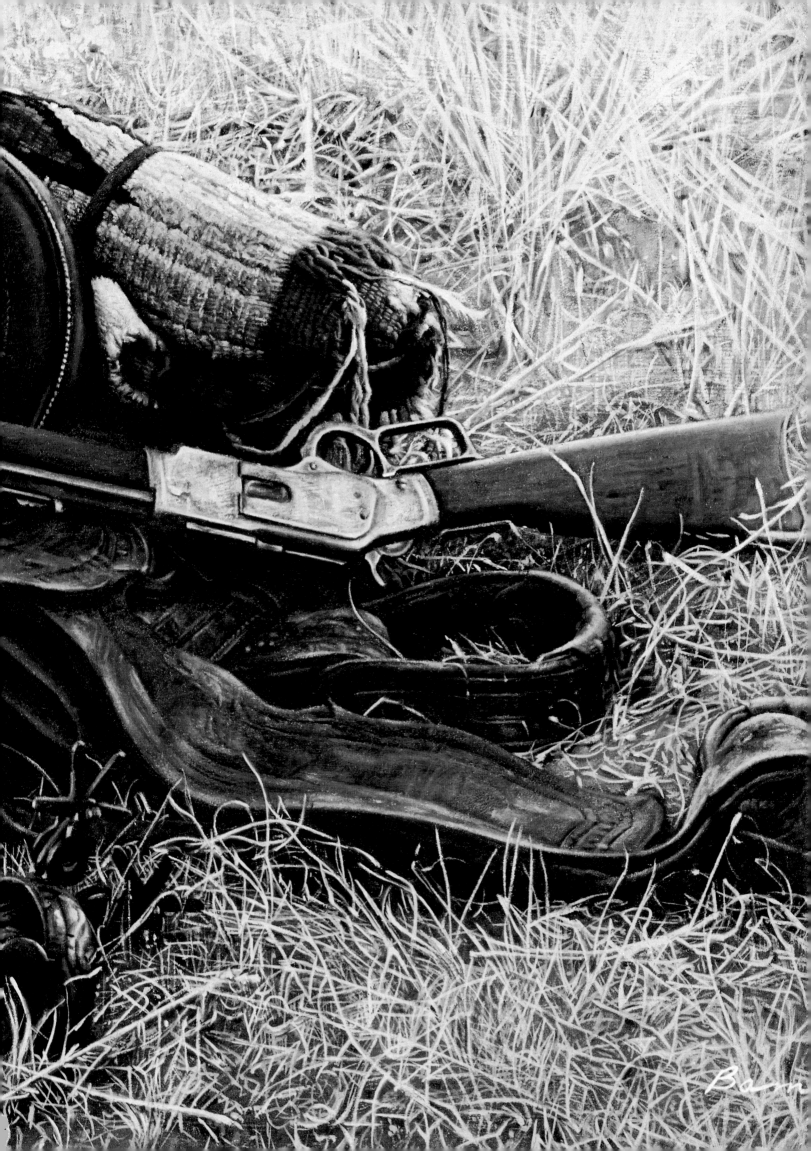

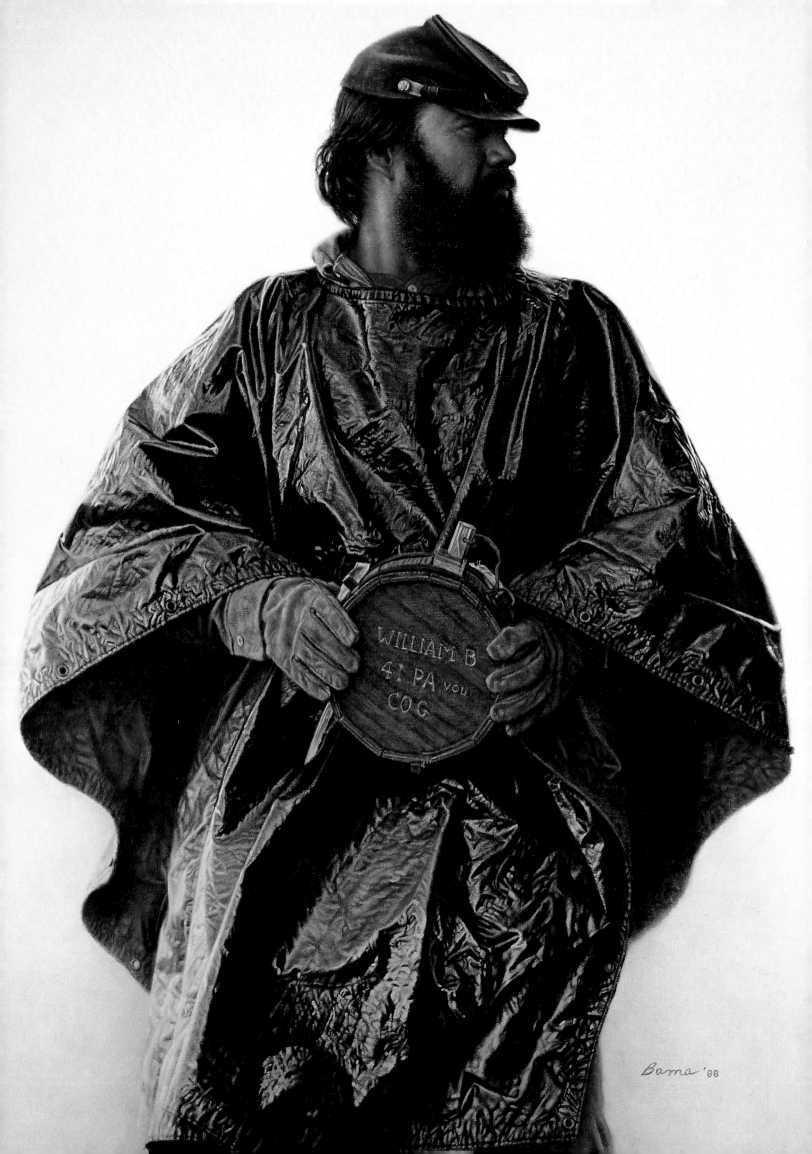

THE VOLUNTEER

CORPORAL, 7TH CAVALRY

*M*aking and wearing authentic Civil War and post-Civil War period costumes is a hobby for artist Jerry Hillard. He participates in war reenactments and has done intensive study on the subject. His raincoat in that long-ago time would serve double duty as a poncho and a tent floor. A glimpse of his underwear adds a touch of red at the collar. The *William B.* on his canteen is a name Hillard has assumed for his portrayals.

*J*ames A. Morris of Garrison, North Dakota, loved the history of the Old West and worked to keep its traditions alive through reenactments of Custer's regiment in meticulously correct copies of uniforms and equipment. As a member of Company F, North Dakota 7th Cavalry in Hazen, he was pictured on an official state map of North Dakota and more recently was featured on North Dakota's license plates. He was the first president of the Garrison Wagon Train organization and at the time of his death in 1986 was captain of Company F, North Dakota 7th Cavalry in Garrison. He was borne to the cemetery in a horse-drawn hearse, pulled by his own team. His son, R. P. Morris, took over his father's captaincy. There was a good reason for Jim Morris' interest in the Seventh. His grandfather served with Custer at Fort Mandan and missed being in the disastrous battle at the Little Big Horn because an illness kept him hospitalized at the post.

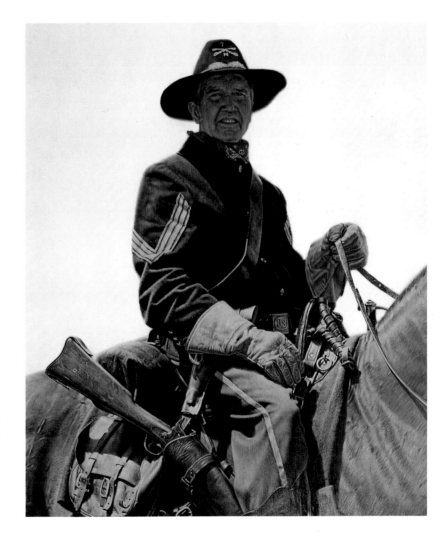

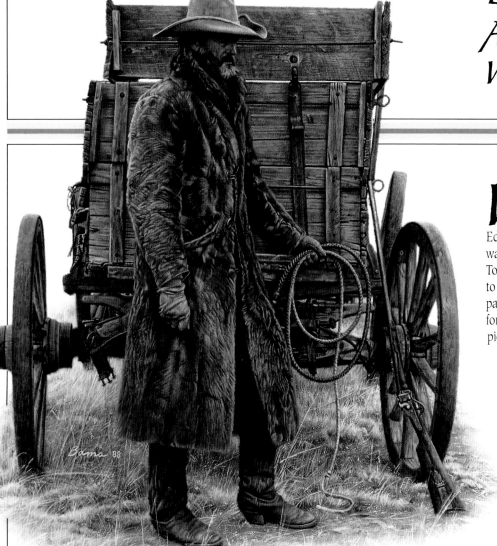

BOB EDGAR AND OLD WAGONS

Wearing a bearskin coat and bracing the butt of a Sharps rifle across the toe of his boot, Bob Edgar stands near a couple of the many relic wagons he has collected for his Old Trail Town in Cody. Edgar introduced the Bamas to much about the history of the West, particularly the region of Wyoming they chose for their home. The wagons are a symbol of a pioneer time when the pace of life was slower, and if you didn't get there today tomorrow was soon enough. Edgar has two long rows of them down the center of Trail Town's street. "Bob never can get enough old wagons," Bama declares. The dog is Edgar's.

THE OLD GREEN WAGON

Scott McKinley was foreman of the Two Dot Quarter Horse Ranch in Montana and had a wood-cutting business of his own. Bama posed him as a freighter, wearing an old fur coat against winter's cold, a whip in his hand, a Sharps rifle leaning against a wagon from the large collection of historic rolling stock in Old Trail Town. The freighter was vital to commerce on the frontier, much like the long-distance trucker today. The teamsters on the Santa Fe Trail helped open the West, for they carried trade goods in both directions between Missouri and many isolated towns of northern New Mexico. Settlements sprang up in the wake of their wagons. Even after transcontinental railroads eliminated the need for freighters to travel halfway across the West, they were still necessary to serve outlying settlements, carrying goods to and from the railroads. They were a colorful and often profane lot, dealing as they did with recalcitrant mules and stolid oxen. It is still said of some men—not always in an uncomplimentary manner— that they "can cuss like a muleskinner."

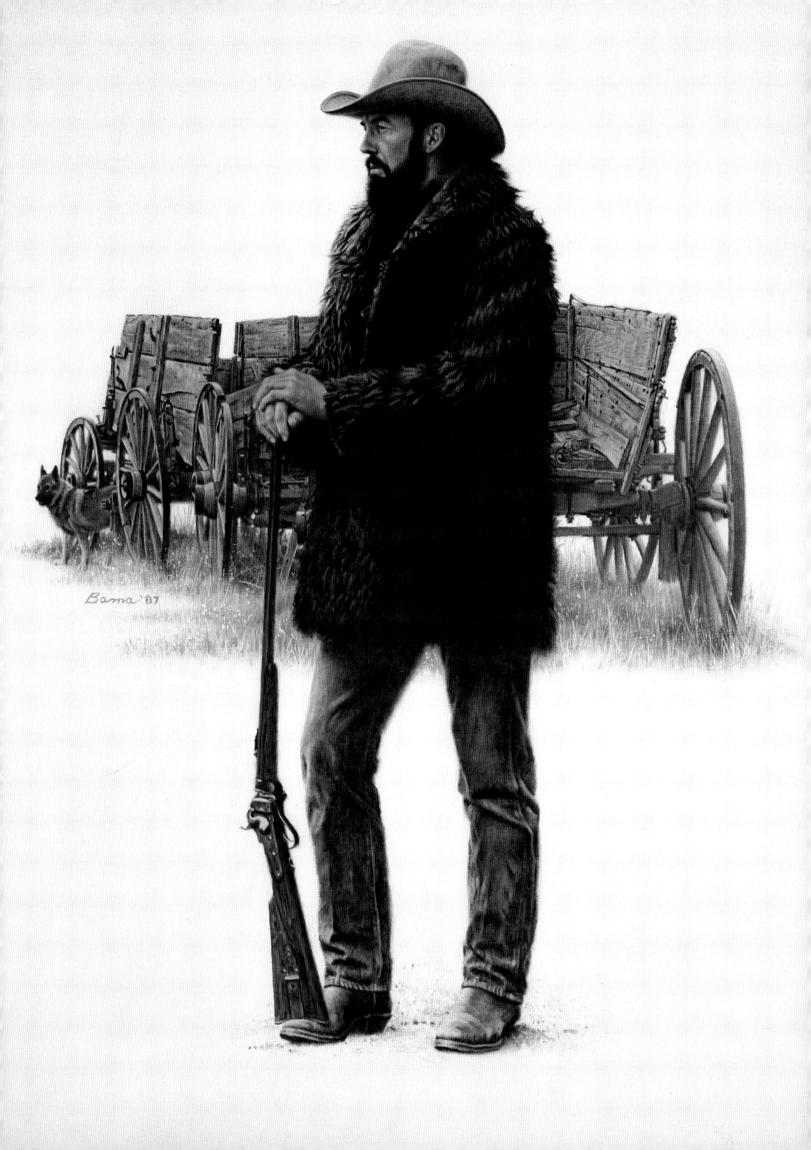

CROW CAVALRY SCOUT—Mike Terry, Indian Reenactor
LITTLE STAR—Mildred Cody, Navajo
THE PAWNEE—Wes Studi, Cherokee Actor in Role
A YOUNG OGLALA SIOUX INDIAN—Known Simply as "Dusty"

SONS

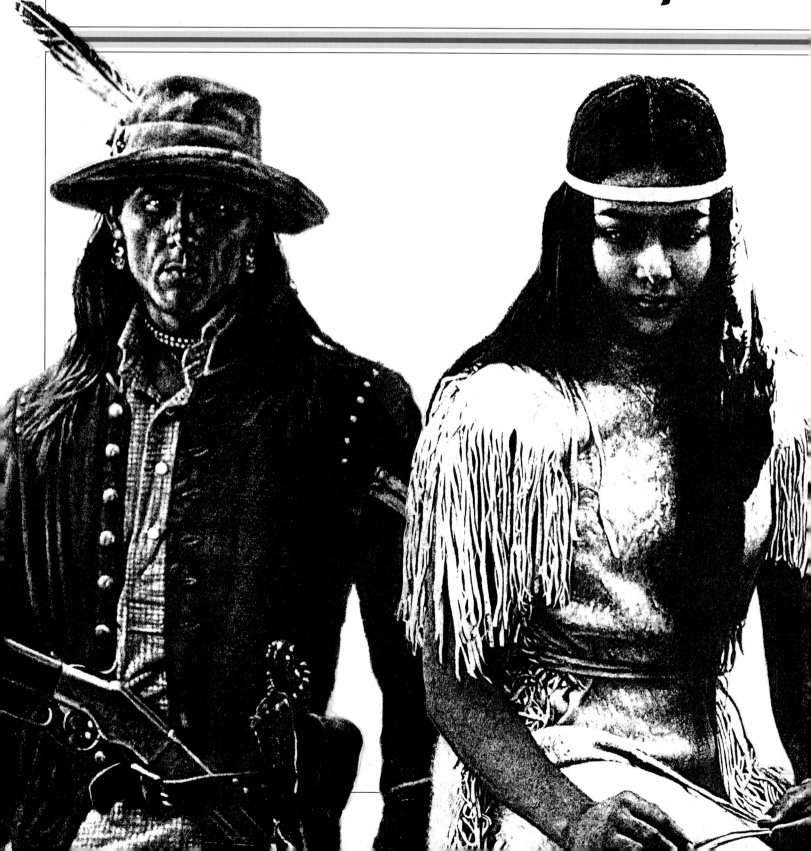

AND DAUGHTERS

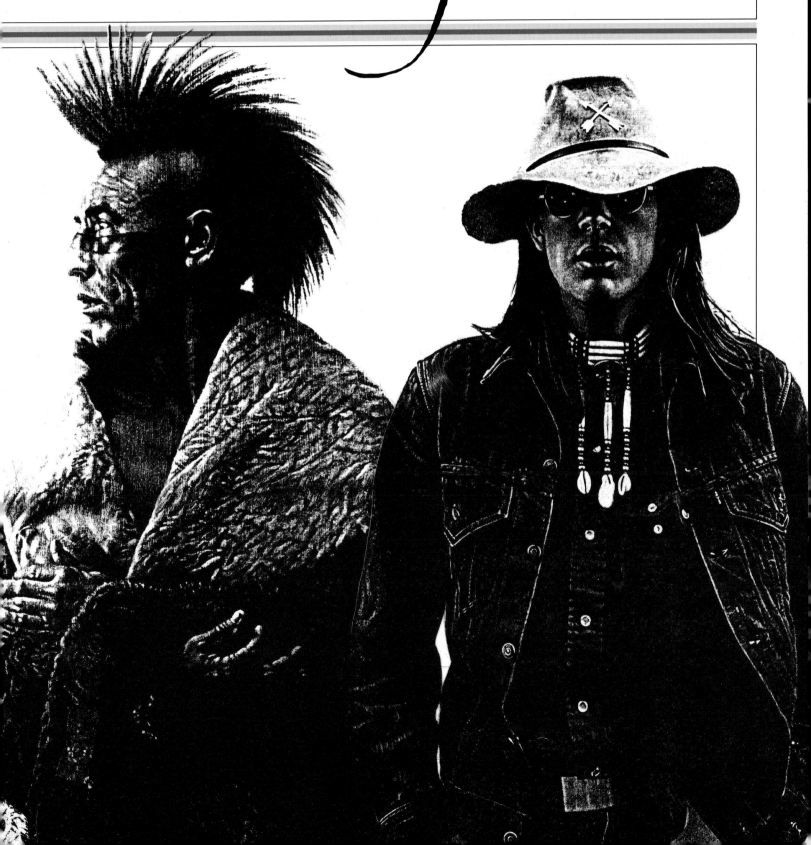

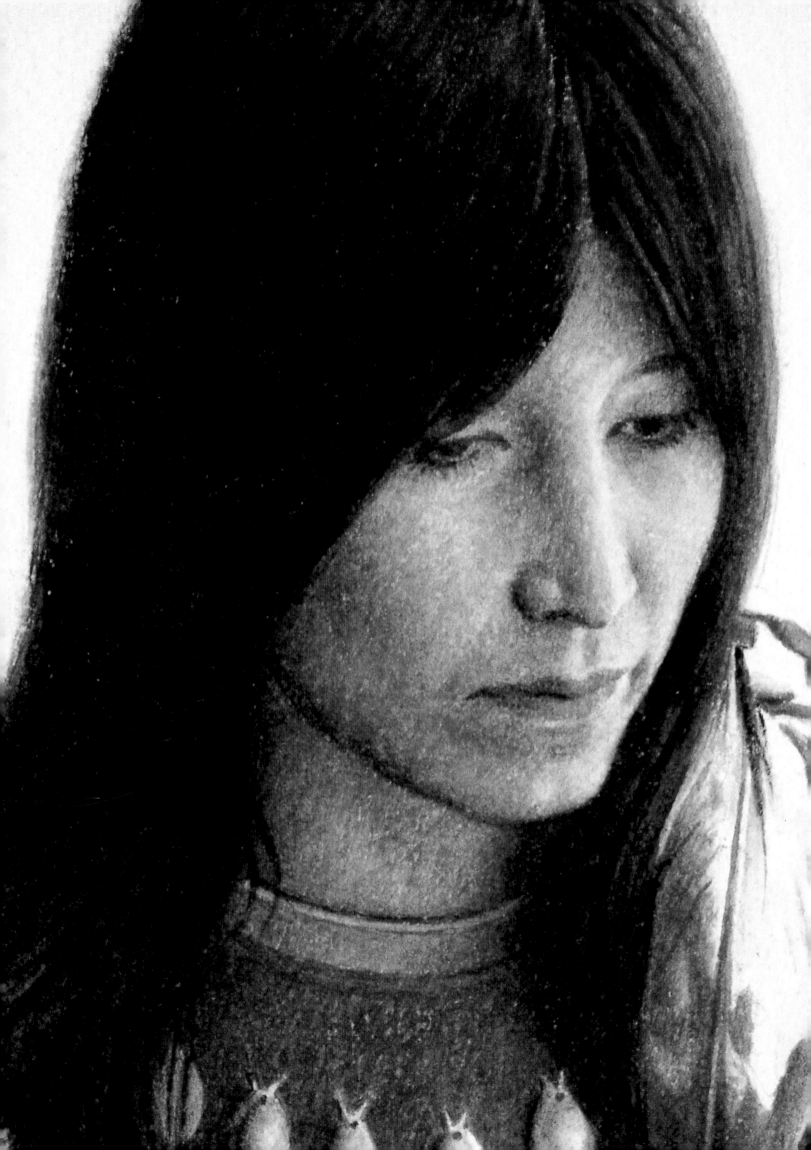

SONS AND DAUGHTERS

James Bama's first introduction to the modern generation of troubled young Indians came at an intertribal soccer and basketball tournament in Denver. A friend there made appointments for him to photograph potential subjects for later paintings. "They came at me faster than they came at Custer," he declares. "In two days I photographed seventeen people."

The pace was hectic and did not allow as much time as he might have liked for developing personal acquaintanceships. However, it gave him an insight into the depth of resentment and despair, the militance of many reservation young people against anything that smacks to them of discrimination, of exploitation, of injustice. He found some of that resentment directed toward him, not for who he was as an individual but for the fact that he was white. It was a new and sobering perspective on an interracial problem as old as mankind.

"All the Indians I had painted at first out here were old. Then I slowly got to know the younger people and became interested in the 1973 Wounded Knee incidents and other events of that nature."

His coming west happened to coincide with a rising militancy among Indians, particularly the young, against the white man's dominance in general and federal Indian policies in particular. This long-festering discontent had begun to surface when Indian veterans of World War II and Korea, and later Vietnam, returned home and found life on their reservations no better than when they had left. Unemployment was rampant, living conditions poor, alcoholism and suicide rates high. They felt that their sacrifices had yielded no tangible gain for their people. Having fought for their country, they were no longer willing to submit to second-class status and regulation by non-Indian bureaucrats who lived far away and knew little about the realities of reservation life.

From 1969 to 1971, as a measure of protest, Indians occupied the abandoned prison compound at Alcatraz. Later, another group invaded the Washington offices of the Bureau of Indian Affairs. This increasing bitterness came to a head in February, 1973, at a hamlet known as Wounded Knee in South Dakota. It was at this place in 1890 that Sioux men, women and children had been massacred by army troops in the last agonized gasp of the Indian wars. In the modern Wounded Knee confrontation, Indian militants—mostly young—defiantly occupied the village and were surrounded by federal troops and law enforcement officers. Although less deadly than the 1890 incident, this one was far more protracted. After seventy-one days marked by sharp exchanges of gunfire, the siege sputtered to an end. But the dark anger of which it was a symptom spread and grew among Indians across the West. Two years later, two FBI agents were killed on the Pine Ridge reservation, resulting in a federal vendetta against the militants. The passions aroused and the issues raised at Wounded Knee II have not yet found resolution.

Of the young militants he met in Denver, Bama said, "They were contemporary and making a statement for today. Many were wary when I photographed them. They were hostile. One of them told me I was exploiting them. I said, 'Look, you don't have to pose for me if you don't want to. But the white people outnumber you. You should get educated and learn how to do something for your people.' Then we got along fine."

Unfortunately, this young man and at least one other who posed for Bama were later murdered on the reservation. That brought home to him with even more clarity the depth of Indian bitterness and the numbing nature of the low expectations harbored by so many.

He does not paint smiling, happy faces on his Indian subjects, whether young or old. "I don't see theirs as a smiling, happy situation."

A positive result of the troubles at Wounded Knee and elsewhere in recent years, from the Indian viewpoint, has been that they have given young Native Americans a new sense of who they are, a sense that they have inherited a unique culture which deserves preservation. It has renewed their interest in the old legends, the old ceremonies and songs, the old dances, the traditional closeness of the Indian to Nature. This is reflected in the many powwows conducted each year across the West, in young people's perpetuation of arts and crafts that at one time seemed about to disappear.

Over the years Bama has spent a great deal of time on reservations, including the 1.8-million-acre Wind River reservation of the Shoshone and Arapaho near Riverton, Wyoming, and the Crow reservation in southern Montana. It was from the first of these frequent visits that he learned that the Indians there do not live as they appear at festive powwows, where they often dress in the most colorful of outfits. At powwows they live out a fantasy far distant from the harshness and deprivation they face in their daily lives.

He found that many of the elderly live with a stoic sadness, trapped by age and circumstances in a situation where life is hard and the future seems to hold no promise of improvement. Poverty has caused many to pawn away the heirlooms that were their tangible link to the past.

"Their traditional way of life is gone, and they are too old to do anything about it. They don't have the education or the will to leave the reservation, so they stay and live in poverty. I tend to paint the older Indians not sadly but humbly, gently.

"The young contemporary Indians, the Wounded Knee types, are more arrogant and defiant, and I paint them that way. I paint contemporary Indians as being of two worlds, part modern mainstream culture and part reservation Indian."

He dwells upon the isolated figure, not the wild dance. When he paints a powwow Indian, he tries to catch him in a reflective attitude, not dancing.

"The revelry is not what interests me; the sadness is. These people are trying to live out a fantasy they can no longer fulfill." He has found that as a white man it is sometimes difficult to reach a full rapport with Indians who struggle to deal with the cataclysmic reality that the white conquest of the West brought to their forebears and that they have inherited in a world alien to their traditional cultures.

"It has been an adventure to approach real people, to do right by them and still make my statement. I am not doing historical or action paintings. I am basically making a symbolic statement about real people. I am not trying to glamorize or to make the Indian look absolutely heroic. I am not trying to present the good guy and the bad guy."

But his strong feelings about the Indians show in his paintings. He declares, "I like everybody. I would like to see everybody in the world do well. I would like to see every kid in the world have a chance in life."

He enjoyed portraying the older Indians and is glad he did so, because those he painted during his early years in Wyoming are no longer alive.

"I still love old people; I love to paint them. But as art, I think the young people are perhaps a better statement because they are *today*. The old people are yesterday. They are in another world. The young people are active and vital, not passive and resigned to their fate."

Regretfully, he feels that many people who love Indian paintings would not welcome a real Indian into their homes, or feel comfortable with one. They prefer the image to the reality. Bama has derived much personal pleasure from the friendships he has developed with many Indians, aside from their importance to his work. He has found that on a personal level they are often far different from the confrontational image they sometimes project. For example, Wes Studi, a fullblooded Cherokee, has now established a promising screen-acting career with his intense portrayals of a Pawnee war-party leader in *Dances With Wolves* and the vengeful Magua in *The Last of the Mohicans*. Yet, Bama has found him genial and obliging. In visits to the Bama home, Studi and his children have spent pleasurable hours playing basketball with the artist and his son Ben.

If Indians are different, if they appear resentful, it is because of what has been done to them, Bama says. They are sensitive to injustice. One of his Indian friends, an artist, is a college graduate and thoroughly sophisticated, yet he has been denied service in a restaurant because of his race. Such unpleasant treatment leaves a mark.

It would be easier in some respects to paint these people from afar, from books and imagination, rather than deal close-up with the modern realities. Bama shuns that direction. "For me personally it would be a cop-out because I feel that I am living here today, and a lot is going on around me."

POWWOW DANCER

Billman Hayes, his wife Joyce and her brother, Aldayne Browning, caught Bama's eye when they performed Indian dances on Native American Day at the museum in Cody. Afterward he invited them to his home for dinner. He found they moved easily from one world to another. "They were like completely different people. They were wearing blue jeans, and she had on a T-shirt with the name of the rock group Chicago. Her brother and my boy played guns." The couple belongs to the Shoshone-Bannock dance troupe, which has performed extensively throughout the United States and Canada. Though Joyce Hayes is Shoshone, her husband is a Maricopa Indian from Arizona, now living at Fort Hall, Idaho.

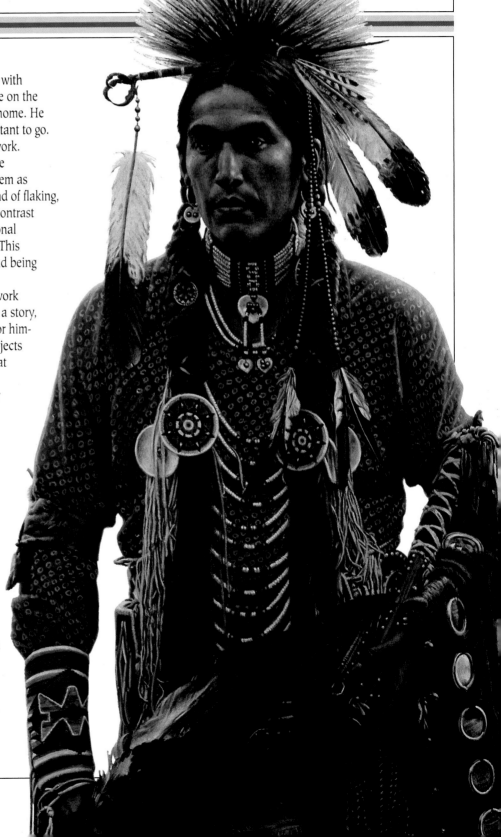

He finds that sometimes he has special entrees with Indians because he has been willing to spend time on the reservations, to socialize, to invite Indians to his home. He travels to places many white people might be hesitant to go. The empathy he has developed is evident in his work.

To symbolize the dead-end aspects of life on the reservation for the young, he has often painted them as three-dimensional figures against a flat background of flaking, peeling walls. He always paints them with some contrast between old and new in their appearance, traditional braids with modern shirts or jeans or sunglasses. This speaks to their dilemma of living in two worlds and being comfortable in neither.

During his commercial art career much of his work was by necessity anecdotal, designed to illustrate a story, to picture an incident. When he began painting for himself, he purposely avoided this. Rarely are his subjects in action. Almost always they are reflective, so that through their attitudes Bama is able to make his statements as an artist, his observations on many aspects of the human condition.

It has been his ambition to produce a body of work uniquely his own, unlike that which others have done before.

"Occasionally I will do anecdotal things, for instance people riding horseback in the snow if the occasion arises, but I really don't look for it. Once in a while I will go somewhere and by chance find a terrific model who happens to be doing those things. But basically I get people and isolate them. I have done very few group paintings. Most Western artists do lots of horses and cows and cowboys, but I try for something very controlled and subtle. That doesn't make it either better or worse; it's just the way I approach my work. Rather than rely on extreme action, I use people and attitudes to tell my story."

In the case of today's Indians, he feels it is a vital story.

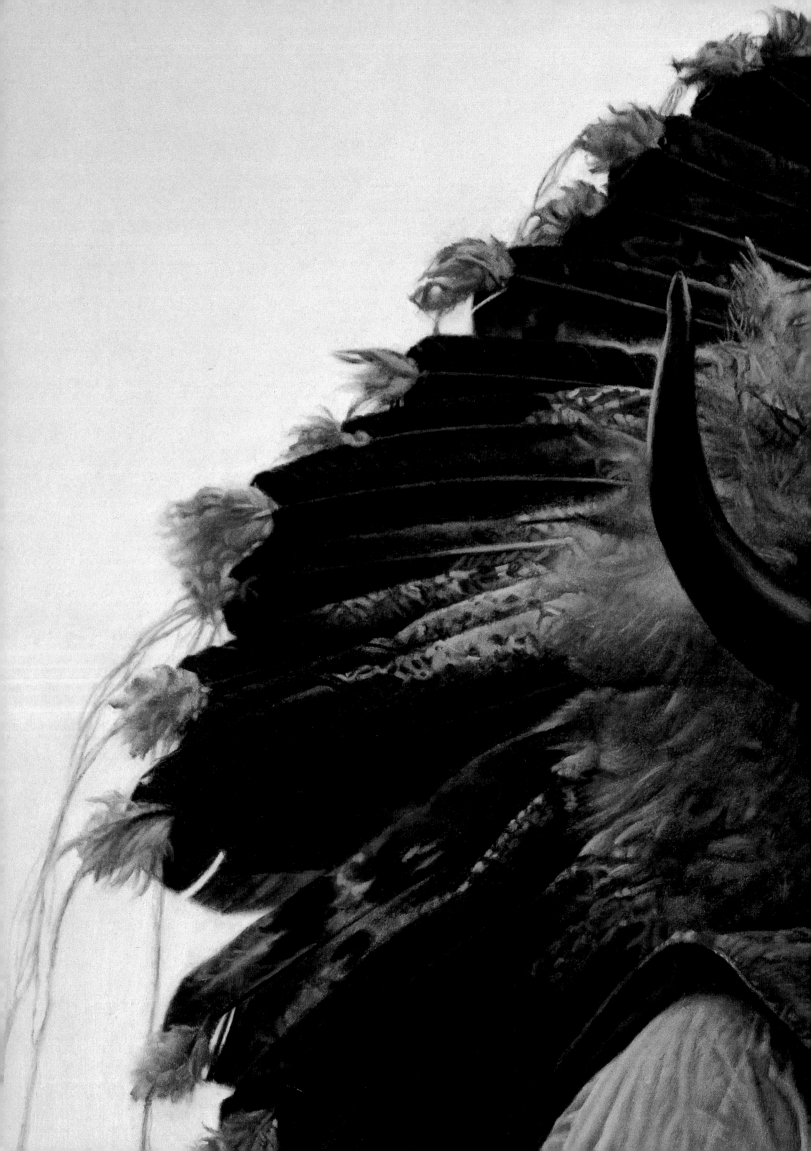

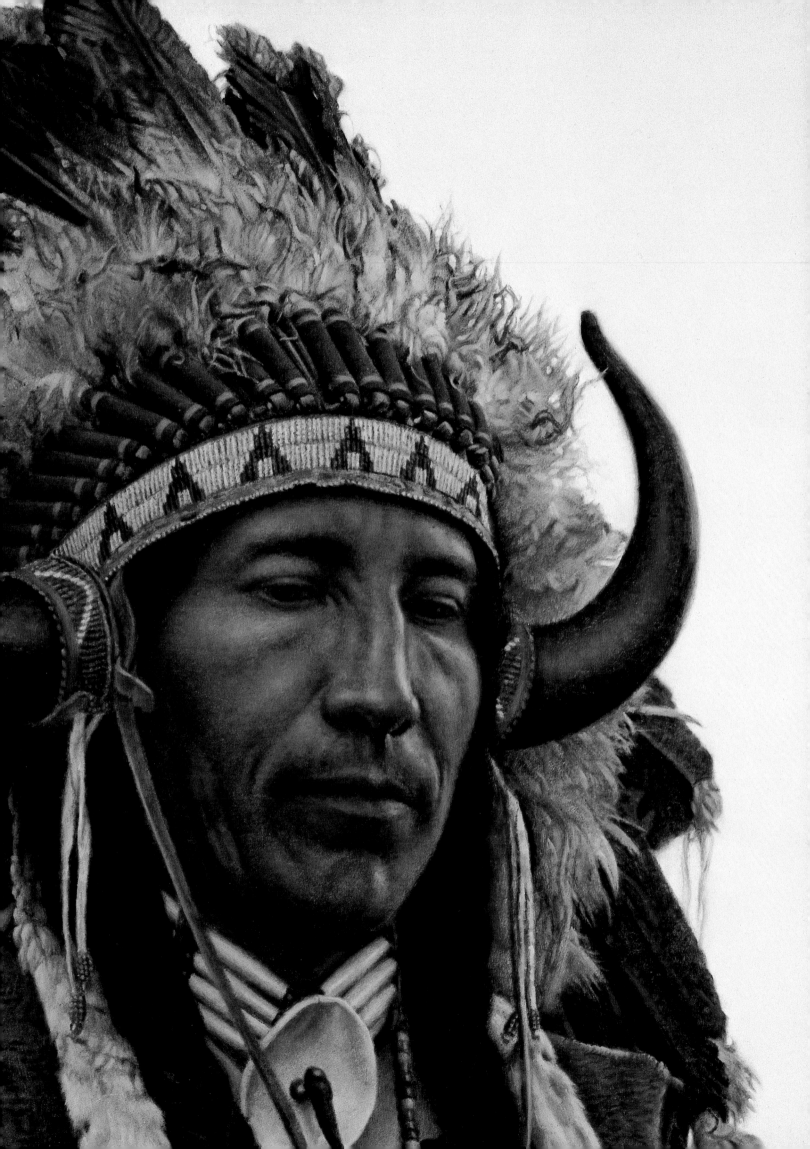

CONTEMPORARY SIOUX INDIAN

*T*his was Bama's largest painting of a contemporary young Indian and is probably his best-known. The original hangs in Cody's Whitney Gallery of Western Art, part of the Buffalo Bill Historical Center. The subject is Wendy Irving, an Oglala Sioux, a modern-day Indian whose choker necklace, ribbon shirt and braids wrapped in otter skin indicate that he clings to the traditions of his people, yet finds himself caught half in one world, half in another. To give the painting a contemporary flavor Bama placed him against a peeling wall and a faded notice that warns, "No Parking, Violators Towed Away." Symbolically the painting seems to say that the Indian does not fit and is not wanted in the white man's affluent neighborhood. Bama declares, "These are sophisticated young Indians, sharp guys, very aware of what is going on. They are not about to sit back passively and endure injustice." Yet as a practical matter they seem severely limited in what they can do other than become educated and find a niche in the white man's world where their old ways have been accorded little or no place.

DESCENDANT OF BLACK ELK

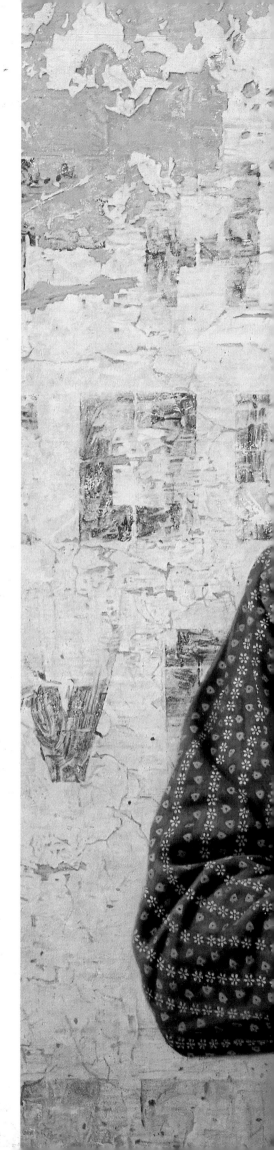

◄ *C*lifton DeSerca, a Sioux, lives and works in the modern world but has strong ties to the last days of the free-roaming horseback Indian of the plains. His great-grandfather was Black Elk, a Sioux holy man whose autobiography is considered one of the most important pieces of Native American literature. Black Elk was born in the Moon of the Popping Trees (December) in the Winter When the Four Crows Were Killed (1863) and as a youngster participated in the battle of the Little Big Horn. In his old age he told his story to John G. Neihardt, who translated it and set it down in the classic *Black Elk Speaks*. DeSerca serves his people in a different manner than his great-grandfather did. He is involved in a reservation outreach program, working with alcoholics. A frequent participant in Indian powwow celebrations, he appeared in Bobby Bridger's mountain-man program, *Seekers of the Fleece*, performed as an outdoor show. He is portrayed here wearing a Sioux headdress and a very old shirt from the trading-post period.

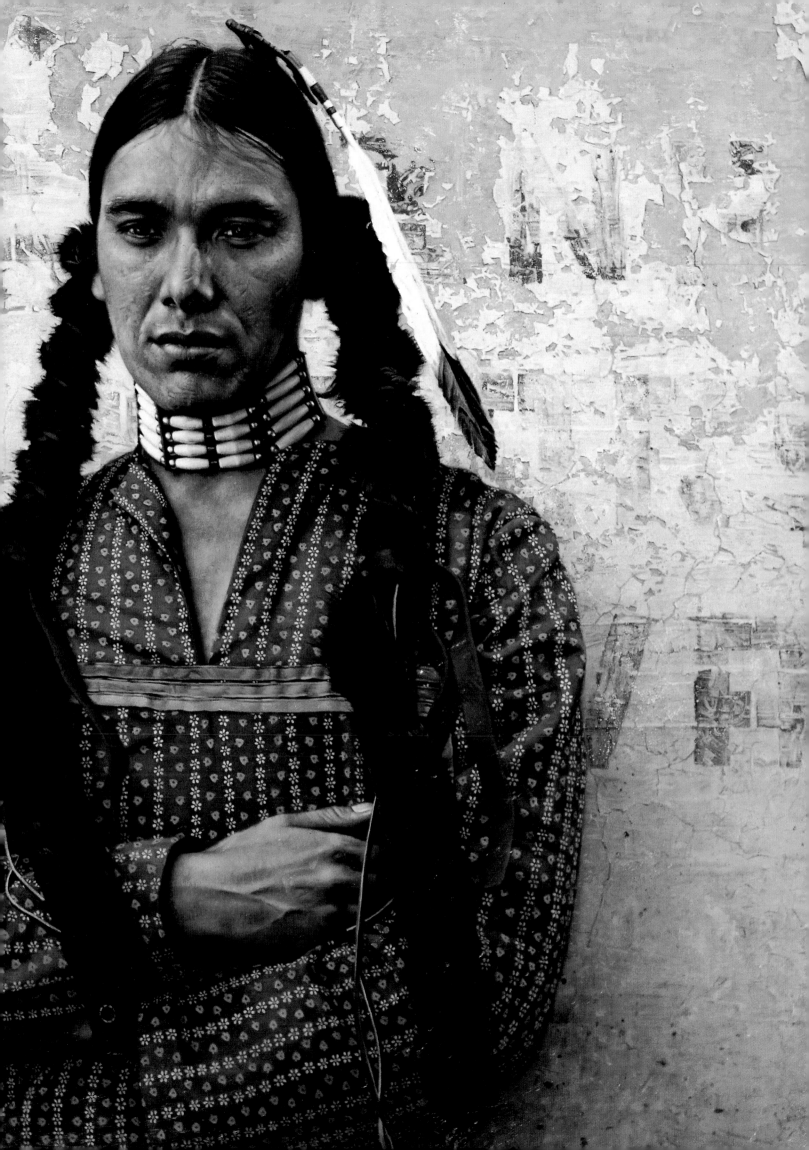

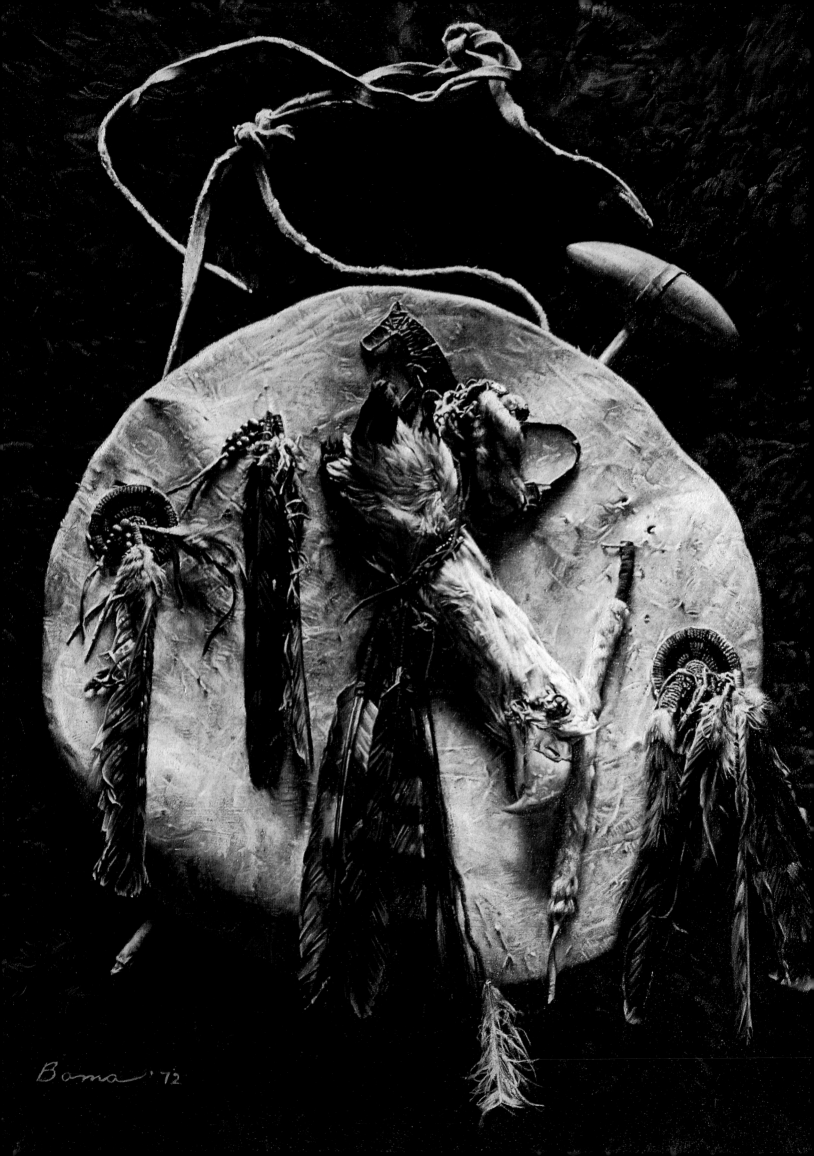

OLD CROW INDIAN SHIELD

SIOUX INDIAN WITH EAGLE FEATHER

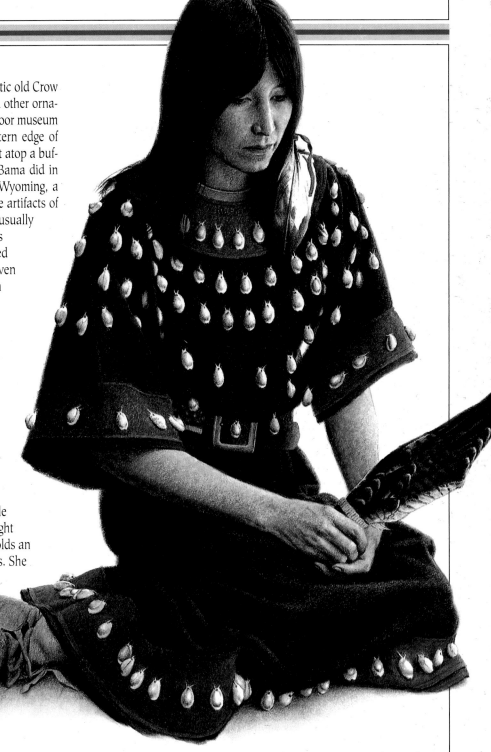

*T*he head of an eagle is bound to an authentic old Crow Indian war shield, along with feathers and other ornaments from Old Trail Town, an outdoor-indoor museum founded by Bama's friend Bob Edgar at the western edge of Cody, Wyoming. A war club is positioned behind it atop a buffalo robe. This is one of many still-life paintings Bama did in the first years after his move from New York to Wyoming, a period when he was becoming acquainted with the artifacts of earlier generations in the West. These war shields usually were made from the thickest part of a bull buffalo's hide, stretched over a willow frame and heat-treated until hard enough to turn arrows and sometimes even bullets. The warrior often decorated his shield with ornaments representing his personal "medicine" and was careful not to let it fall into enemy hands where that medicine might be turned against him.

*F*ew people today realize the extent of the trading network that existed among Indians before the white man dominated the continent. Items from either coast found their way to the interior of the country, so that plains Indians might decorate themselves with seashells from a thousand or more miles away. Here Zandra Apple, an Oglala Sioux, wears a dress decorated with shells in a style that her grandmothers and great-grandmothers might have worn more than a hundred years ago. She holds an eagle-wing fan, often used for ceremonial purposes. She was one of the participants Bama met at a basketball and soccer tournament in Denver's Indian cultural center. Between matches, seventeen of the young people posed for him in a variety of authentic outfits representative of various tribes.

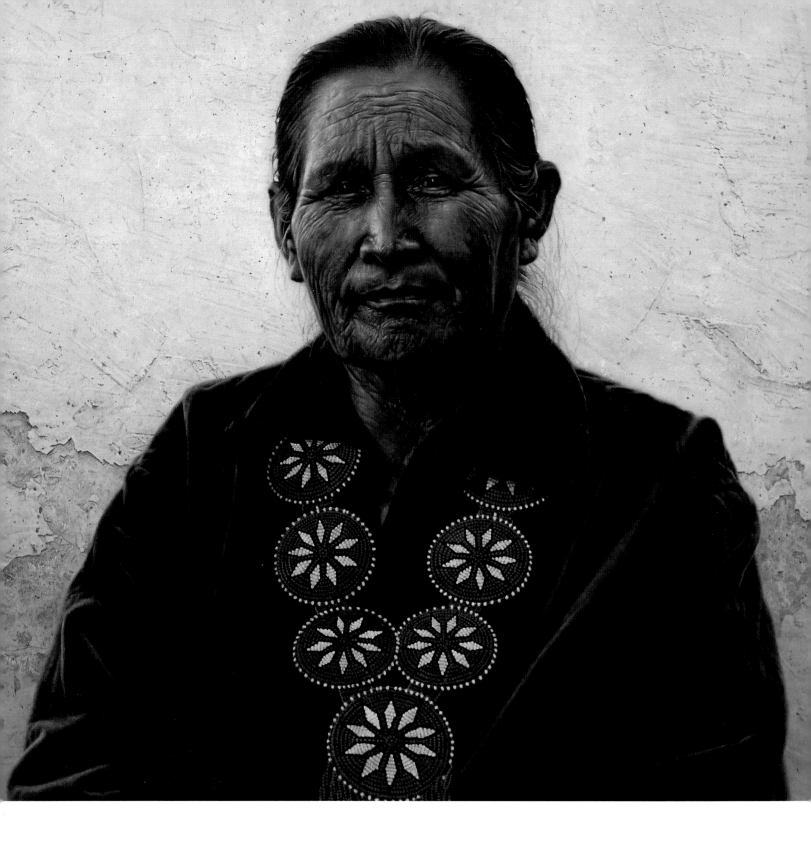

NAVAJO WOMAN

Wyoming is hardly considered a homeland for the Navajos, however, Bama met this woman when she came to visit her son, Lee Guererro, who was working as a silversmith in Cody and had played basketball with Bama. She brought her whole family with her. Bama photographed them all, but he was especially intrigued by the mother's striking look, her innate dignity, her deeply lined face revealing a life of hard work, of long exposure to the harsh desert sun and wind. She wears a beaded squashblossom necklace over a traditional black dress. "I had always wanted to paint the Navajos, and this was my first opportunity," Bama says. "She was a truly handsome woman, and the only one of her family dressed in traditional clothes when they were in Cody. The pictures were taken the day after my son Ben was born, an exciting time for me."

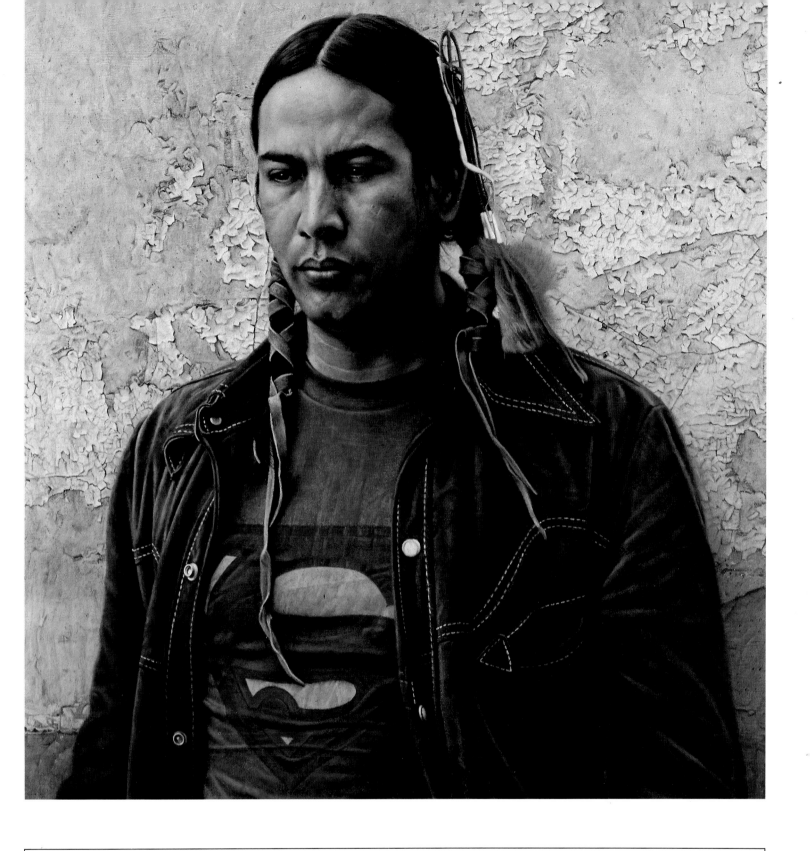

A SIOUX INDIAN

A Superman shirt and a militant young Indian seemed to Bama an ironic incongruity. It symbolized today's reservation youths whose heritage goes back to warrior grandfathers and great-grandfathers but who find themselves with limited power to change their lives. "I couldn't have conjured up a combination like that," Bama says. "It said to me that here is a guy who would like to have exploits like Crazy Horse and do brave and courageous things but has no vehicle for doing it anymore." Publisher Malcolm Forbes bought the painting. Of it he wrote: "A great painting that says it all. Look at the expression on this young Indian's face. Brooding. Perplexed. Depressed. ...It's not really the incongruity that gets to you; it's the way one suddenly sees, realizes what a harrowing disharmony it is for American Indians—with hundreds of years of their own culture—to be displaced, enveloped by people and cultures totally alien to their heritage."

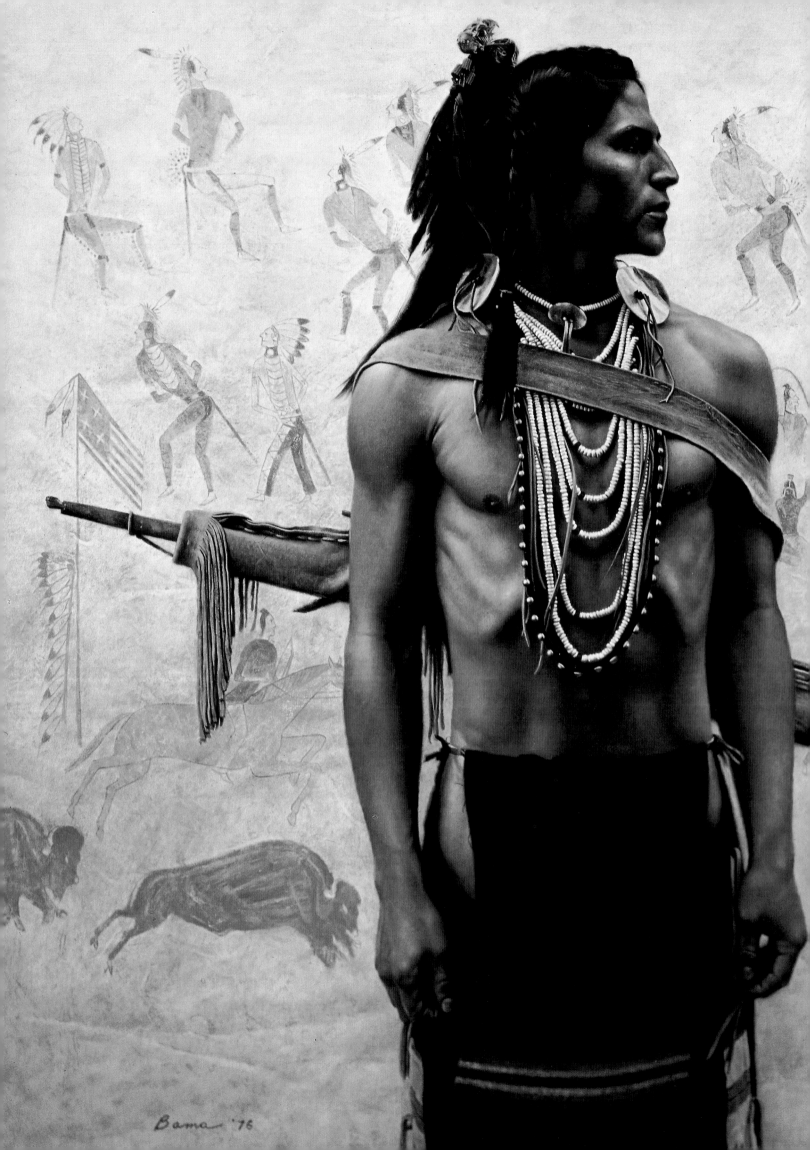

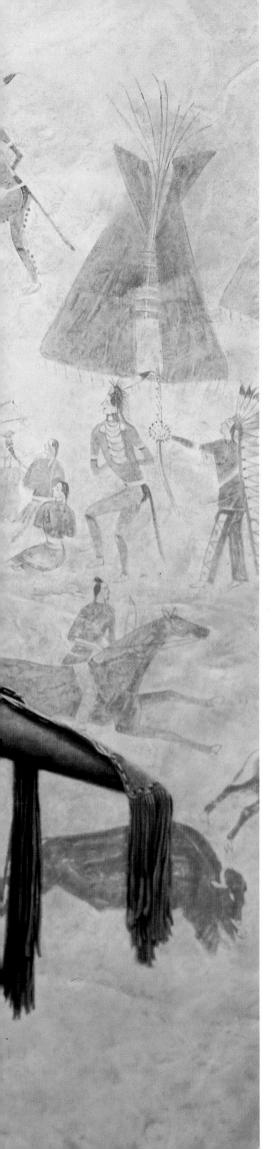

A MOUNTAIN UTE

T hough Lloyd Chavez is a Mountain Ute, here he poses with traditional Shoshone accoutrements. Bama thought him a particularly striking-looking young Indian and has done four paintings of him. Chavez has a sparrow hawk tied in his long hair. He wears a shell necklace, a deer-skin bow case or quiver slung across his back. Behind him is a plains Indian hide painting depicting Indian dances, a buffalo hunt and a captured American flag. In the absence of a written language, such paintings recorded events in the life of an individual or a band. Sometimes they were done in calendar style, recounting pictorially the highlights of each passing year. Often they decorated a warrior's tepee, so that all who happened by could recognize the occupant's past deeds.

SOUTHERN CHEYENNE WARRIOR

C had All Runner was one of several militant young Indians Bama photographed at the time of the 1973 reservation troubles at Wounded Knee. All Runner camped in Cody, Wyoming, and prevailed upon the operator of Old Trail Town to fly the flag upside down as a token of Indian displeasure over the way their lives were going. He was a formidable-looking and angry young man, bearing scars from a past fight or fights. "He thought I was exploiting him," Bama says, "and I had a long discussion with him about education being the Indian's only way out." The artist presented him here as a plains warrior, cradling a Springfield .45-70 in his arms. The warpaint, All Runner's own idea, adds to the fierce appearance of a man who looked more than ready to fight but lacked a clear-cut place to do it, or a clear-cut enemy to challenge. Bama learned that All Runner was later murdered on the reservation.

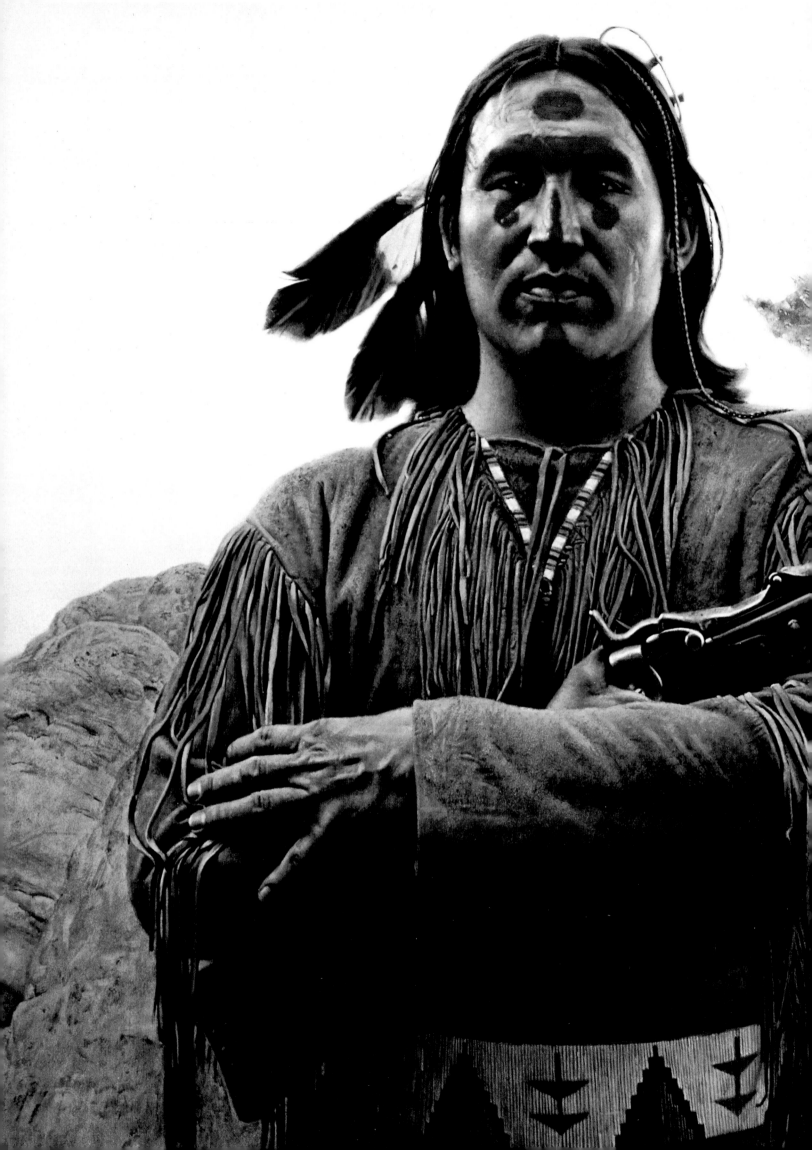

© Bama '75

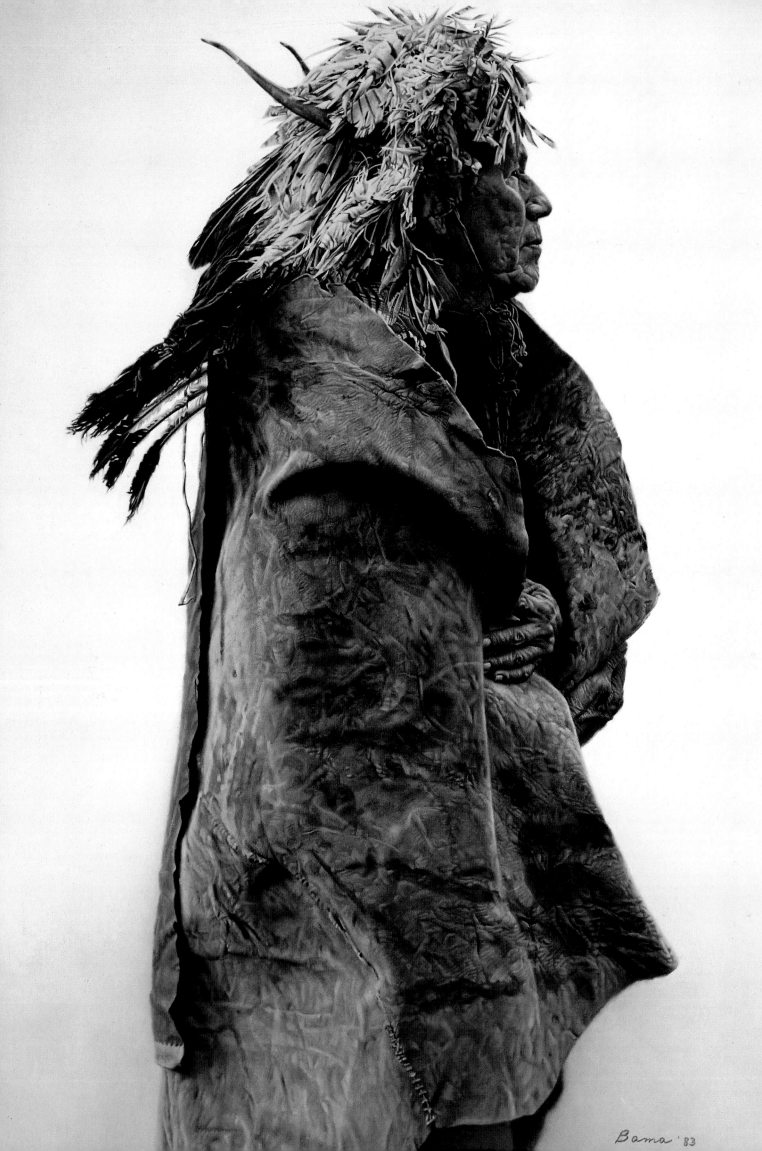

Bama '83

CROW INDIAN WEARING 1860'S WAR BONNET

OLD BUFFALO SKULL

◀ Francis Stewart, who posed five times for Bama, brought with him his great-grandfather's split-horn warbonnet and a shirt worn in battle in the 1860's. The headdress features owl feathers on the top. Stewart, a modern-day Crow medicine man, wrapped an elk hide around his shoulders. Says Bama, "I was excited about this one. It was something different than I had ever painted." The Crows in an earlier time held some of the best hunting grounds in the Rocky Mountain region and therefore were constantly defending themselves against encroaching neighboring tribes such as the Sioux and Cheyenne. Old animosities have not completely faded away. In modern reenactments of the Custer battle, Crows often portray the Indians who defeated the troopers. In real life, they were allies of the military. This still causes some resentment among descendants of those who *did* fight against Custer.

This ancient skull was found at the bottom of a cliff that had been the site of a "buffalo jump" during the long-ago time before the Indian acquired the horse and streamlined his method of hunting. Members of the band, working afoot, would stampede a herd over a bluff or deep washout, where women, older men and even children waited to club, stone or spear the crippled animals to death. A stone axe would be used to break open the skull. The brains would be removed for food or to be mixed with ashes for the hide-tanning process. The stone at right was grooved for attachment of a wooden handle, which would turn it into a formidable weapon to employ against either crippled buffalo or tribal enemies.

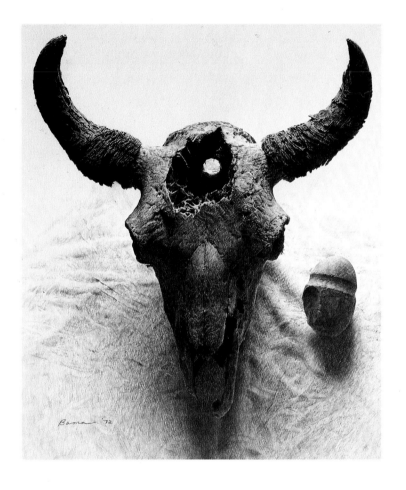

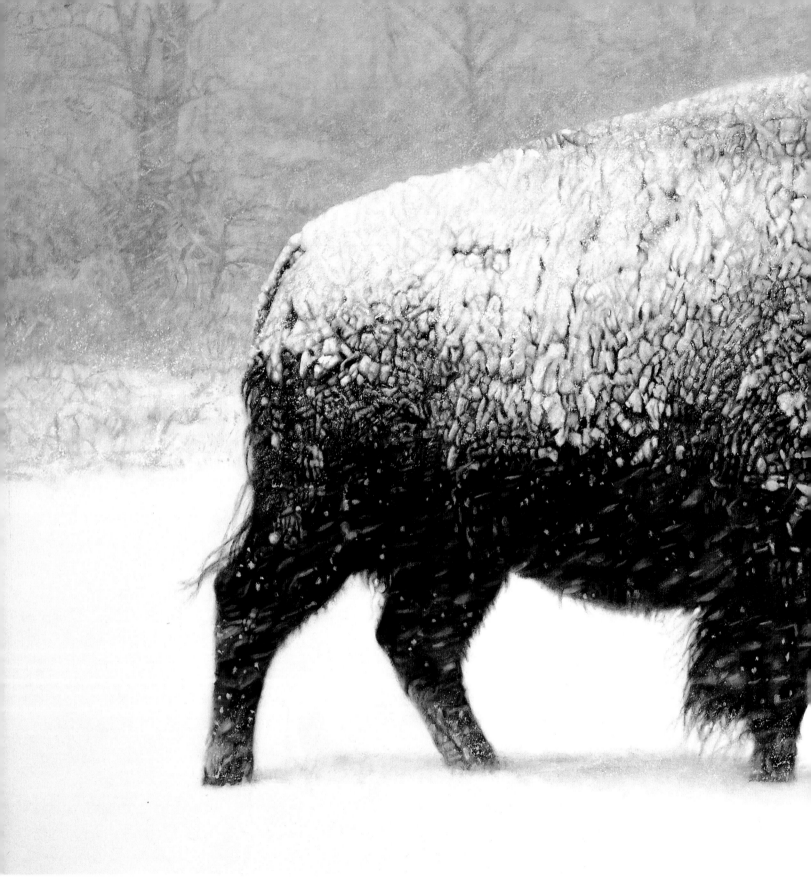

BUFFALO IN STORM

The buffalo was the staff of life for the plains Indian. Thousands of years of natural selection had adapted it to survive during extremes of drought and extremes of winter weather. Where domestic cattle might starve, the buffalo would paw its way down through deep snow to find forage beneath. So long as the Indian had a dependable supply of buffalo he was able to resist white encroachment into his homeland. The early robe trade made some impact upon numbers but put the buffalo in no danger of extinction. With the advent of a new tanning process in the early 1870's, which increased

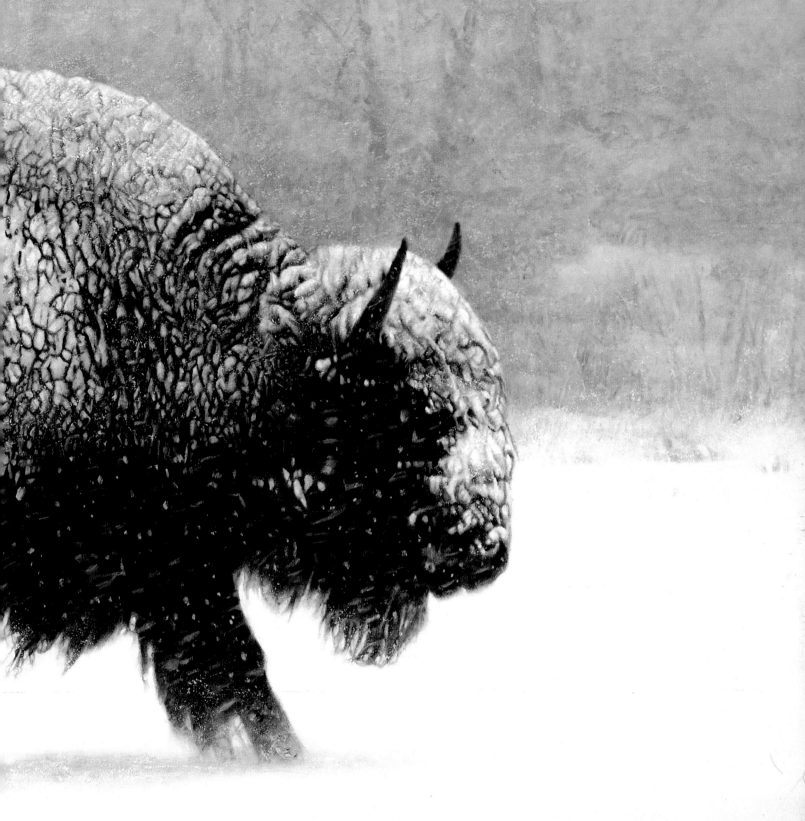

Bama '87

the commercial value of raw buffalo hides, frontier military officers encouraged hunters to disregard treaties that reserved certain hunting grounds for the Indians. They reasoned that when the buffalo were gone the Indians would have no recourse but to surrender and accept the reservations. In less than a decade, the millions of buffalo which had roamed the plains were reduced to a tiny remnant, and the once-proud Indians were fated to a pointless, dead-end life as wards of the government. Bama sketched this painting on a brutally cold day when snow was fourteen inches deep and ice encrusted the trees.

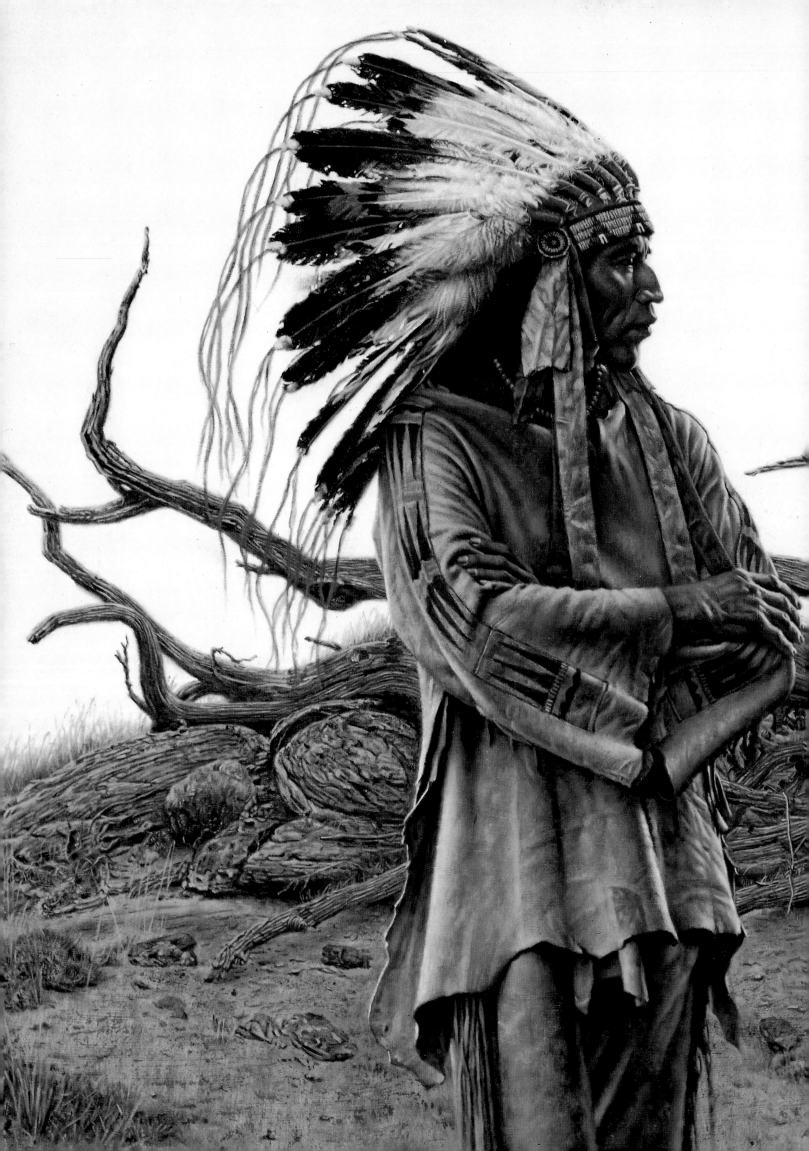

Wes Studi, a Cherokee, has gained stature acting in films, particularly as Magua in *The Last of the Mohicans*. Here he posed as a Blackfoot warrior seeking a vision. It was a custom among plains Indians for a boy approaching manhood to venture out alone on a personal vision quest as a rite of passage, seeking a guardian spirit to protect him and guide his life. He would fast four days and nights, awaiting sign that such a spirit had come to him. Later he might revisit the site many times, seeking fresh visions and renewing his closeness with the spirit.

KEN BLACKBIRD, AN ASSINIBOIN SIOUX

Ken Blackbird first posed for Bama when he was about nineteen, wearing a Sioux buffalo-horn headdress and buckskins. Now in his 30's and a professional photographer, he has become a good friend of Bama's. A large, strong man, he worked several years clearing trails for the U. S. Forest Service. He lives on an Assiniboin Sioux and Gros Ventre reservation near Belknap, Montana, and spends time photographing powwows. He also does publicity shots for Bama. "He has a sixth sense," the artist says. "He seems to show up as if by magic when we have chocolate cake."

[95]

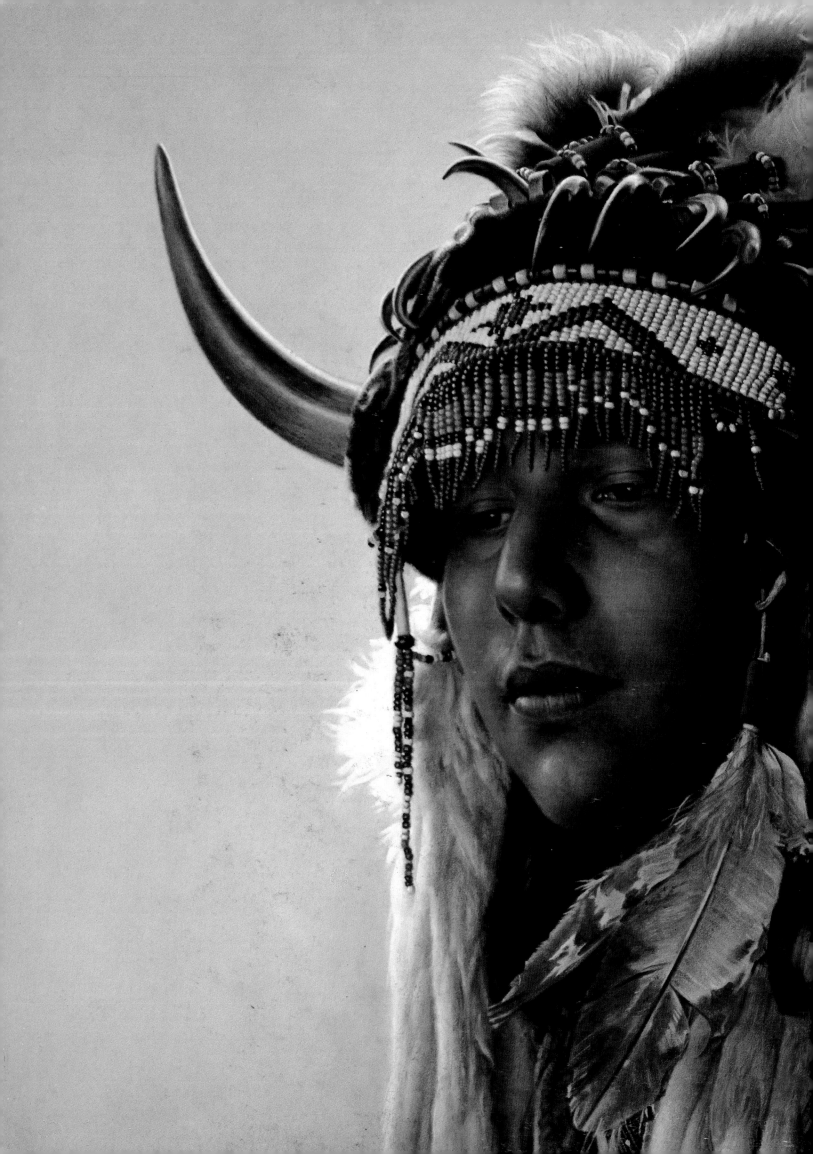

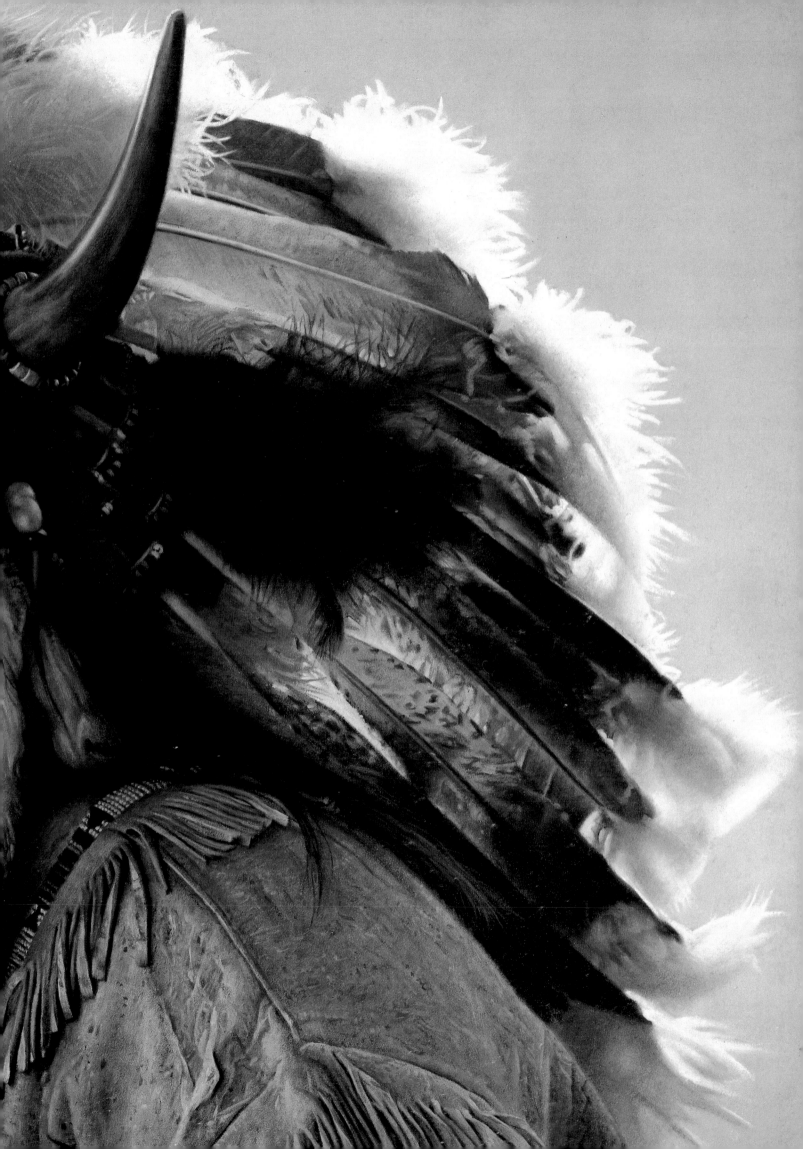

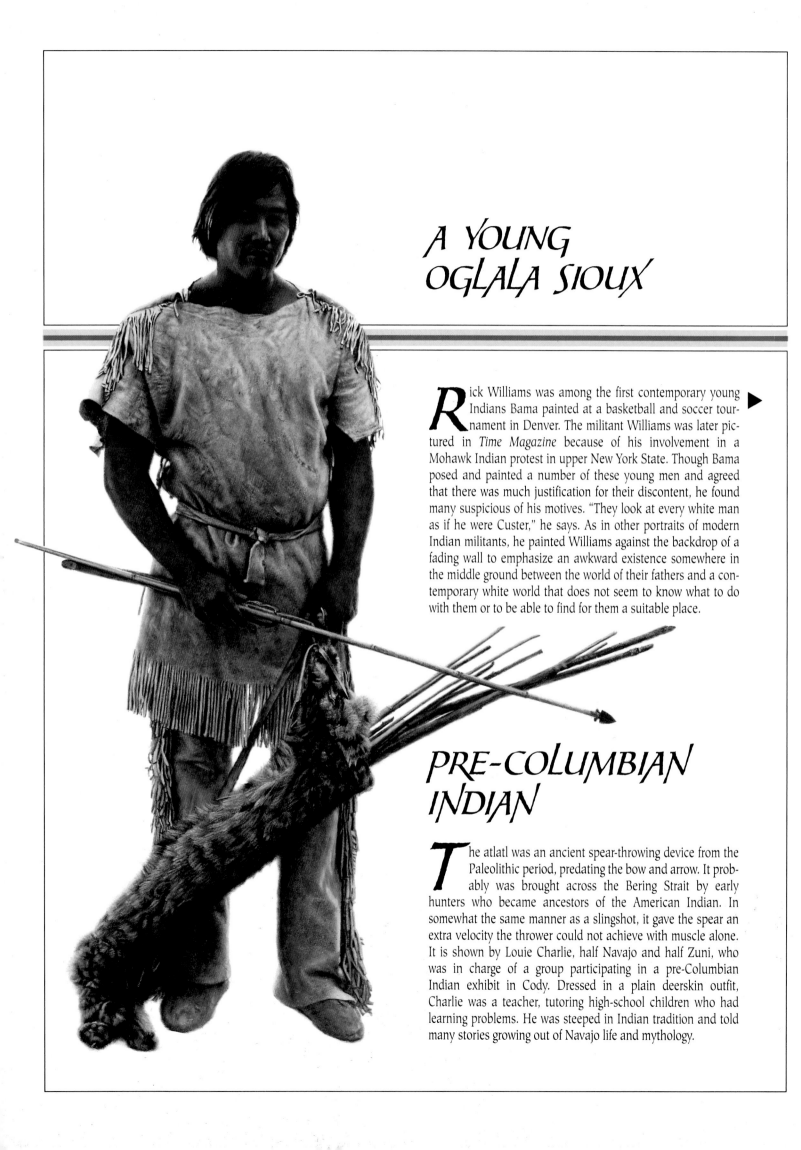

A YOUNG OGLALA SIOUX

Rick Williams was among the first contemporary young Indians Bama painted at a basketball and soccer tournament in Denver. The militant Williams was later pictured in *Time Magazine* because of his involvement in a Mohawk Indian protest in upper New York State. Though Bama posed and painted a number of these young men and agreed that there was much justification for their discontent, he found many suspicious of his motives. "They look at every white man as if he were Custer," he says. As in other portraits of modern Indian militants, he painted Williams against the backdrop of a fading wall to emphasize an awkward existence somewhere in the middle ground between the world of their fathers and a contemporary white world that does not seem to know what to do with them or to be able to find for them a suitable place.

PRE-COLUMBIAN INDIAN

The atlatl was an ancient spear-throwing device from the Paleolithic period, predating the bow and arrow. It probably was brought across the Bering Strait by early hunters who became ancestors of the American Indian. In somewhat the same manner as a slingshot, it gave the spear an extra velocity the thrower could not achieve with muscle alone. It is shown by Louie Charlie, half Navajo and half Zuni, who was in charge of a group participating in a pre-Columbian Indian exhibit in Cody. Dressed in a plain deerskin outfit, Charlie was a teacher, tutoring high-school children who had learning problems. He was steeped in Indian tradition and told many stories growing out of Navajo life and mythology.

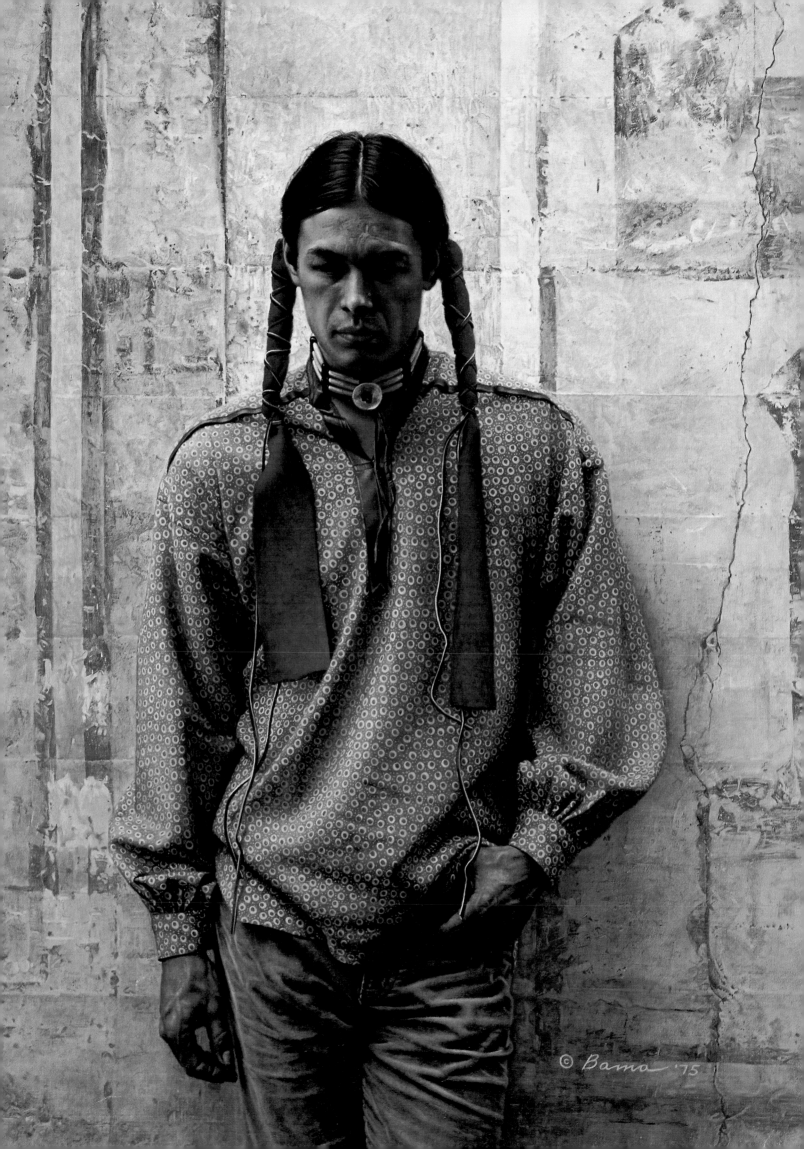

TONY MARTIN, HUNTING GUIDE—Cowboy from California
DON SMALTZ, OUTFITTER AND GUIDE—Owner of Red Pole Ranch
KEN HUNDER, WORKING COWBOY—Rodeo Team Roper

THE

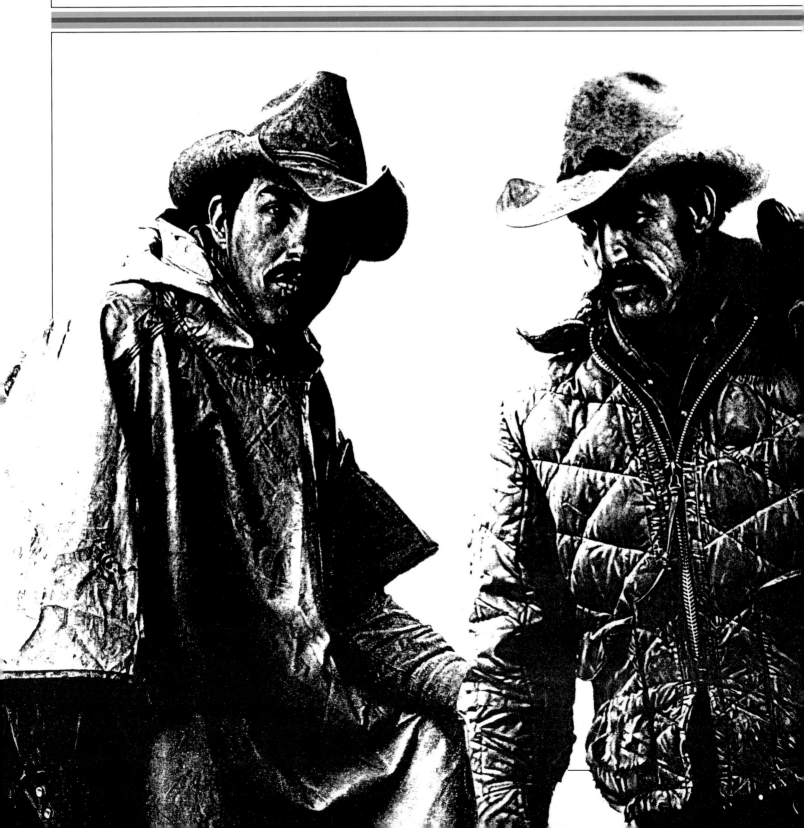

WORKING WEST

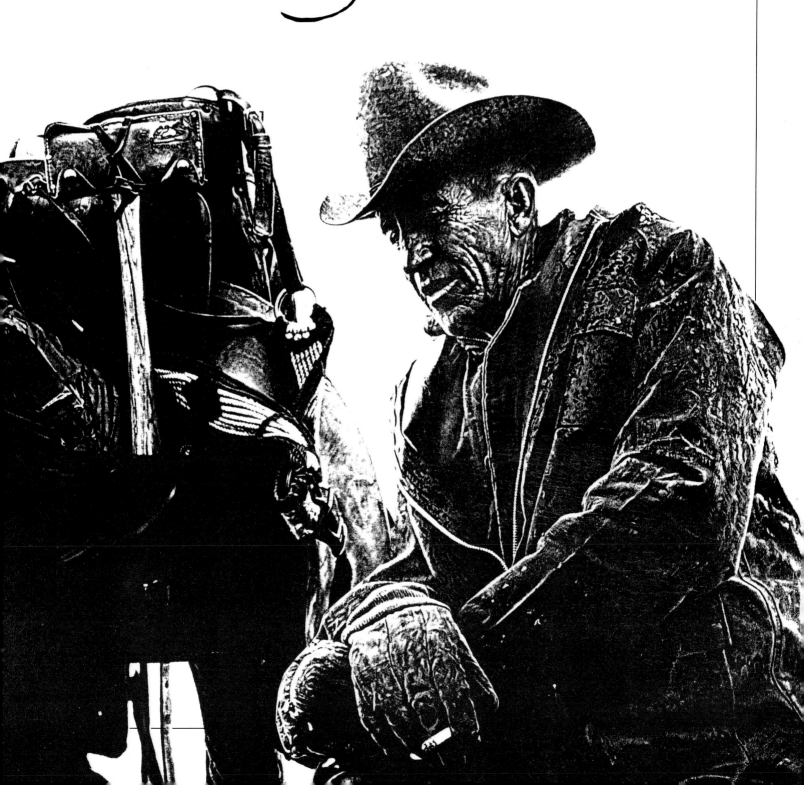

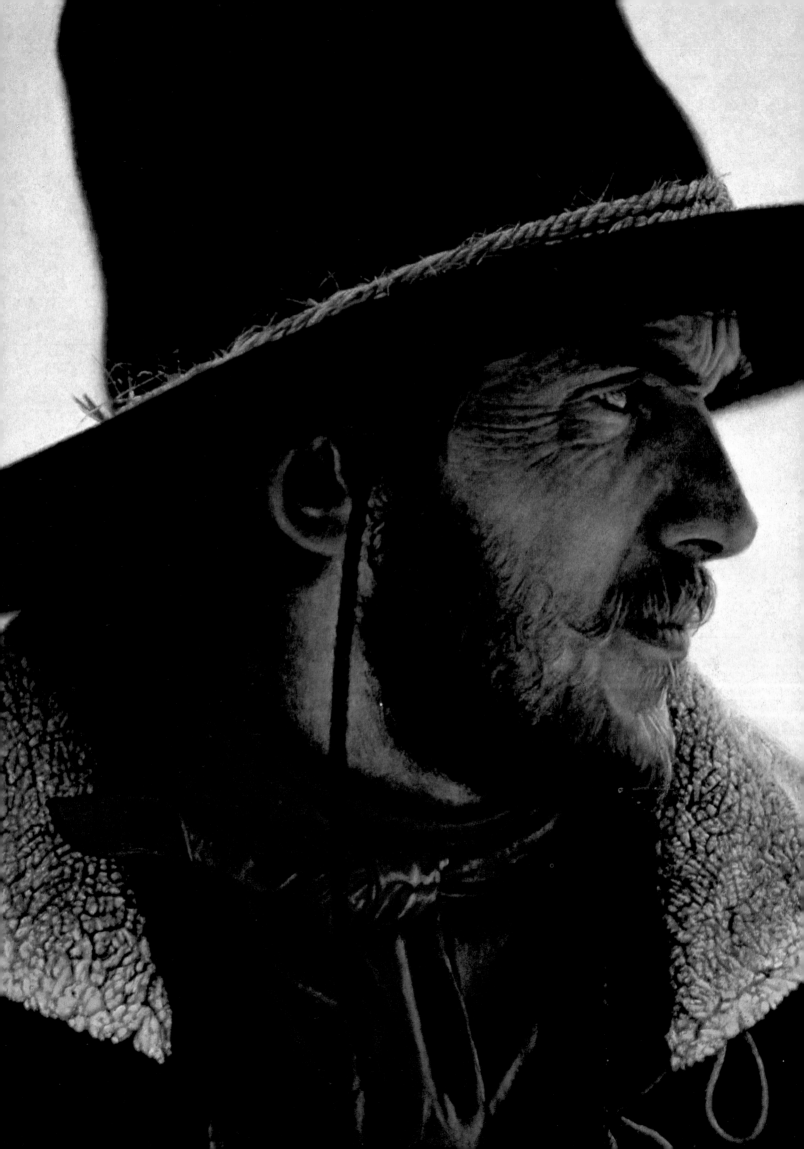

THE WORKING WEST

Beyond the color and spectacle of the mountain-man rendezvous, the Indian powwow and the rodeo lies the reality of the modern working West, little seen by the average tourist unless he pulls off the interstate and seeks it out. James Bama has tried to remain as far as possible from the interstate, discovering and painting the rich variety of today's working West, often much different from the "show" West envisioned and sought by tourists.

He became an easy convert to the Wyoming rural lifestyle. Early years on the Bob Meyers Circle M Ranch showed him a world far different from his previous experience in New York City. He missed going to the beach, but the mountains and the clean, white snow were worthy replacements. He missed the variety of sports available in the city but found pleasure through personal participation in areas of country life totally new to him.

"Our whole life changed," he says of himself and Lynne. "We loved the West from the first. We helped round up cows and lay out salt blocks. We rode horseback every day, and the scenery was magnificent. The only way to really see it is to get on a horse." The horse, of course, remains a vital part of the working West.

He found that there are still real cowboys. They are far fewer than in the past, but they manage to survive nevertheless, rounding up cattle or wrangling horses and dudes. There are still men who live in wagon-camp isolation on the high mountain meadows from spring until fall, loose-herding sheep flocks as they graze, directing them to the best forage, protecting them from predatory animals, very much as it was done a hundred years ago.

There are men who work as outfitters and guides, taking paying guests into faraway canyons and up the rugged Rocky Mountain slopes on camping and hunting expeditions, showing them remote regions little changed since early mountain men explored them in the distant past. There are those who still run their traplines much as the oldtime trappers did, and prospectors who search out the hidden places in hope of finding mineral wealth their predecessors missed.

Indeed, much of Wyoming's history is kept alive in the workaday world of people who call it home.

A major percentage of the Western lands are federally owned. Ranchers, timber companies, miners and others pay use fees under a permit system. Improvements such as roads, fences and corrals are built sparingly so that much of the land remains wide-open range, looking little different than when the Indians had sole dominion. Ranchers face a special challenge in controlling the movements of their animals. That is one reason the cowboy is still a necessity. He may haul his horse partway with a pickup and trailer, but for much of his daily work he must ride horseback into roadless areas where a vehicle cannot go.

A common practice is for the rancher to own the land upon which the headquarters is located. Often this is bottomland, homesteaded by an earlier generation in valleys and along rivers and streams where he may cultivate fields and raise a winter's supply of hay through the summer growing season while his livestock graze government land at the higher altitudes. Early in autumn, before the snow flies, he and his cowboys bring the herds down from the mountains to winter on hayfields or on accessible rangelands where hay can be carried when snow is too deep for the animals to paw through to the grass beneath.

Cattle can be turned loose on the open range in summer to fend for themselves. The cowboy's main duty then is to prevent their straying from their designated allotments, doctor any injured or sick, and see that they are supplied with salt and supplementary minerals that may be required to offset any deficiency in their forage.

Sheep, however, are more vulnerable and require constant attention to protect them against predators. Therefore, herders remain with them when they go up into the mountains for the summer. Afoot or on horseback, often accompanied by a dog or two, the herder keeps the flock moving to fresh feed from one day to the next, usually within a broad circle around his camp. He lets the sheep scatter to graze, but not so far that they cannot easily be gathered late in the day and moved to

their bedground. His camp centers usually around a sheepherder wagon, compactly designed for efficiency and a modicum of comfort. In recent years the wagon has sometimes been replaced by a small travel trailer. Camp is moved as often as necessary to provide the sheep new forage and prevent their overgrazing, damaging the range.

One of the landmarks Bama noticed early in his Western experience was tall piles of stones known as "sheepherders' castles," built sometimes out of boredom, sometimes as a means of helping herders or camp tenders to locate a good campsite season after season.

The sheepherder is likely to be an older man, able to cope with solitude for long periods. He must have patience, for sheep require slow, gentle handling and an understanding of their herd instinct. To try to "cowboy" them as might be done with cattle usually leads to frustration at best. At worst, it can create chaos, scattering the sheep, separating ewes from their lambs to the detriment of the flock. And though in cowboy lore the sheepherder is regarded as being little brighter than the sheep, the reality is that many are highly literate. The nature of their work gives them more leisure than the cowboy is likely to enjoy. They have time and solitude for introspection, and many are avid readers.

In ethnic terms they are a highly mixed group—Anglo, Hispanic, Indian. Traditionally, a large percentage of sheepherders in the mountain states have been Basques, for the Basques have a long history of association with sheep. The more frugal have often built large flocks of their own. An old sheep-industry axiom holds that the Basque works for the flock owner a few years, spends next to nothing, and in time *becomes* the flock owner. Fewer and fewer are entering the sheep industry today, however.

Sheep numbers across the West have decreased sharply in recent years for a number of reasons, including smaller grazing allotments, predator pressure and shortage of herders. The old-time sheepherder wagon is harder and harder to find on the summer ranges.

Though some men, like Bama's friend Slim Warren, remain cowboys so long as they are physically able to handle demands of the job, many cowboys are young men who perceive adventure and romance in the life. Some are born to the work and tend to remain at least on the fringes of the occupation all their lives. Others come from urban environments, bent on living out their perceptions whether or not they resemble reality. A majority of these eventually drift into other occupations as the romantic aura of cowboy living dissolves under the weight of long hours, hard work, summer's blistering heat and winter's biting cold.

In mountain states like Wyoming, many prefer to be called buckaroos rather than cowboys. Though the two terms are essentially synonymous and the work more or less the same, the buckaroo dress code tends to be somewhat more colorful than that of the traditional Southwestern cowboy.

Bama has become aware that many young cowboys tend to be restless, moving often from one job to another. Because ranches are much busier in summer than in winter, whether working cattle outfits or catering to guests, many cowboys find themselves out of work when the snow begins to fall. They fill in with part-time town jobs or as guides and outfitters during hunting season. Some run traplines to stay busy in the winter months.

He once painted a picture of a drifting cowboy who later worked on a dozen different ranches before eventually, by pure coincidence, ending up as foreman on a ranch owned by a woman who had bought the painting years earlier.

Some of the people he has painted have unusual stories. Al Smith, one of the old cowboys he painted several times, worked as a guide, a camp cook and a trapper, still riding as much as forty miles a day on horseback when he was in his seventies. As a younger man he had also been a coal miner and later a deputy sheriff. Despite having lived what most people would regard as an adventuresome life, he always wished he had been born a century earlier so he could have been one of the original mountain men.

HUNTING CAMP WRANGLER

Jesse Ballantyne is a Canadian cowboy who has lived in the United States for some years. Young artist Carrie
Fogwell used to call Bama's attention to potential models for his paintings. When she introduced him to Ballantyne,
Bama told her, "That's the one you should marry." And she did. She is now a ranch wife on the Padlock
Ranch at Ranchester, Wyoming, and has two children. Besides working with horses and cattle, Ballantyne
performs for ranch guests, playing guitar and singing Western songs, some of them his own.
He is pictured here in a working outfit as he came down from a remote horse camp.
The pistol on his hip was carried to frighten marauding bears away from the horses.

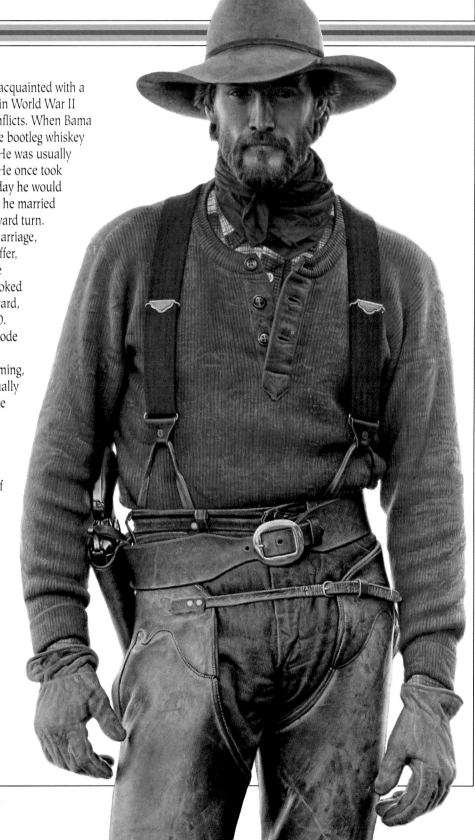

Early in his Wyoming days Bama became acquainted with a rugged-looking cowboy type who had fought in World War II and Korea, earning Purple Hearts in both conflicts. When Bama first knew him, he was a prospector and made bootleg whiskey on the side, at least enough for his own use. He was usually broke but never seemed concerned about it. He once took Bama out panning for gold, certain that one day he would find his gold lode and his fortune. Eventually he married a rich woman, giving his lifestyle a sharp upward turn. Personality differences finally broke up the marriage, however. He refused a $200,000 settlement offer, seeking more. After the case went to court, he wound up with only a secondhand Jeep. It looked as if fortune had deserted him. Shortly afterward, a wealthy relative died and left him $400,000. Even so, he was still looking for that mother lode of gold when he died.

Sadly, during his twenty-five years in Wyoming, Bama has seen the number of cowboys gradually reduced as old traditional working ranches are bought up by conglomerates for purposes, usually recreational, that may not always reflect traditional realities of the working West. The pensive mood in so many of the cowboys he has painted reflects their sense of displacement, a realization that their way of life is slowly diminishing and that tomorrow will be much different than yesterday.

He finds that one feature of the real West has not changed: its easy informality. "Here I have a sense of community which never existed in New York. I never knew anyone there beyond my own block and the people I worked with. Out here the people who wait on you in a store are likely to be your neighbors. I know my mayor, my governor, my congressman, my two senators." They are all part of today's working West.

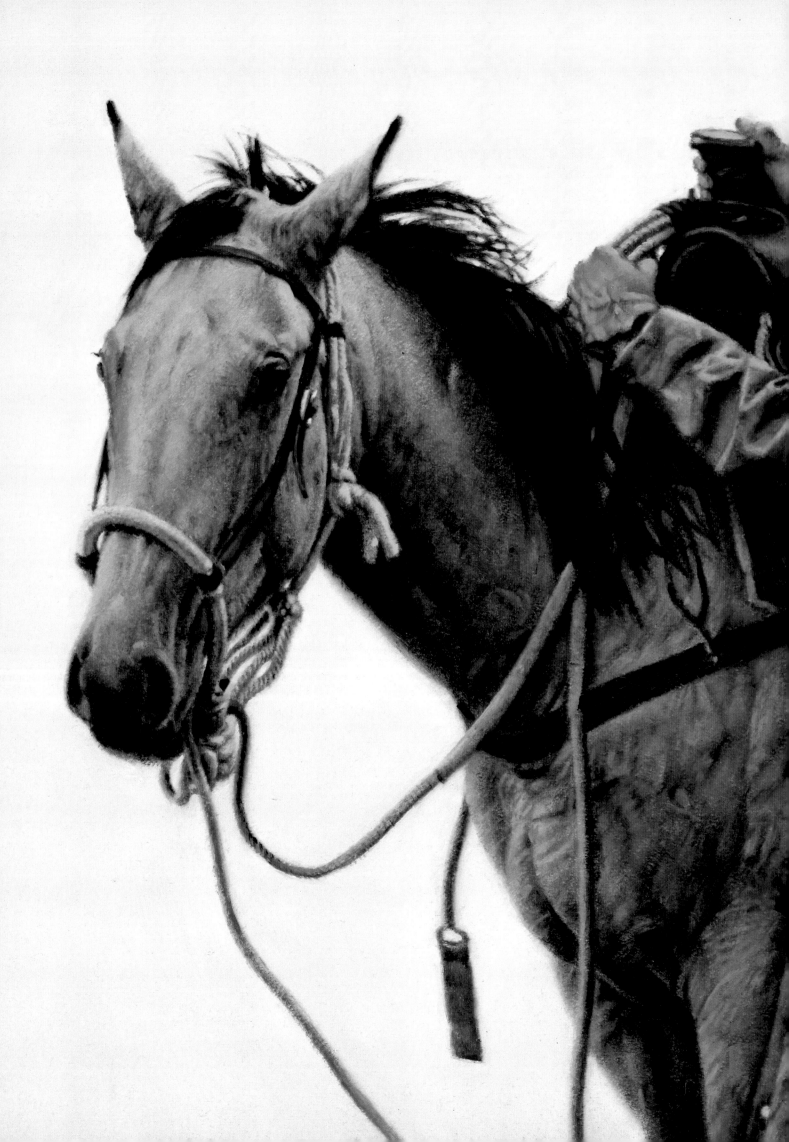

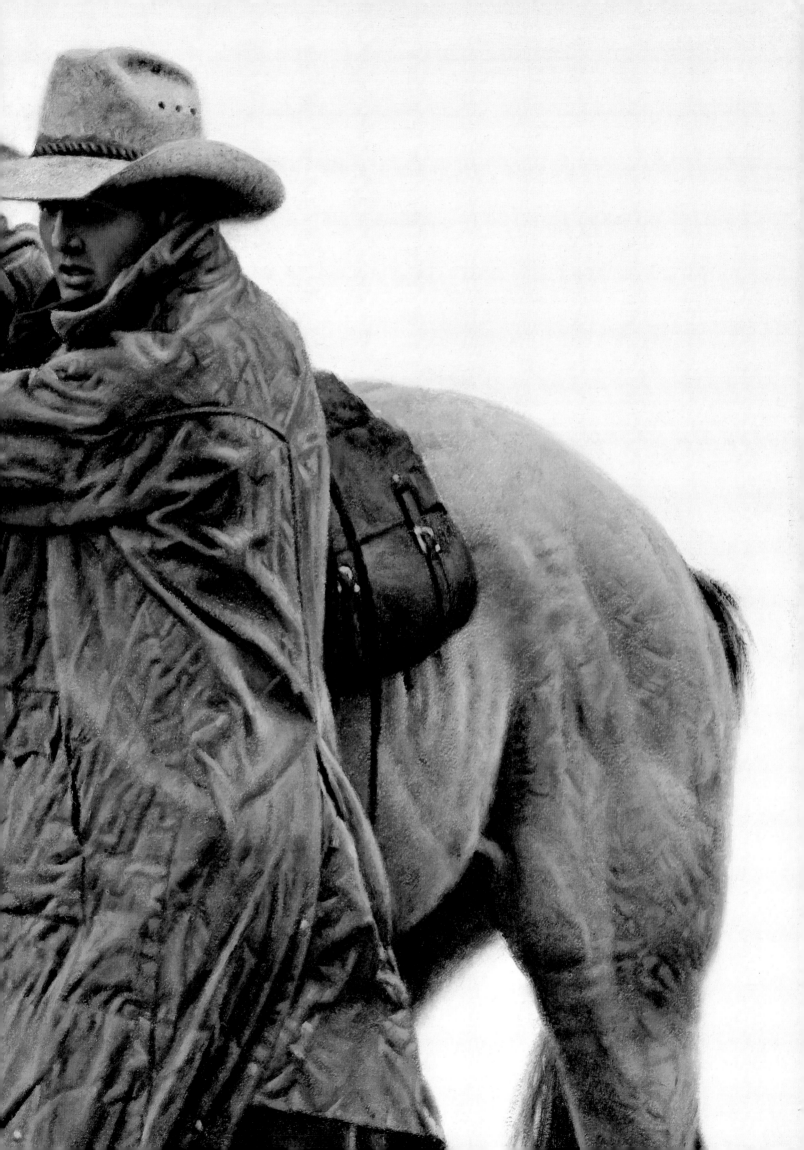

BITTIN' UP, RIMROCK RANCH

LEE MARTIN, STANDING STAR RANCH

◄ **B**ama was scouting the Rimrock Ranch for potential cowboy models when Greg Laughen rode in from a pack trip to prepare for his return to college. He was training a young buckskin to accept the bit in its mouth but still retained the hackamore with which the bronc received its first lessons in responding to the rein. The horse has what cowboys would term "a watermelon under the saddle," an arch in its back indicating that it is still not at peace with the whole idea and may start pitching when the rider steps aboard. The uneasy position of its ears is a further indication of potential trouble. Rodeo bronc riders get to quit after eight seconds, but under working-ranch conditions Laughen will have to stay in the saddle—or attempt to—until the horse gets tired of trying to put him on the ground. Bama particularly likes painting the colors of buckskins and Appaloosas.

Lee Martin, originally from Florida, dresses in today's buckaroo style, including duster, leather vest, bright-colored shirt and a pair of short chink chaps which barely reach the knee. The horn of his saddle is heavily wrapped, one mark of a "dally" roper who makes his catch, then quickly twists the rope around the horn a time or two rather than have it tied hard and fast to the saddle. In event of trouble he has only to let go of the rope to free himself from the animal at the other end of it. On the other hand, the dally method sometimes takes a toll on fingers and thumbs, caught between the rope and the horn. This painting illustrates Bama's meticulous attention to detail: the grain in the wood, the teeth in the zipper, the strands in the coiled rope, even stitches in the leather. This painting was chosen for the cover of his 1985 show catalog.

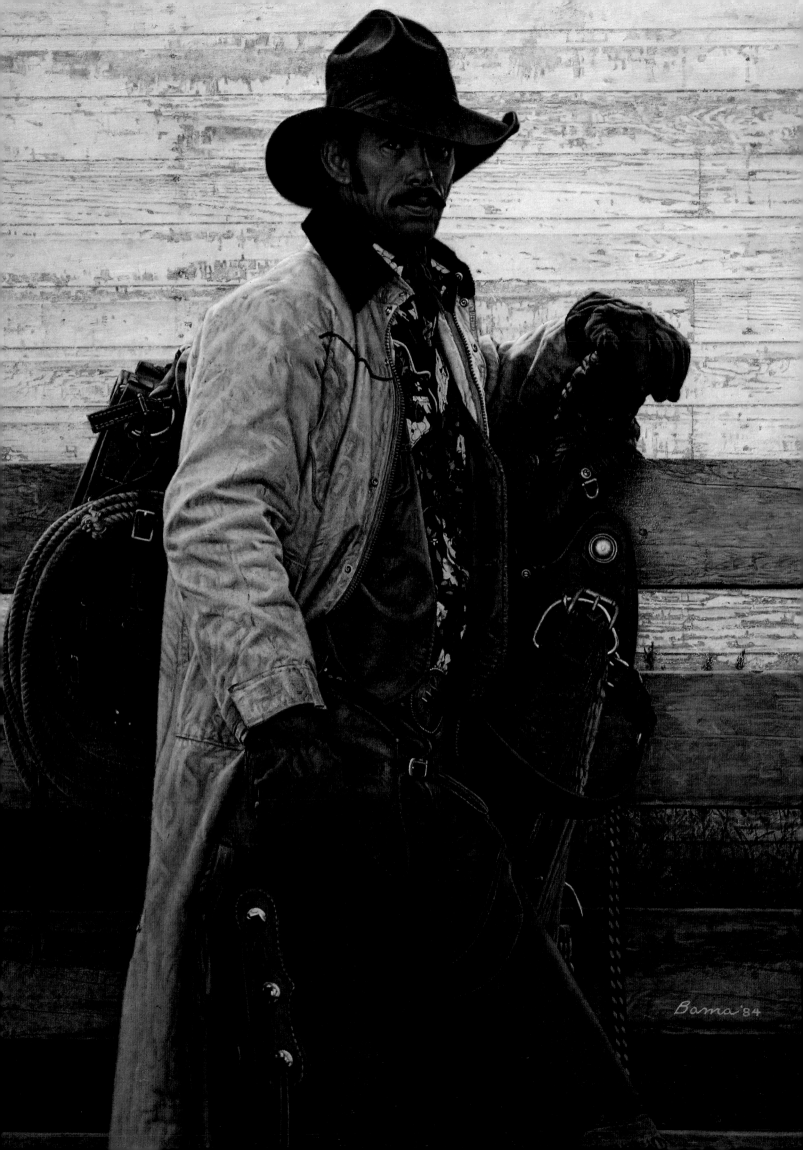

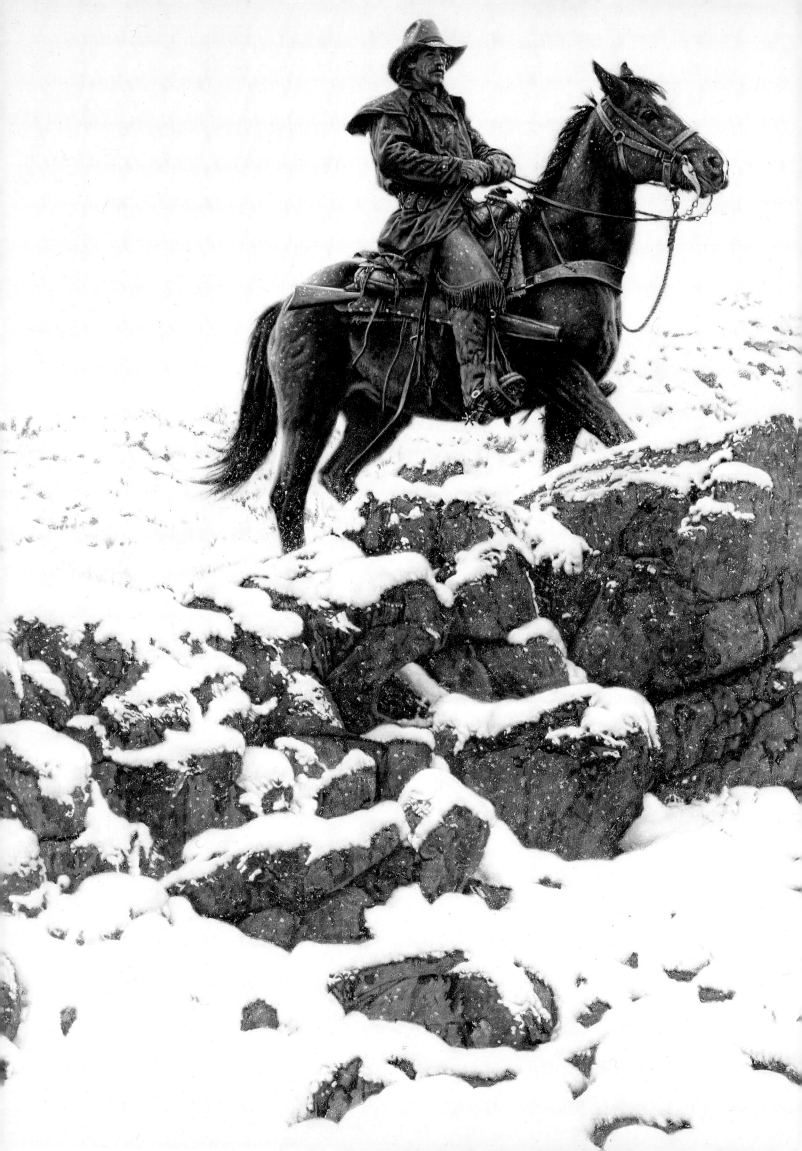

RIDING THE HIGH COUNTRY

*J*im Williams was a frustrated modern-day mountain man when Bama first met him. He was living in a cave, trapping during the winter, then built a log shelter with a bathtub outside. Bama says, "He's trying to find a girl who would like to live the way he lives. I hope he does someday, for he is a fine fellow." Bama borrowed a horse from neighbor Gary Fales to place Williams in the role of a modern-day cowboy working his way through winter snow to a camp in the high country. He carries a rifle in a scabbard beneath his leg and wears knee-length chinks of a buckaroo style rather than the longer and more traditional batwing or shotgun chaps.

RICKY MORRIS, A BUCKAROO

*R*icky Morris personifies today's buckaroo. The word *buckaroo* is an Americanized version of the Spanish *vaquero*, which literally means *one who works with cows*. But Bama found that the modern buckaroo of the Rocky Mountain states effects a look not necessarily the same as that of cowboys in the Southwest. It amounts almost to a uniform, and those devoted to the style are precise about what they wear, making certain that each component fits with the others, starting in Morris' case with a big black hat that has a flat, broad brim and a "stampede" string hanging loosely beneath the chin to prevent the hat from being lost in a high wind or a hard run. A bright neckerchief contrasts with the dark sheepskin-lined coat, which covers the suspenders that are a mark of most modern buckaroos. Morris grew up helping work his father's cattle near American Falls, Idaho. Bama found him on the Pitchfork Ranch at Meeteetse, Wyoming. The buckaroo look is a far cry from the urban cowboy get-up of a few years ago, which Morris found objectionable. He declared that people who know cowboys can tell a real one from the imitation almost at a glance. It is not just the clothes: it is an attitude, something in the weather-punished face and the way a man of the saddle carries himself that sets him apart.

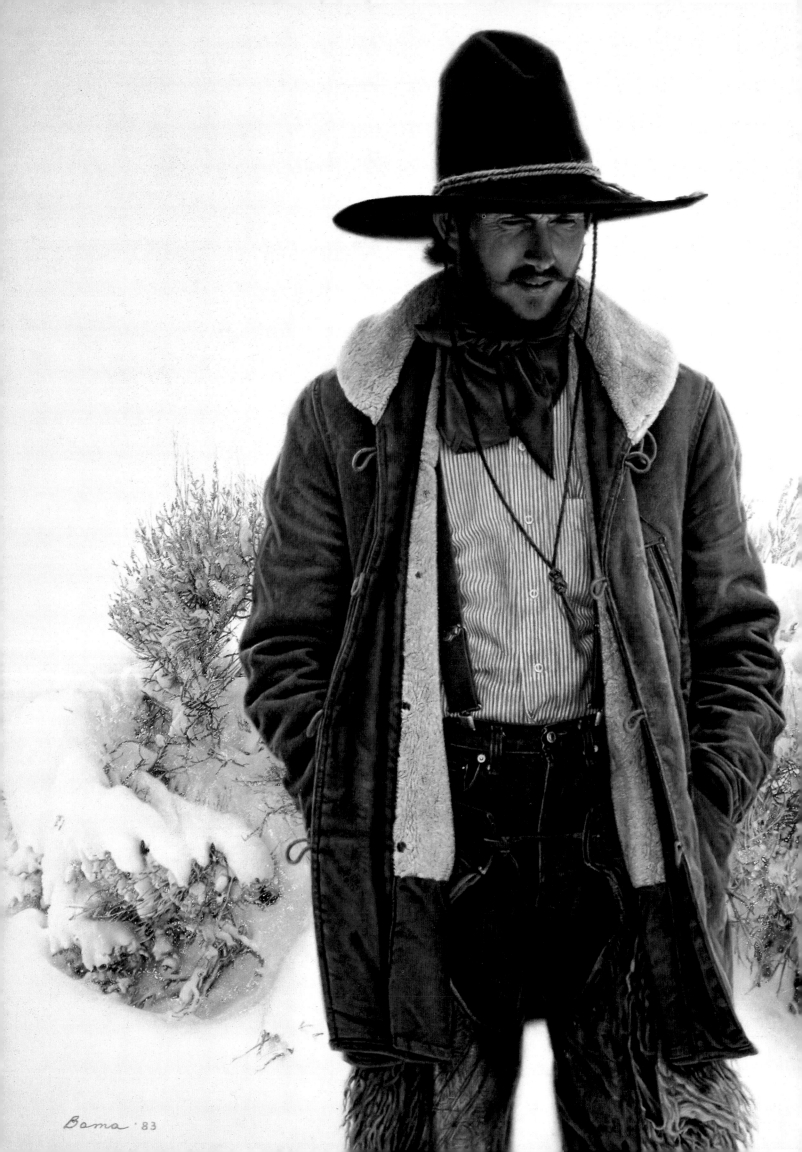

OLD SADDLE IN SNOW

*F*ascinated by old saddles because of stories they conjured up in his imagination, Bama acquired this one and set it out in the snow, hoping to achieve the proper artistic effect. One night when the temperature was minus 20 degrees, a light dusting of snow fell just right. In early times, cowboys would spend several months' wages to own a fine saddle made by Hermann Heiser of Denver, George Lawrence of Portland, Frank Meanea of Cheyenne, Sam Myres of Sweetwater and El Paso, Newton Porter of Phoenix or R. J. Andrew of San Angelo.

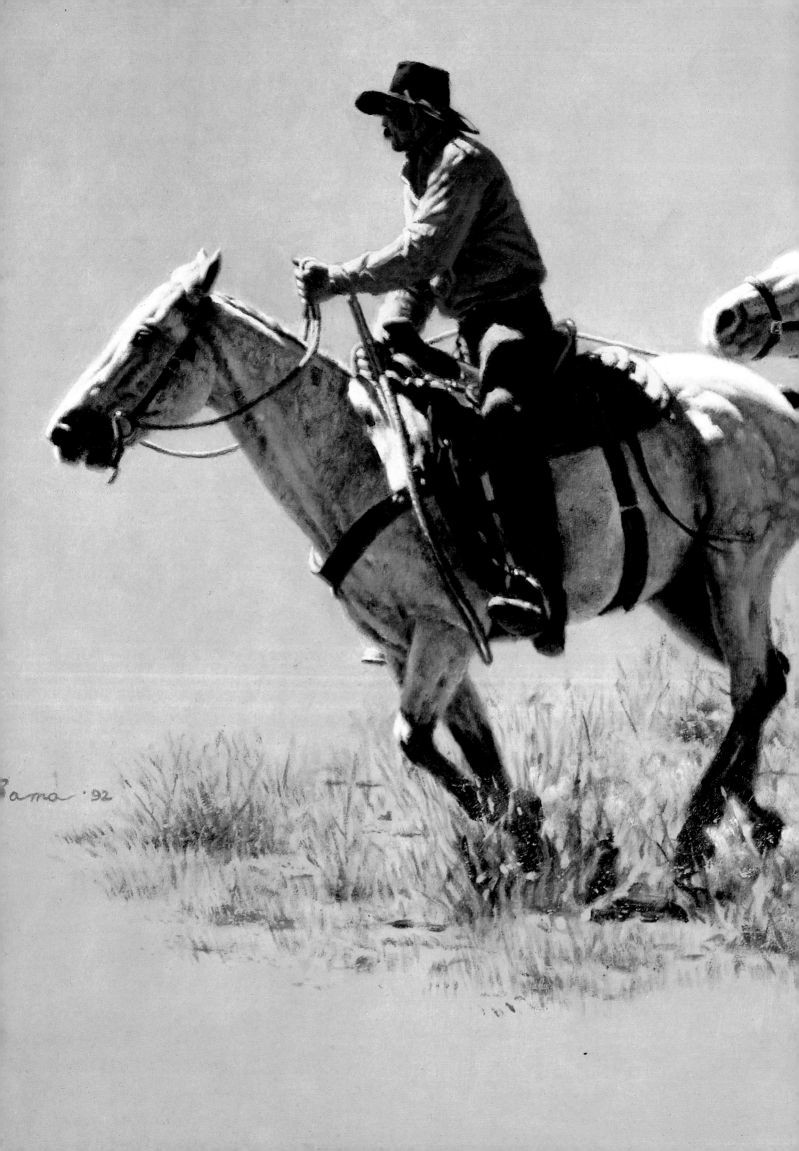

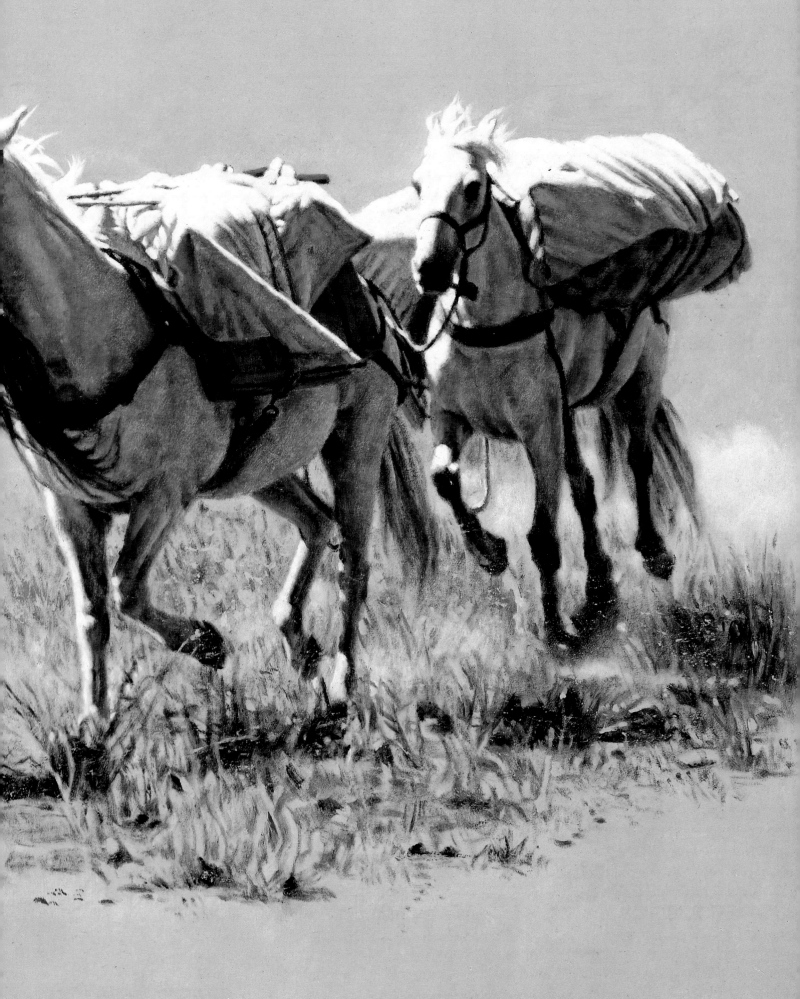

RIDING IN NOVEMBER

J oe Cole, a gun and saddle trader, called neighbor Bama one fall day to ask if he would like to photograph him and friend Wayne Ringler dressed in 1920's cowboy style. Cole wears a pinched-crown hat typical of that period. Both men sport leather cuffs, rarely seen since the early 1930's. Ringler is decked out in vest, shotgun chaps and a black hat. He has four sons, all of whom wear black hats, making it easy to pick them out of the crowd when they are in town together. The grass is autumn-cured and waiting to be covered by winter's snow. Today, many men brought up as cowboys move into less strenuous and better-paying urban occupations but still pitch in to help nearby ranches on weekends or days off. Because of the high cost of employing large numbers of hands fulltime, ranches today often depend upon weekend cowboys for much of their special work such as branding or moving livestock to and from summer ranges.

COMIN' ROUND THE BEND

◄ C ody, Wyoming, has a Frontier Festival every June, featuring dancing, old crafts, weaving, quilting, saddlemaking, Indian beadwork, buckskin mountain men and a camp cookout. An action highlight is the packhorse race, to which ranchers and professional outfitters bring teams. Contestants must spread all their equipment on the ground. At a signal they must pack it up and tie it onto their packhorses, then run them full tilt to the end of the contest field and back, hoping to finish in the shortest time. Here the rider leads his two packhorses into the far-end turn before starting the dash to the finish line. This is an all-white-horse outfit.

[116]

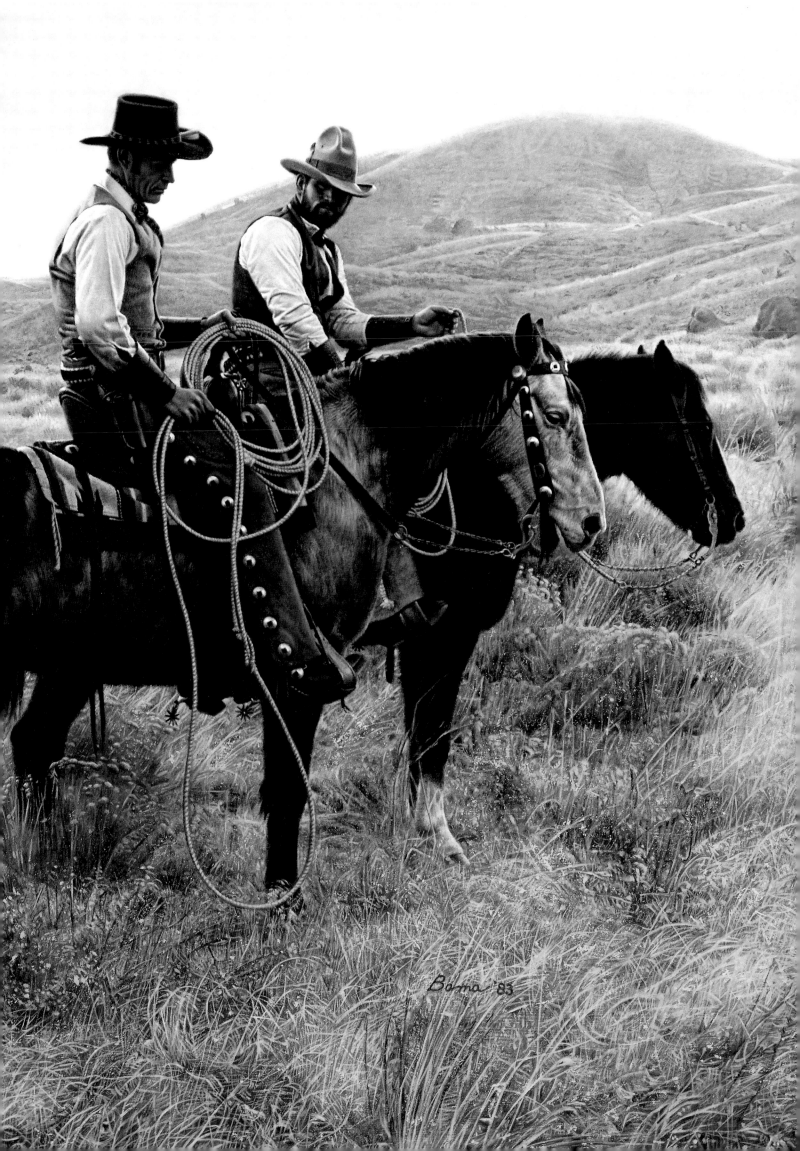

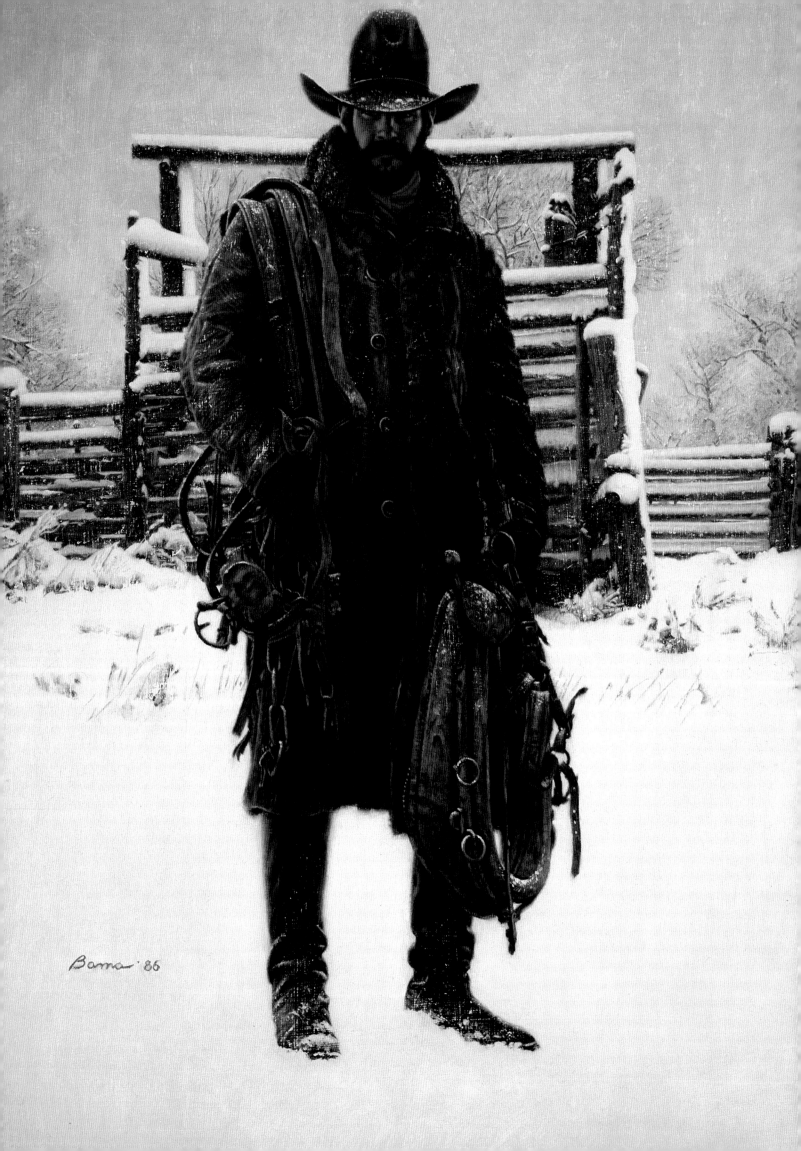

THE TEAMSTER

◄ **B**ecause many cowboys live a transient life, they sometimes cross Bama's trail once or twice, then he never sees them again. Steve Winters showed up in Cody a few years ago with nothing except the clothes on his back. He said he was an "army brat" looking for a cowboy job. Unfortunately it was the wrong season of the year for ranch employment, even for a strong man who stood about six-four and weighed perhaps 240 pounds. He posed for Bama in the guise of a teamster, holding horse collar and harness from Bama's own collection. Shortly afterward he drifted away, and Bama has no idea where he eventually settled. It is something of a joke in Cody that guest ranches support the cowboys in the summer and Bama supports them in the winter.

Midwesterner Dale Foors moved to Cody intending to become a cowboy. Here he takes on the guise of a teamster, wearing an old fur coat from Bama's collection. A lot of people drift across the Western ranching country, inspired by its legends and hoping to live out a fantasy of becoming cowboys. Only a small percentage stay the course. The cowboy life offers far more of hard work than of romance, and it demands skills not quickly or easily acquired. Most of the best cowboys are born into the occupation, growing up on ranches and learning at an early age how to ride and rope, how to read horses and cattle and anticipate their moves before they make them. Real cowboys are far fewer today than in the past, but so long as there are cattle there will have to be men who know how to handle them.

[119]

DEDE FALES, CAMP COOK

CHUCKWAGON

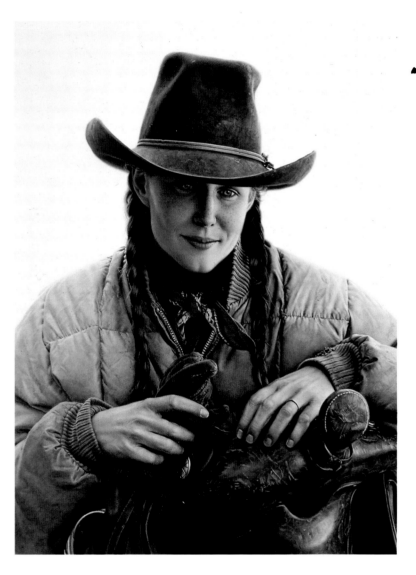

*J*erry Kinkade is a Culligan man by occupation, selling water in Cody, but he is a cowboy and wagonmaster by choice and by upbringing. His father, the late Harley Kinkade, was a rancher and longtime sheriff of Park County, Wyoming. "If anyone was ever his father's son, Jerry is," Bama says. "He has the same sense of humor, the same love for horses, wagons and the Western lifestyle." This painting came out of a day Bama spent photographing Western scenes for a friend's calendar business.

*D*aughter of a Baltimore stockbroker, Dede Fales came to Wyoming to see the West and worked on a guest ranch near Cody before marrying cowboy Gary Fales. Now raising four daughters, she has served as camp cook for an outfitting business operated by her husband's family on the Rimrock guest ranch about seven miles from Bama's home. Noted artist Frank Tenney Johnson used to spend summers on the place before it began catering to guests. Bama has found several of the ranch's cowboys to be good models for his paintings because the ranch management likes them to keep a Western look that pleases tourists. The ranch organizes pack trips and hunting parties in spring and fall. This painting has been highly popular, reproduced in several magazines along with articles about Bama and his work.

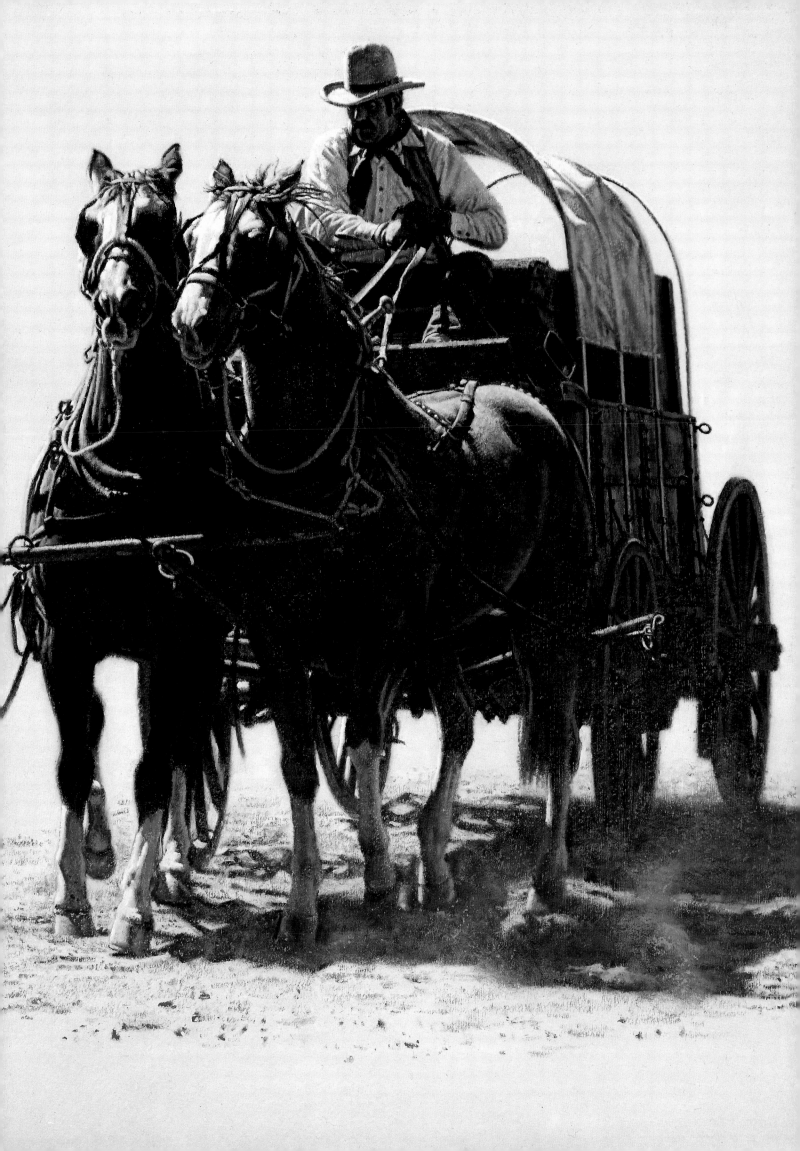

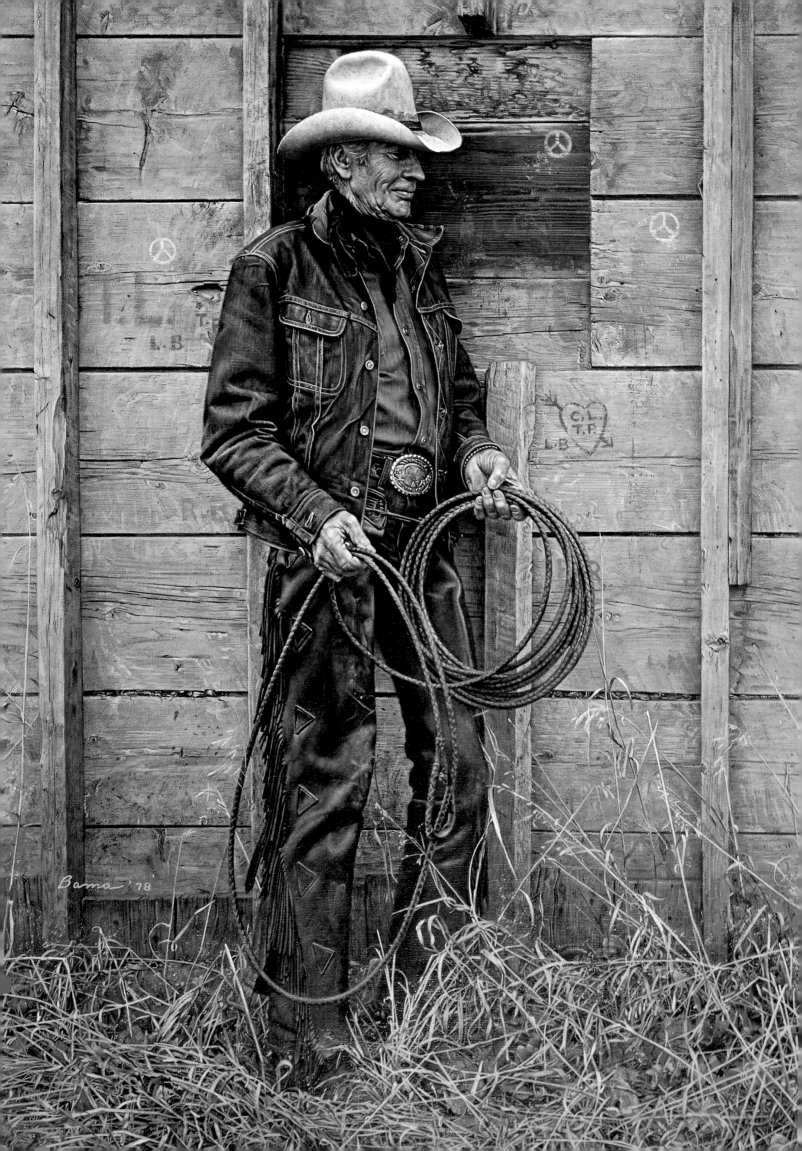

SLIM WARREN, THE OLD COWBOY

Slim Warren was among the retired cowboys who killed their long hours and long days on the street corners of Cody, too old and stove-up to do serious ranch work anymore. He was a product of an earlier time, his heyday long behind him and the conservative views of his age group now under widespread attack. To dramatize the generational divisions of the time, Bama painted him in the Vietnam-era context, exemplified by peace symbols painted amid other grafitti on the wooden shed behind him. Because he regards Warren as having been a classic example of the old cowboy, Bama has painted him nine times. Warren felt out of place and lonely, like most aging cowboys who find themselves unhorsed in their final years and confined to the limits of a town instead of enjoying the fresh air and freedom of the ranches where they had spent the best years of their lives. He was grateful to anyone who would tarry awhile and listen to him tell about earlier times when the range seemed always green, the horses always fat and ready to give a rider a challenge. *(Smaller portrait— SLIM LIGHTING UP)*

CHUCKWAGON IN SNOW

During the more than two years Bama lived on the Bob Meyers ranch west of Cody, he always found magic in the snow and its softening effect upon whatever it touched. Invented in the 1860's by Texas cattleman Charles Goodnight, the chuckwagon served as home base for cowboys on cattle drives or on roundups. It is seldom used in its native state any more except on a few large ranches, but it remains popular in open-range states of the far West where distances are great and it is impractical for cowboys to return to the comfort of a ranch house every night.

[123]

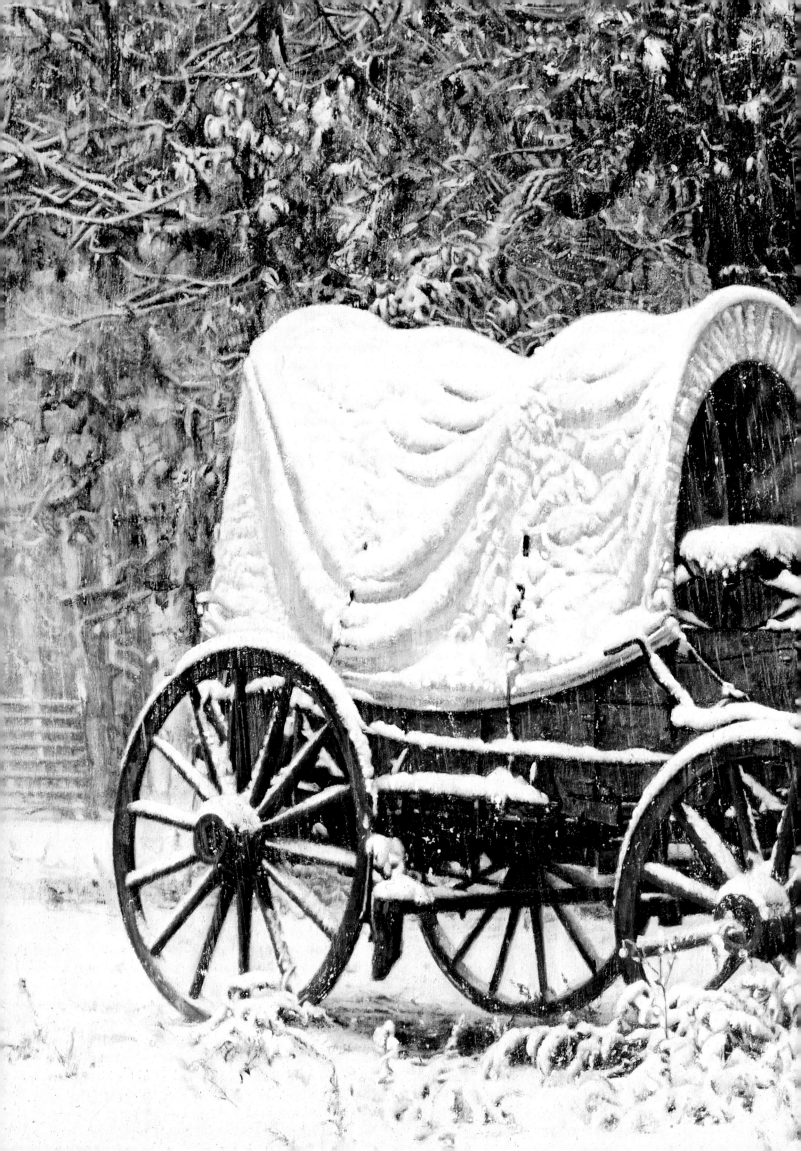

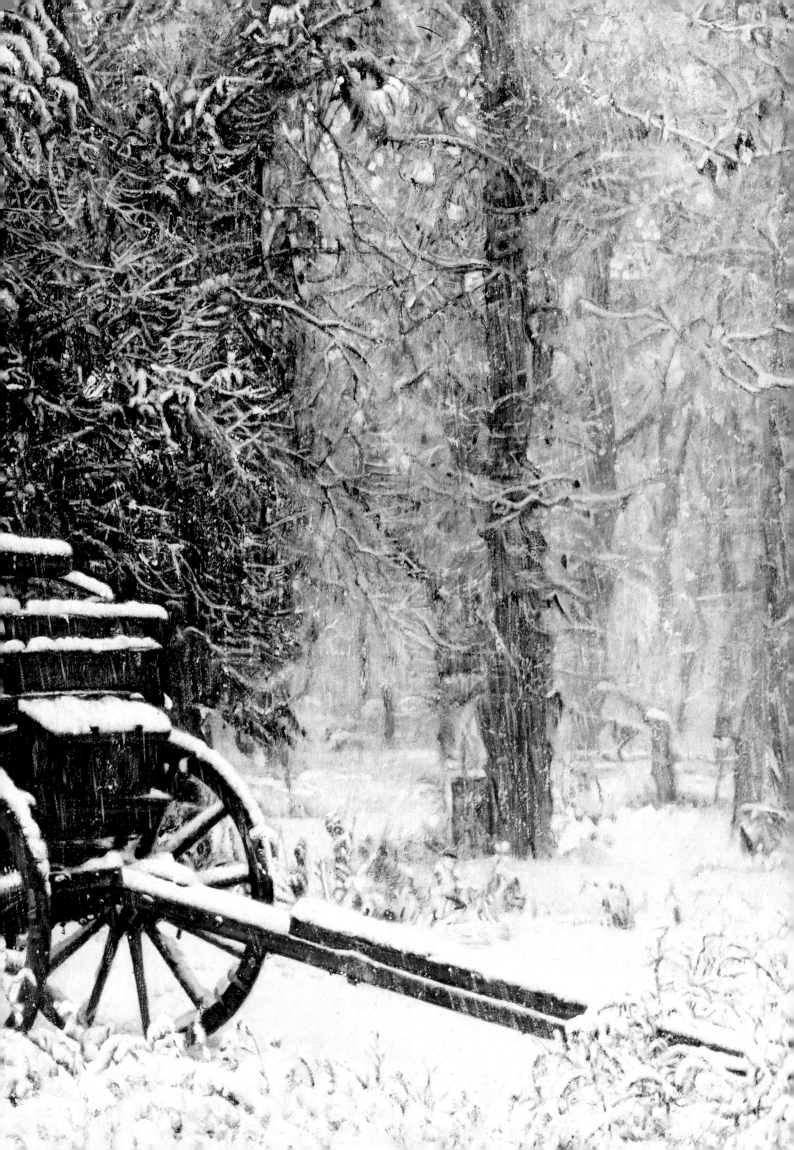

YOUNG SHEEPHERDER

*L*ynne Bama was taking photographs in the Oregon Basin near Cody when she came across two old-fashioned sheepherder wagons in the snow. They belonged to the Sleeper Ranch, owned by Hunt Oil Company. Her artist husband had heard many stories about old sheepherders with long beards, so he went out hoping to find one he could paint. Instead, he came across college student Duke Early, who was filling in for one of the regular sheepherders during the Christmas–New Year holidays. Bama felt sorry for him in his isolation and took him some oatmeal cookies to ease the monotony of meager camp fare. Not until afterward did he find out that Early's mother was carrying hot food to him twice a day. The incident became a running joke for years between Bama and Early. Afterward, every time Early visited Bama, he took *him* cookies. Early now works as a game warden at Pinedale, Wyoming, and is married with two children. Life in a sheep wagon was not quite as Spartan as it appeared. The wagons were well designed to take fullest advantage of their limited space. And the butane tank standing beside this one bespeaks an element of modern luxury.

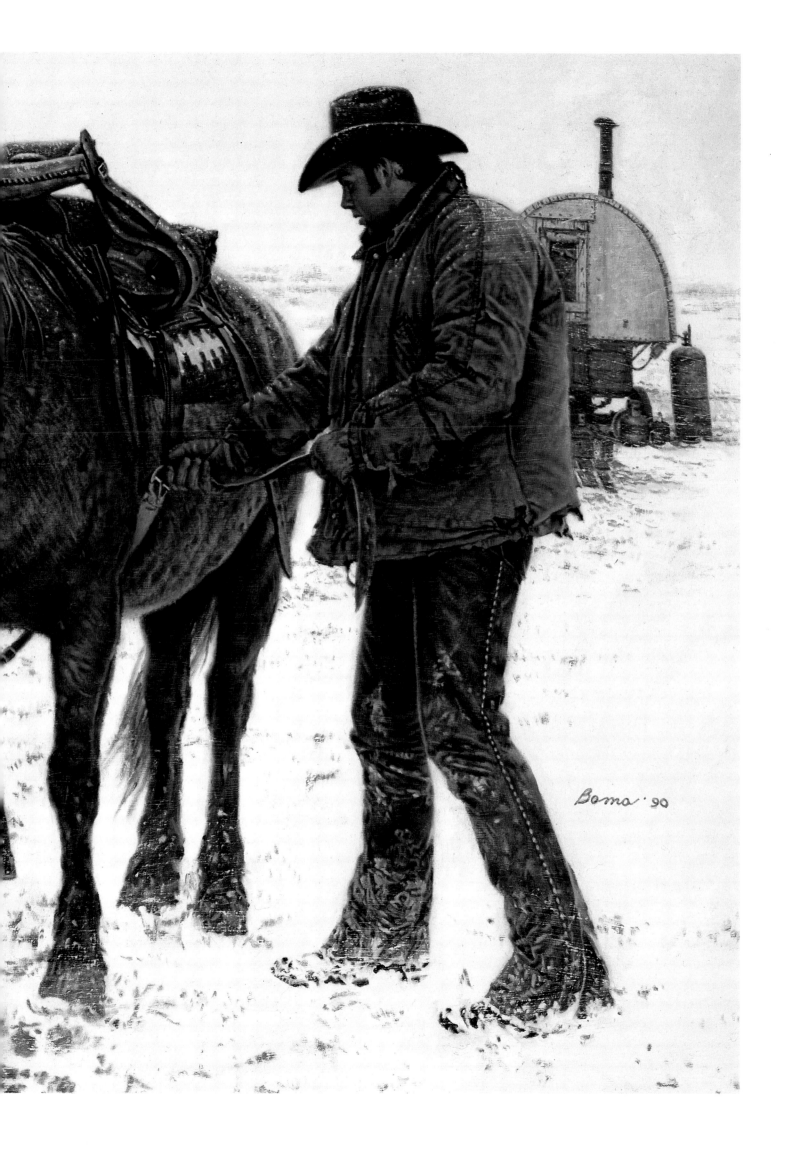

BERNIE BLACKSTONE'S OLD SADDLE

BUCK NORRIS, CROSSED SABERS RANCH

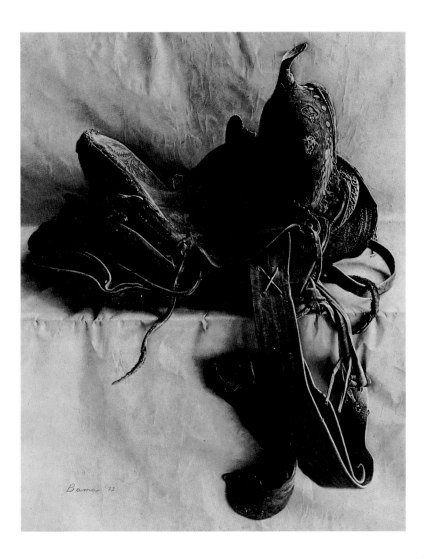

Buck Norris works with his parents, who own the oldest ranch on the North Fork of the Shoshone River west of Cody. Besides being a cowboy, he is a trapper and likes to dress in buckskins for mountain-man rendezvous celebrations. This is one of Bama's more popular prints and brought letters from several women inquiring about Norris' marital status. Here he stands in the snow, carrying saddle, bridle and rope. If suffering is necessary for good art, Bama paid for this painting. On the way to the ranch he stuck his car in a snowdrift that was up to his hips and walked the rest of the way through deep snow. A snow plow had to be brought to free the vehicle.

If old saddles could talk, many a story they could tell of wild chases, hard falls, dangerous contests between man and beast. Bama was fascinated by such relics of the Western past, so when he was told that the late Bernie Blackstone's eighty-year-old saddle had been offered for sale to a saddleshop in Cody, he jumped at the chance to buy it. It had been built before the turn of the century on a high-cantle tree that went out of style decades ago. And though it was in terribly worn condition, Bama was glad to be able to preserve it. He feels that every old saddle has a story and a life of its own, like the person or persons who rode it. The saddle now is fully a hundred years old.

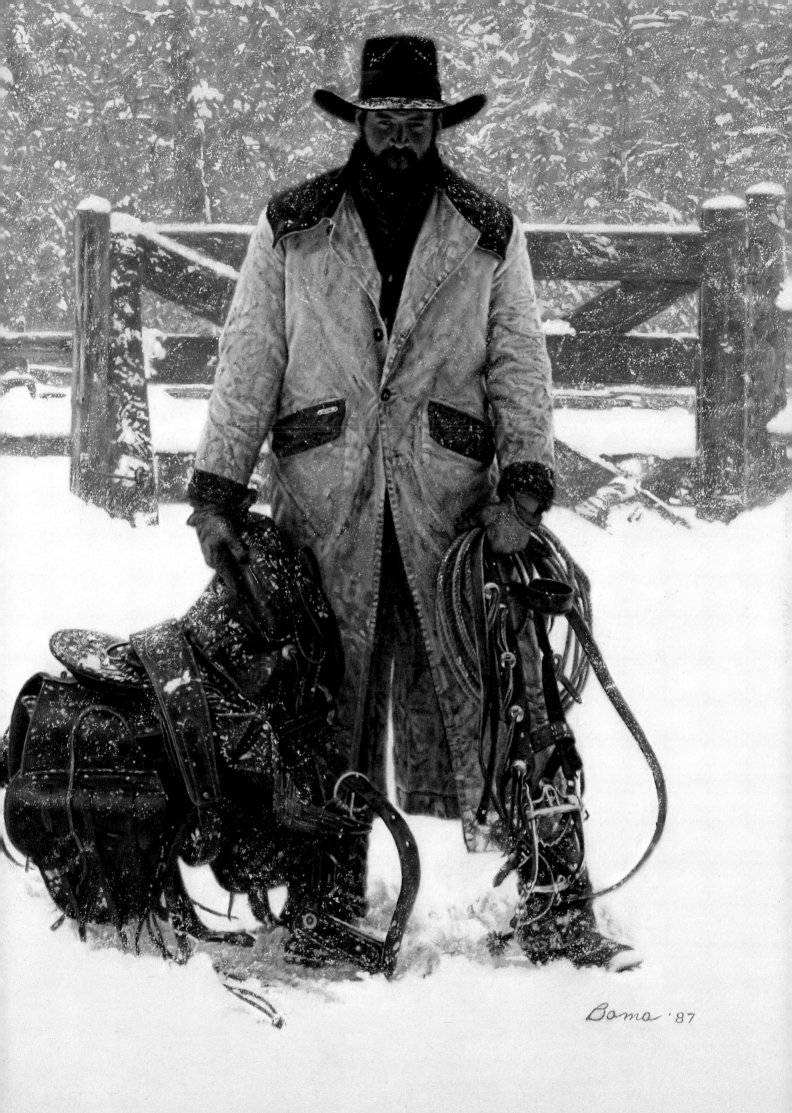

Bama '87

INDIAN RODEO PERFORMER—Vicki Adams, Navajo Trick Rider
DON WALKER, BAREBACK RIDER—Old Tradition, Modern Look
ARAPAHO INDIAN DANCER—Performer at Cody Powwow
NORTHERN CHEYENNE WOLF SCOUT—Mike Terry, Indian Reenactor

RODEOS

AND POWWOWS

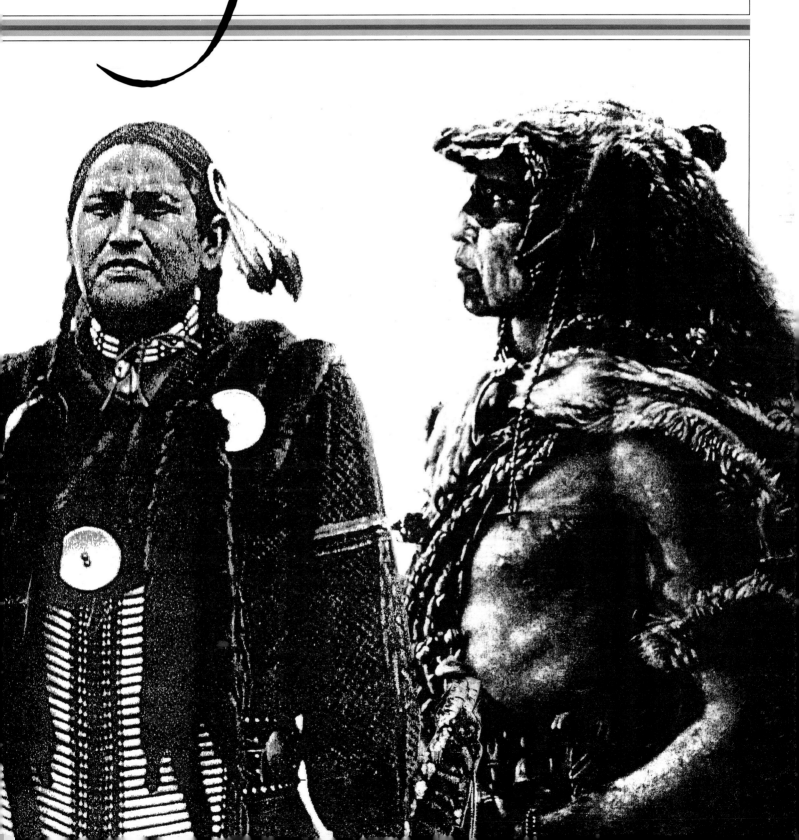

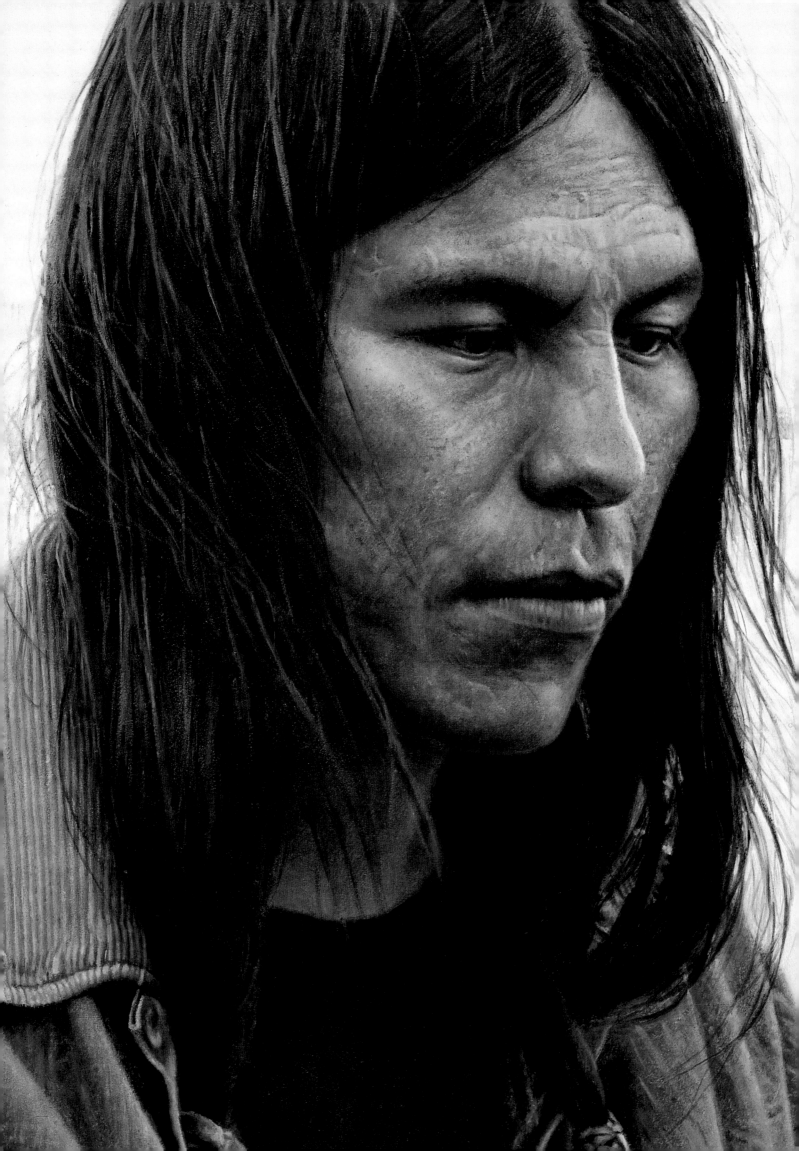

RODEOS AND POWWOWS

As an artist, James Bama is always aware of the conflict between pure art and the influences of the marketplace. On the one hand the artist likes to paint what pleases him. On the other he finds it difficult to ignore the buying public's preferences.

Soon after his move to Cody, a gallery owner told him about the pecking order for Western art. "He said an old cowboy will sell for more than a young cowboy. A young cowboy in an old hat and a bright kerchief will bring more than a cowboy in new clothes. A guy with a beard will bring more than one without a beard. A mountain man in period dress will sell for more than a cowboy. An Indian will sell for more than a mountain man, a brave will sell for more than a squaw, and a chief in headdress will sell for more than anybody."

Bama, of course, has painted them all, without regard to the variable market. He paints whatever excites his imagination and stirs his creative energies.

For bright color, he has turned often to the rodeo and the Indian powwow, for they shine with it.

Rodeo came as a surprise to him. He had lived in Wyoming about two years before he attended one, and he did so then only because a visiting friend from the East wanted to see it. What he found excited him far more than he expected: the colors, the sport, the danger. Rodeo is more than simply an attempt to reenact the old West; it is a creation all its own.

"Three of my passions have always been sports, show business and the circus," he declares, "and rodeo is all three. It has a tremendous amount of danger as well as sport and entertainment. It gave me a chance, as a painter, to use bright colors for a change instead of the muted browns which I found in most working cowboys. So I hung around the chutes and got to know the performers. They are very contemporary, and any color goes: red, green, purple, orange, blue."

For years he went to every nearby high school, college and professional rodeo, searching out potential subjects to make his statements about today's West. He met many champion riders and ropers. Yet, never has he painted a cowboy on a bucking horse, nor does he paint ropers chasing a calf. He likes to paint the people, not the action. His first rodeo painting was of a bronc rider holding his rigging. Bama saw him like a modern-day knight holding his helmet.

"These are brave, rough, tough guys, always on the road, doing what they want to do. Very few of them make any real money, but they all have to make their try."

Because of a boyhood love for the circus, he was particularly attracted to the rodeo clowns. He found them reminiscent of those in the circus, yet they go several bold steps farther. Each time a rodeo clown puts on his greasepaint, he knows he must walk out into the arena and pit life and limb against hoofs and horns to protect the downed bull riders. Behind the facade of the funny face is a sobering reality.

Similarly, the rodeo cowboy knows he faces risks that belie the surface glamour of the sport. Bronc and bull riders are particularly vulnerable, and ropers are subject to severe injury if a running horse falls or they become entangled in a lariat. It is little wonder that they may appear pensive behind the chutes, beyond the view of the crowd. Bama has often captured that solemn mood.

Rodeo is the only major sport that has grown out of an occupation, and in which practitioners of that occupation do for competition and entertainment the same things they do in their workaday lives. Several Western towns lay claim to the honor of hosting the first rodeo. Probably the foremost competitors for this honor are Pecos, Texas, and Prescott, Arizona. In an earlier time virtually all the contestants were working cowboys. In the Pecos rodeo of 1883, for example, several ranches along the Pecos River placed bets about which had the most able cowboys, and they played out the contest on the town's main street.

The Wild West shows of Buffalo Bill, Pawnee Bill, the 101 Ranch and others featured cowboys riding and roping, though usually as an exhibition rather than a contest to determine who was fastest or best. Modest units known as "bronc shows" traveled from town to town across the West, playing in places too small to support the large extravaganzas. Rough riders and

[133]

The people who frequent these impromptu contests are the kinds of real Westerners Bama seeks out for his paintings. They are truly the sons and daughters of the pioneers, being themselves in their own natural element.

showmen such as Booger Red Privett and Pecos Pate Boone gained regional reputations without trying to rival Buffalo Bill. They carried with them the rankest broncs they could find, rode them, then challenged local cowboys to try their luck, offering prizes for those who managed to stay aboard.

These shows faded under rising transportation costs, but local rodeos gradually supplanted them, stressing the contest aspect. Some were put together by hometown enthusiasts, others by professional promoters who drove or hauled their rodeo stock from town to town. Only a relative few cowboys in those early days became professional rodeo contestants; the prize money was too small to afford them a living unless they could supplement their winnings by working for the promoter. All too often, cowboys were cheated of their winnings by promoters who pleaded insufficient gate receipts, or even skipped town with the money. This led, in 1936, to a strike by cowboys at the Boston Garden rodeo and organization of the Cowboys Turtle Association, forerunner of the Professional Rodeo Cowboys Association.

*M*any of today's young contestants come up through high school and college rodeo before they hit the professional circuit. Thus, they are likely to be seasoned veterans by their early twenties and by thirty are looking uneasily back over their shoulders at the up-and-coming younger competition.

Close cousin to the rodeo is the weekend country roping, less professional and therefore more accessible to the average working cowboy from the forks of the creek who stands little chance in the big shows such as Denver, Cheyenne or Calgary. There is hardly a location in the West that is not within pickup-driving distance of a country calf roping or team roping on any summer weekend. Urban women who complain about being "football widows" can find counterparts among Western women who are weekend "trailer-hitch widows" from early spring until the snow flies.

The people who frequent these impromptu contests are the kinds of real Westerners Bama seeks out for his paintings. They are truly the sons and daughters of the pioneers, being themselves in their own natural element.

Indian fairs and powwows have much in common with rodeo in that they are highly colorful and have competitive aspects. Indeed, many feature rodeos as part of their program, usually limiting the competition to Indian contestants. They honor the Indian heritage with parades, ceremonial dancing and camping in tepees in the manner of tribal grandfathers and grandmothers.

*Y*et, just as the rodeo cowboy in his bright red or blue shirt and green or purple chaps is a far cry from the working cowboy in faded shirt, patched jeans and run-over boots, the powwow Indian resplendent in blazing color is more spectacular than his ancestors who wore tanned buckskins and wrapped themselves in buffalo robes or trade blankets. He stands in contrast also to the gray reality of reservation life before and after the powwow.

An early eye-opening experience for Bama was his first visit to a Crow Indian Fair, conducted each August just east of Crow Agency, Montana. It began in 1903 for exhibition of agricultural products and livestock from the Crow reservation and has grown into a major intertribal social event, attended by thousands of Indians. Though originated by the Crows, this fair welcomes participation by all tribes in its parades, its dances, its rodeo and horse races, its feasts and sings, and finally its "give-away" ceremony at which gifts are distributed among guests, a custom long practiced among the plains Indians.

Many powwows occur across the West each year, usually on or near a reservation. Some are large and draw visitors from hundreds of miles away. Some are small and primarily local. A powwow has been described as something much more than simply a dance; it has been called "an Indian happening," a group celebration of their heritage.

Powwow participants pride themselves on the finest of regalia, particularly for the dances and parades. Though in ear-

[134]

BAREBACK RIDER

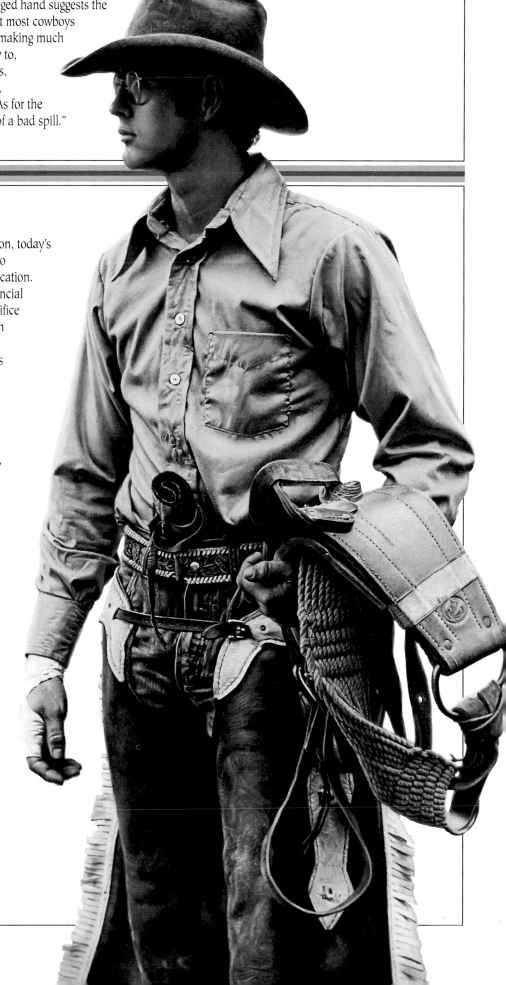

Don Walker was the first rodeo performer Bama ever painted. He depicted him as a modern-day knight, holding his bareback rigging instead of a helmet. The bandaged hand suggests the many hazards of rodeo life, but Bama found that most cowboys have a macho attitude that prevents them from making much of their injuries. They ignore them, or at least try to, performing despite their pain. Of Walker, he says, "He had all the look of the young rodeo cowboy, the hat, the shirt, the decorative leather chaps. As for the bandage, he said it was nothing, just the result of a bad spill."

lier times each tribe's clothing had distinctive elements that marked the wearer's tribal affiliation, today's powwow costumes are tending more and more to take on a generic quality that blurs such identification. Moreover, they often represent a significant financial investment, made at a substantial personal sacrifice to the wearers and their families. But they are, in effect, a statement of pride, a symbolic denial of the poverty and substandard living conditions which are an everyday reality.

In their workaday lives, powwow participants may be checkout clerks in a supermarket or may pump gasoline at a service station. But for a day or a few days they are resplendent in buckskin and beadwork, in bright feathers and blankets more colorful than was known by the ancestors they revere and whose image they set out to recreate.

They are, Bama says, trying to live out a fantasy. "And my fantasy has always been to paint people living out their fantasies."

Several of the younger Indians he has painted in period outfits have carried their reenactment of historic times beyond the powwow to outdoor pageants and to such films as *Walks Far Woman*, *Dances With Wolves* and *The Last of the Mohicans*. They honor their ancestors before a broader international audience.

In a sense, both the rodeo cowboy and the powwow Indian are engaged more in show business than in an accurate reenactment of their history. But that is probably right and proper. They are of *today*, not of yesterday. It is today that interests James Bama most.

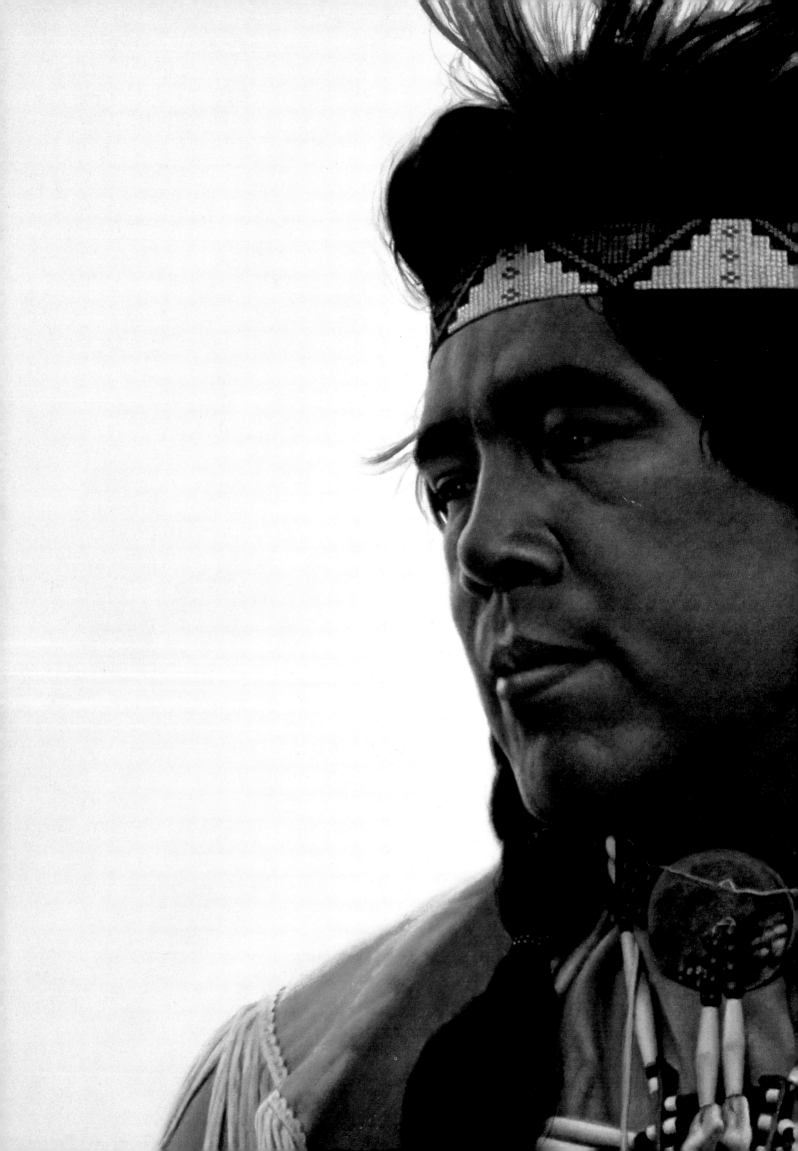

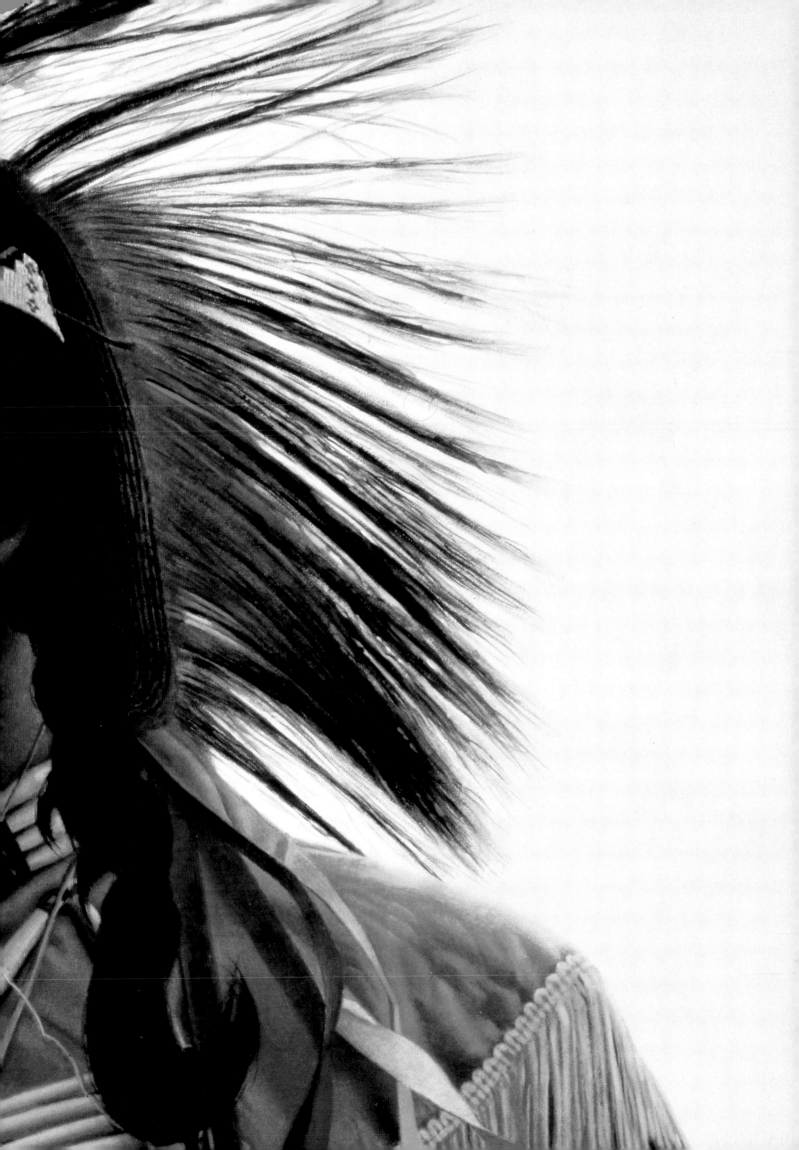

CROW INDIAN DANCER

SIOUX SUBCHIEF

◀ **W**alter Eugene Old Elk manages to bridge two separate cultures, the Indian heritage of his Crow people and today's modern white-man world in which he lives. He is a grandson of Curly, the famous Crow scout of Custer's 7th Cavalry. Old Elk, who stands a tall six-four, performs in Indian powwow ceremonies and dances wearing a brightly colored outfit including breastplate, bone necklace, braids and a roach. He participates in an outreach program, taking troubled children on wagon-train rides to give them a taste of country life and a glimpse of old traditions. Bama photographed him at a Crow Fair. The following year, after the painting and print were done, he went to the next Crow Fair. He found Old Elk coming in with an outreach wagon and a load of children. Old Elk was very pleased when Bama handed him a copy of the print. The artist comments, "The guy was so big and tough looking that I was almost afraid to take his picture, but he turned out to be real nice." He met four of Curly's grandsons, all of them large, all looking like pro football players. Curly happened not to be with Yellowhair's command at the hour the Sioux enveloped it. After watching the slaughter from a distant hill, the seventeen-year-old scout wisely retreated, finding the steamboat *Far West* and delivering the first word of Custer's fate to the outside world.

Meeting Mike Terry was a rare opportunity for Bama, because Terry is a leading authority on the plains Indian, his customs, his equipment and his dress. Terry, part Seminole, was lecturing at a seminar and had just completed constructing this splendid Sioux Wichasa headdress with buffalo horns, a type worn by a subchief. It lacks the feathers on top that would denote a full chief. Terry explained the significance of his paint markings: the red circles on the chest represent the power of the sun to heal wounds left by participation in the grueling sun dance; lightning bolts dart from the eyes to represent courage and fierceness. The war shield's decorations, symbols and colors are drawn from the owner's vision of a personal guardian spirit. The lance is ceremonially wrapped in otter skin. "Mike is very dramatic in his presentations," Bama says. "He does not like people to watch him make up. He likes to come out with a flair and shock everybody with his wonderful outfits. He is a real showman." He is also a valued custodian of the plains Indian culture.

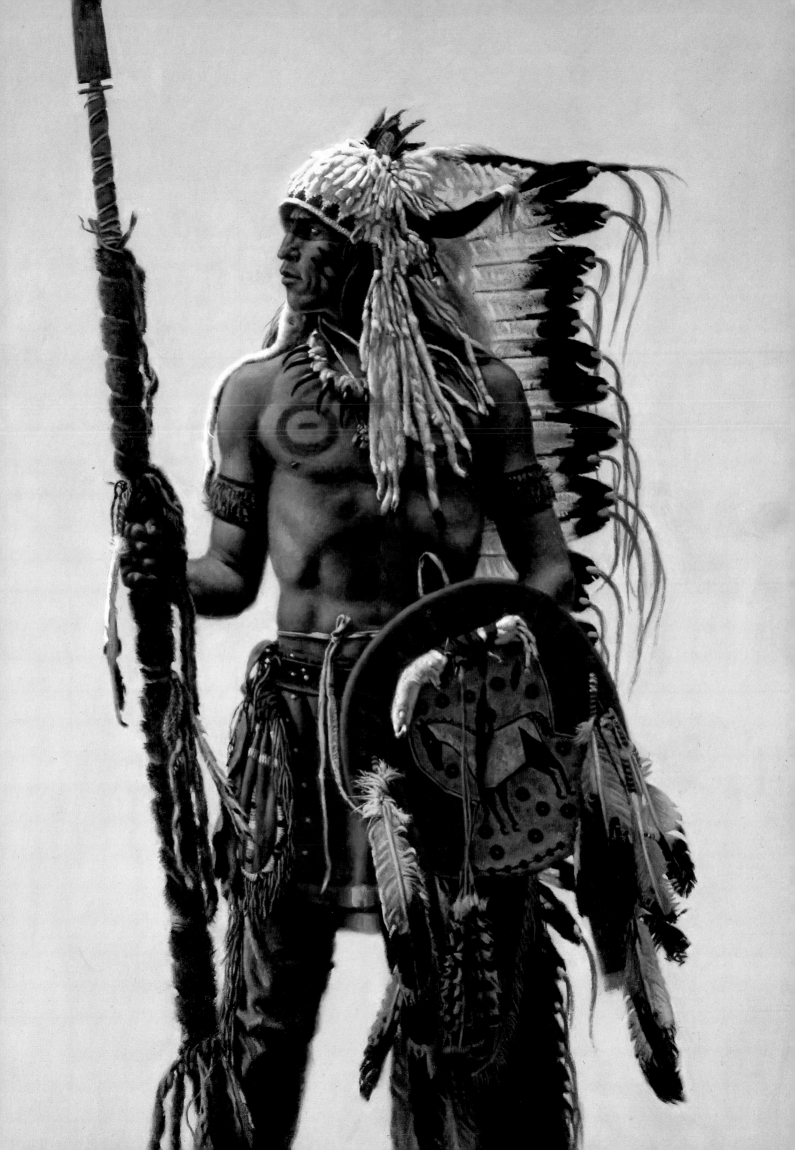

FRED GARLOW-
BUFFALO BILL

BUFFALO BILL
WILD WEST SHOW

Charlie Evans, a rancher from North Platte, Nebraska, enacted the role of Buffalo Bill Cody in a centennial recreation of the original Buffalo Bill Wild West Show. The real Cody, who won his name killing buffalo to feed railroad crews and later became famous as a civilian scout for the frontier army, owned a large ranch at North Platte. It became a base of operations for his huge show as it toured major cities of the United States and Europe. Seventy-three at the time he rode an Appaloosa descendant of a Cody stallion, Evans handled the horse like a youngster, Bama says. Now in his eighties, he is still called upon at times to impersonate Cody, but he does not ride horseback much any more. The real Buffalo Bill in his prime displayed his horsemanship by riding hard and fast in the show's arena. As old age and arthritis crippled him, he had to be helped upon his horse behind curtains, unseen by the crowd, and make a slow, careful circle around the arena before riding out and being helped to the ground. Heavy debts wrested ownership of the show from him, but he continued to work until only months before his death, a tragic figure circling the arena in a buggy, refusing to give up.

Fred Garlow was the oldest of Buffalo Bill Cody's two grandsons, the other being Bill Cody. He owned and operated a successful guest ranch on the North Fork of the Shoshone River near the eastern entrance to Yellowstone National Park. A fine hunting guide and outfitter, he was highly regarded in the community which his grandfather had founded and given his name. When fund-raising began for construction of the Buffalo Bill Historical Center, Garlow toured the country performing as his grandfather. He raised a great deal of money for the museum, now Cody's greatest tourist attraction. Most people know of Buffalo Bill as a frontier scout and a showman, but fewer know of him as a progressive entrepreneur who spent a fortune building and developing communities in the West. One of his projects was construction of the famous Irma Hotel, completed in Cody in 1902 and named for his daughter, Garlow's mother.

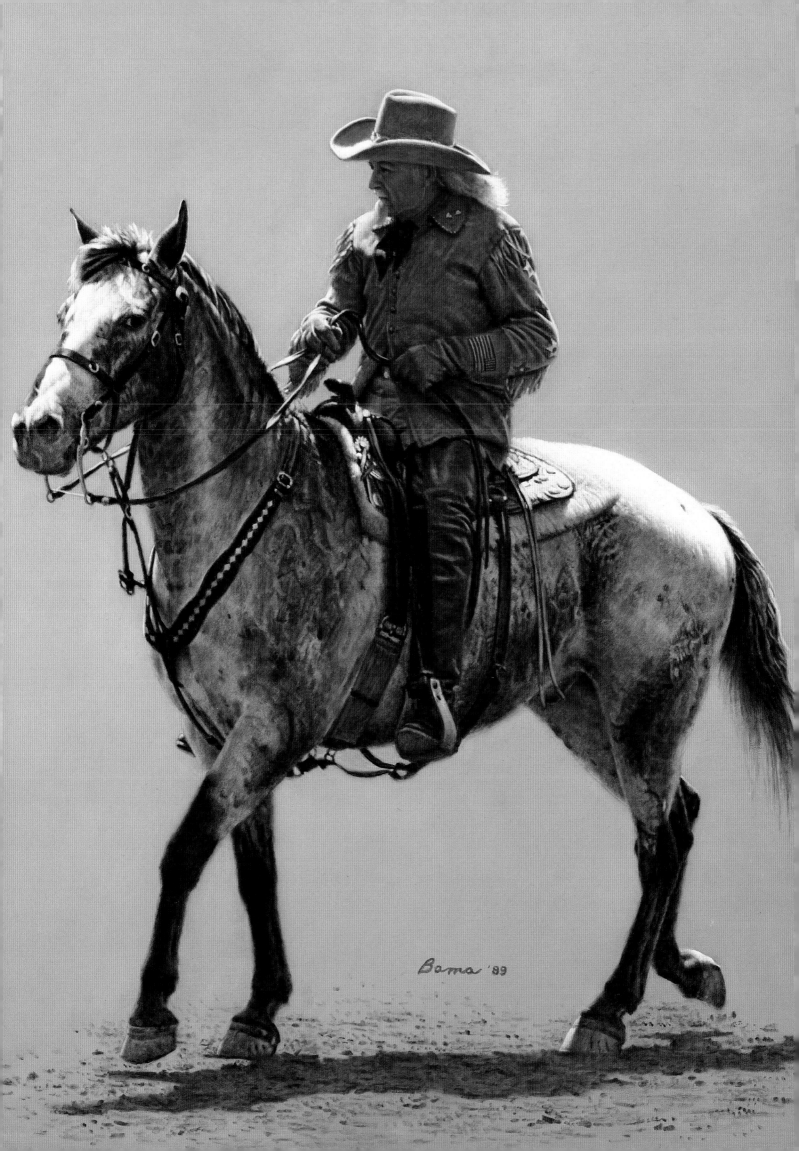

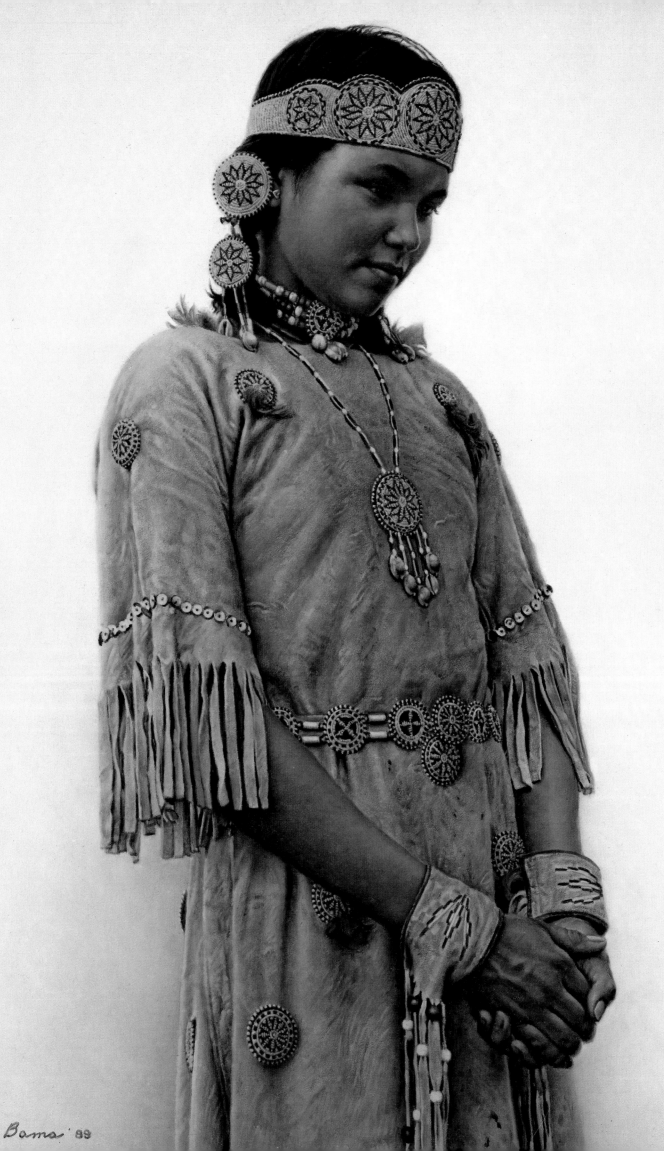

LITTLE FAWN, CREE INDIAN GIRL

RICHARD BADMILK, OGLALA SIOUX

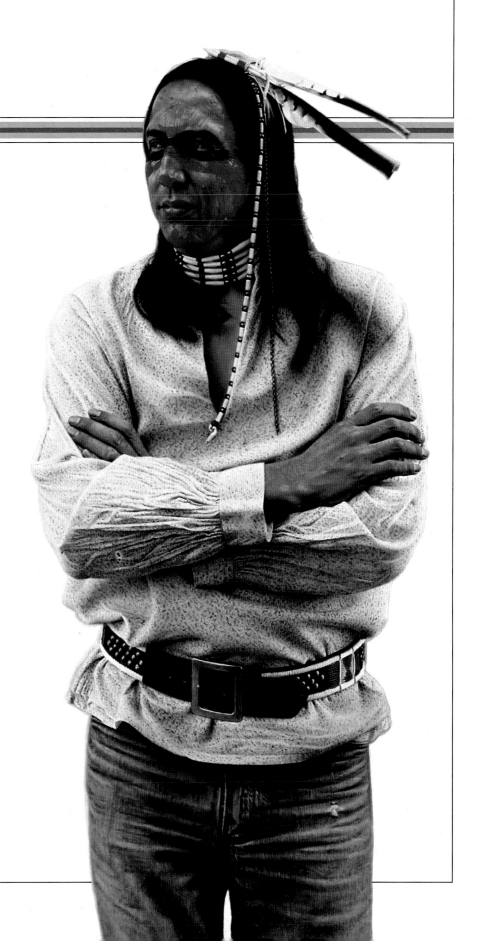

◀ **R**hesa Campbell, a Cree, was adopted and raised by a white family but has held onto much of her Indian heritage. Bama found her at a burial ceremony for Tuffy, a shepherd dog which for many years had been a constant companion to the modern-day mountain man known as Timber Jack Joe. Dressed in a white deerskin dress, the beautiful young girl in her early teens offered up an Indian prayer in the sign language of her plains ancestors. Bama found her very poised and sure of who she was.

When Bama met Richard Badmilk in Denver and saw him made up with his warpaint, he thought him a typical young contemporary Indian who dreams of doing something heroic but is stymied by today's realities. "He is dressed up for stealing horses and counting coup like his ancestors but has nowhere to go to do it," Bama says. Badmilk personified the image of the youthful reservation Indian resentful of his situation but unable to change it. Here he wears what is known as an Indian ribbon shirt, with light pattern which caused the painter many long hours of meticulous work, recreating hundreds of fine details. "I call it *Revenge on Custer,*" he says, "making me paint all their ribbon shirts." The Badmilk story has a sad ending. He was eventually killed on the reservation.

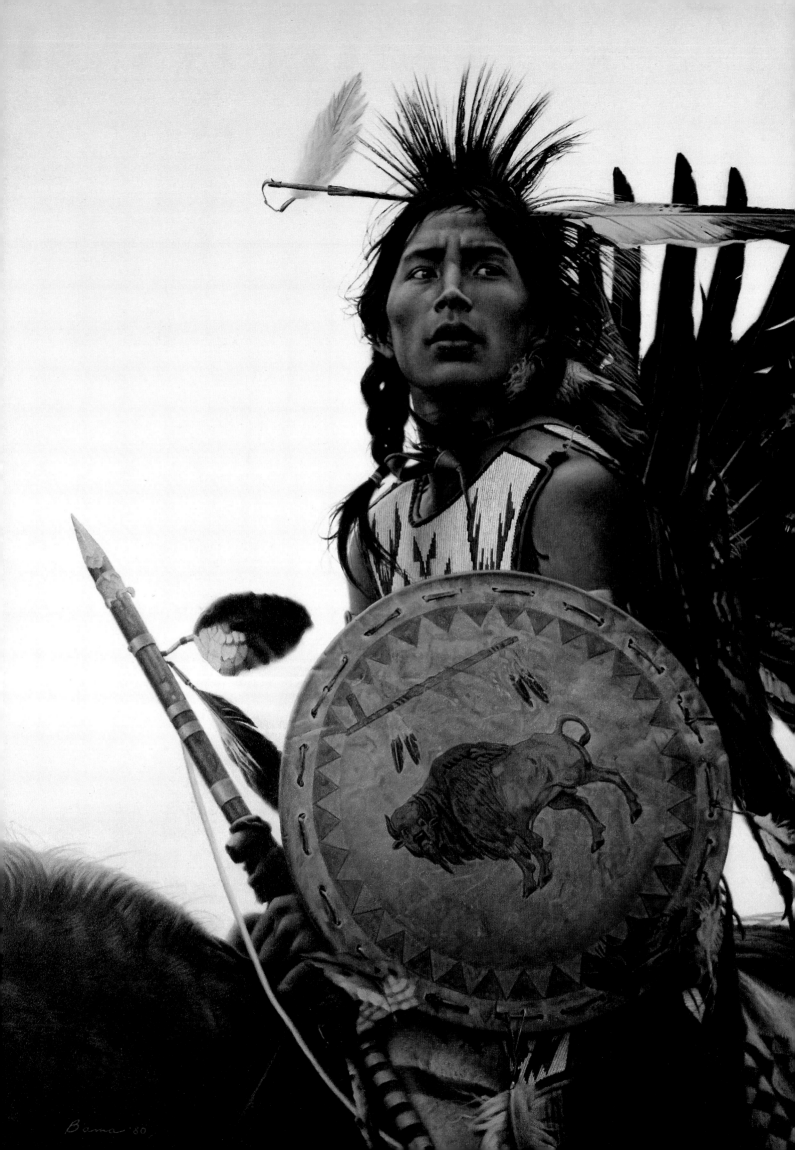

YOUNG
PLAINS INDIAN

Though this is among Bama's most striking Indian portraits, he never got to know the subject's name. He saw the young man in the grand entry at a Crow Fair and photographed him during a moment that the parade halted. The riders moved on before the artist had a chance even to speak. He was struck by the symbolism in the wings tied across the brave's back, making him look like a messenger of death, or perhaps an angel with black wings. Bama also liked the way the long feather in the roached hair crosses the wings as sort of a counterpoint. He has never again seen quite the same mix of elements in an Indian parade or powwow. The combination of outfit with dramatic attitude was a happy accident. "It is something you could never get in a pose," he declares. "He just had this look in his eye. He could have been living in 1879, not 1979. Most Indians today don't have quite the look of Indians photographed from the Civil War to the turn of the century."

THE DAVILLA
BROTHERS

Many young cowboys dream of glory in the rodeo arena, but relatively few ever make it into the top ranks. A majority suffer a season or two of abuse from broncs and bulls, winning little or no money but a lot of bruises for their efforts, and decide there are less strenuous ways to make a living or gain a name. Bama came across the Davilla brothers behind the chutes at a Cody rodeo, awaiting their time to ride. They had come up from New Mexico to work as cowboys for the summer, but one wound up taking a job in a restaurant, the other in a gift shop. Their real ambition was to make it in rodeo, but Bama recalls, "The few times I saw them ride, the luck of the draw did not favor them. They were unable to complete their rides." He did not see them again, though he met their younger brother in Cody the next year, working through the summer as a wrangler on a guest ranch.

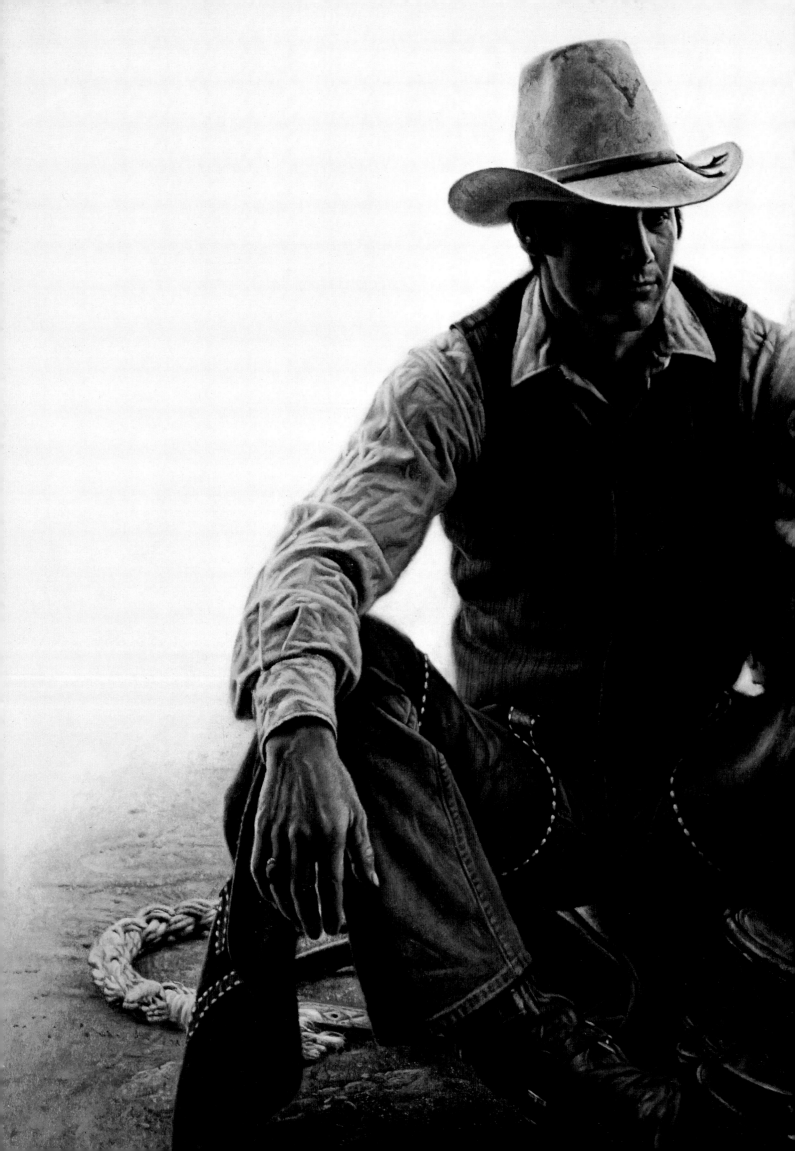

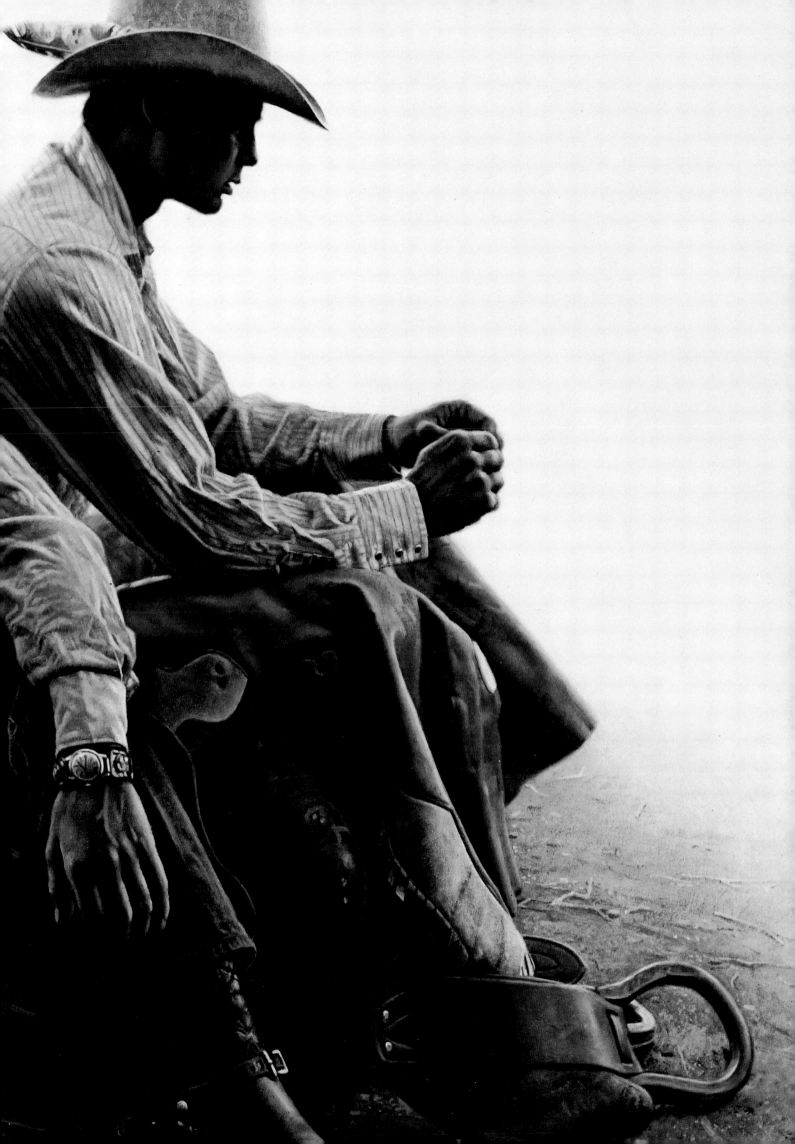

Bama '8

COWBOY
FROM KAYCEE

*A*s an artist Bama has always been fascinated by deeply lined faces, searching for the life stories of experience and hardship they signify. He came across Junior Johnson of Kaycee, Wyoming, at a team roping in Cody and considered him to have a classic cowboy face, Hollywood-handsome in a rugged sort of way. He found later that Johnson had a regional reputation as a roper and bronc rider. Johnson became a rodeo producer himself, furnishing livestock for shows in the area. He gave Bama his hat for the artist's collection of Western props. Kaycee, Johnson's home-town, is near the canyon where General George Crook's troops attacked and overran Dull Knife's Northern Cheyenne camp in 1876, five months after Custer's defeat. It is also near the rugged mountain hideout of the Hole-in-the-Wall gang of Butch Cassidy and the Sundance Kid fame. At a cabin not far away, a small army of vigilantes representing big ranchers besieged and killed cowboy-settlers Nate Champion and Nick Ray in the notorious Johnson County War of 1892. Shortly afterward the vigilantes themselves were trapped on the TA Ranch, and military intervention was necessary to rescue them from enraged local citizens.

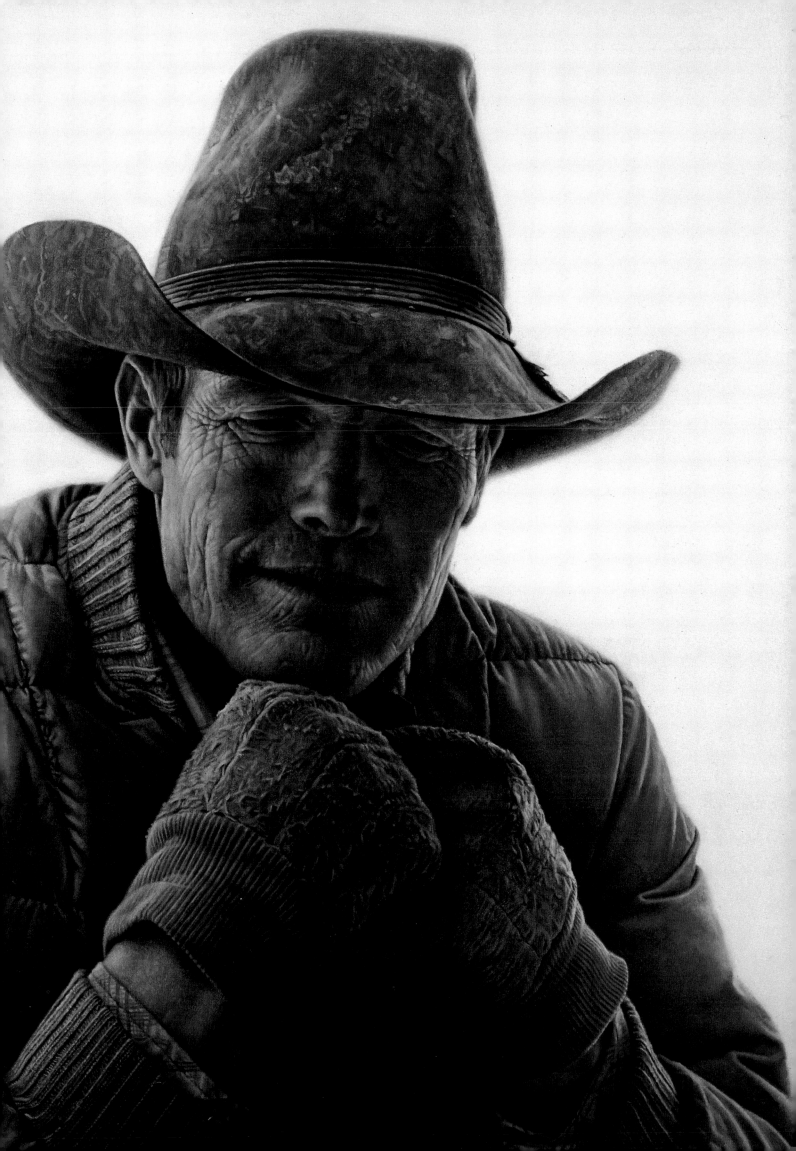

SID, THE RODEO CLOWN

WAITING FOR THE GRAND ENTRY

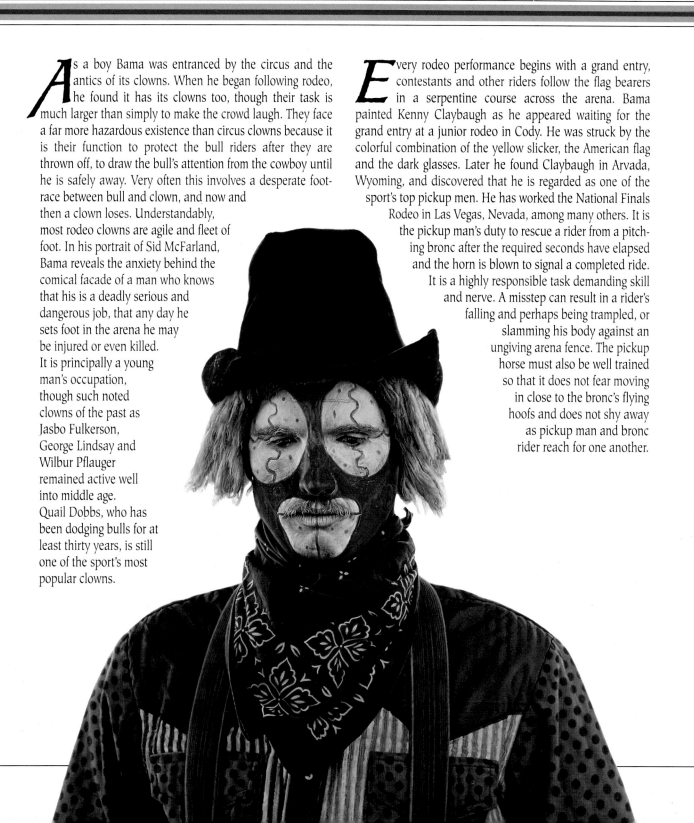

As a boy Bama was entranced by the circus and the antics of its clowns. When he began following rodeo, he found it has its clowns too, though their task is much larger than simply to make the crowd laugh. They face a far more hazardous existence than circus clowns because it is their function to protect the bull riders after they are thrown off, to draw the bull's attention from the cowboy until he is safely away. Very often this involves a desperate foot-race between bull and clown, and now and then a clown loses. Understandably, most rodeo clowns are agile and fleet of foot. In his portrait of Sid McFarland, Bama reveals the anxiety behind the comical facade of a man who knows that his is a deadly serious and dangerous job, that any day he sets foot in the arena he may be injured or even killed. It is principally a young man's occupation, though such noted clowns of the past as Jasbo Fulkerson, George Lindsay and Wilbur Pflauger remained active well into middle age. Quail Dobbs, who has been dodging bulls for at least thirty years, is still one of the sport's most popular clowns.

Every rodeo performance begins with a grand entry, contestants and other riders follow the flag bearers in a serpentine course across the arena. Bama painted Kenny Claybaugh as he appeared waiting for the grand entry at a junior rodeo in Cody. He was struck by the colorful combination of the yellow slicker, the American flag and the dark glasses. Later he found Claybaugh in Arvada, Wyoming, and discovered that he is regarded as one of the sport's top pickup men. He has worked the National Finals Rodeo in Las Vegas, Nevada, among many others. It is the pickup man's duty to rescue a rider from a pitching bronc after the required seconds have elapsed and the horn is blown to signal a completed ride. It is a highly responsible task demanding skill and nerve. A misstep can result in a rider's falling and perhaps being trampled, or slamming his body against an ungiving arena fence. The pickup horse must also be well trained so that it does not fear moving in close to the bronc's flying hoofs and does not shy away as pickup man and bronc rider reach for one another.

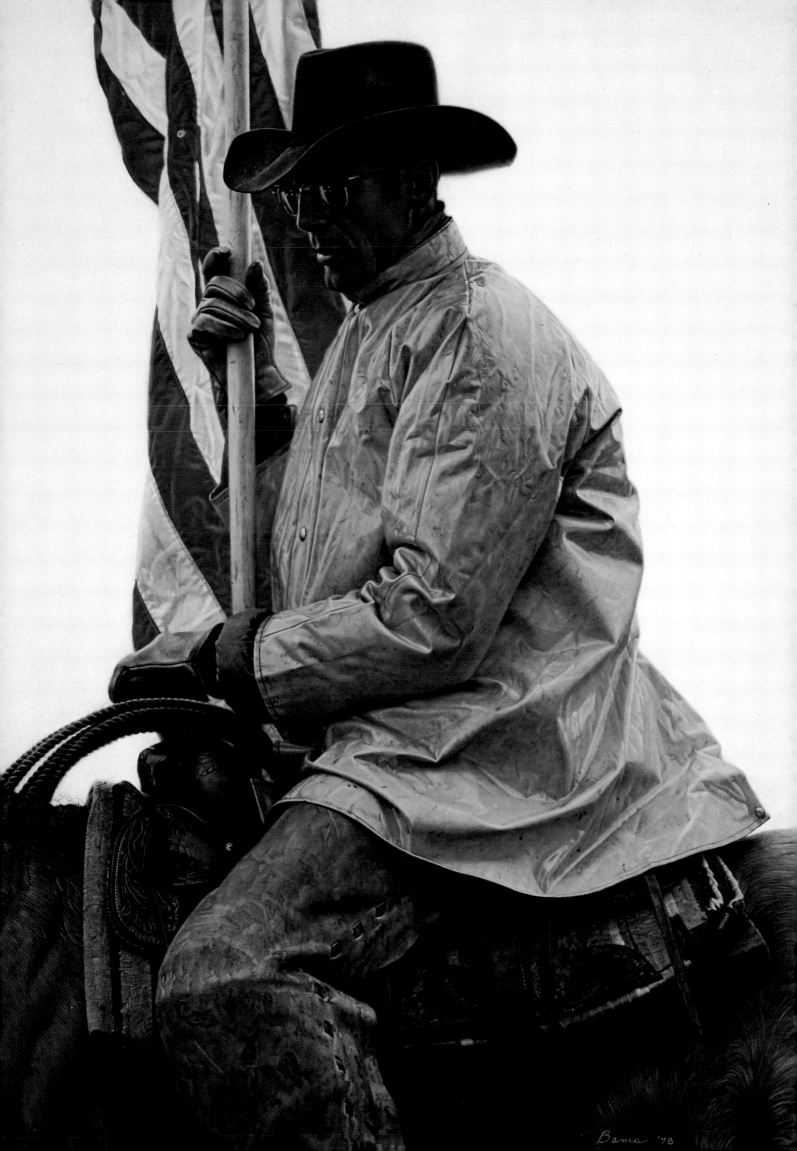

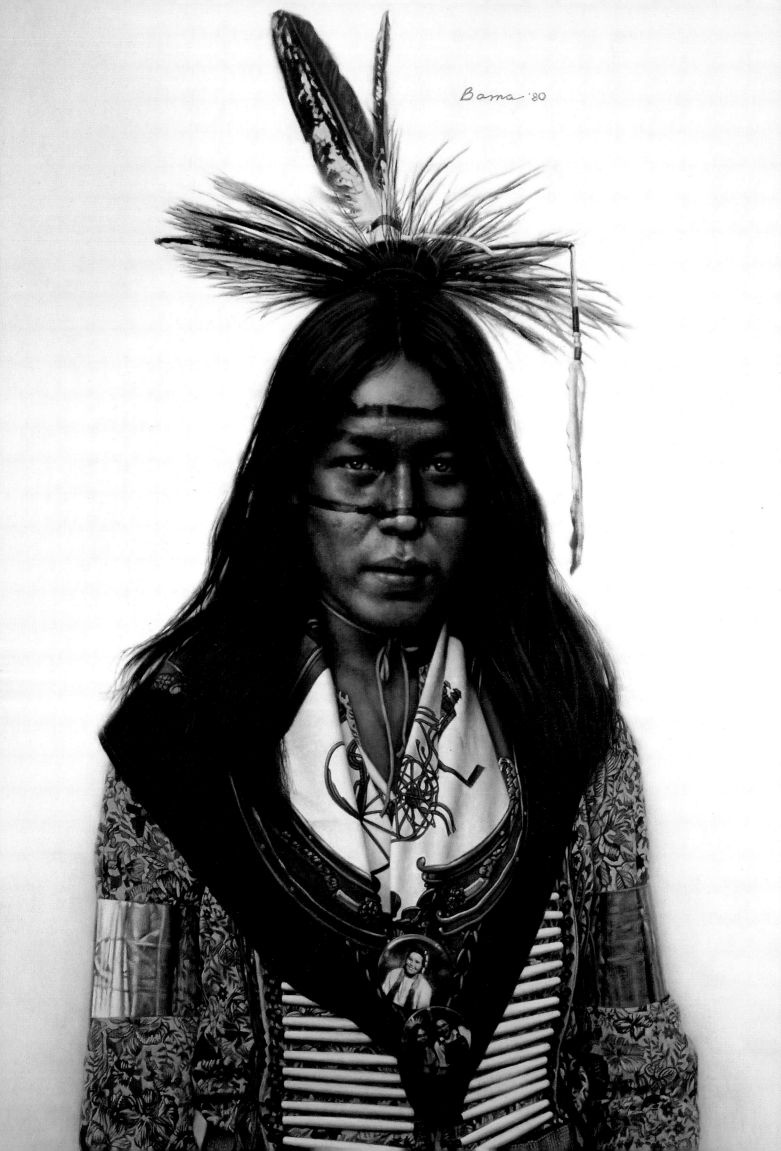

INDIAN BOY AT CROW FAIR

RICHARD SMITH, FLAMING RAINBOW

*T*his was one of four Norsk brothers, Arapaho boys from the Wind River Reservation, who danced at a Crow Indian Fair. Each lad had his own distinctive outfit and his own pattern of face paint. Suspended from his neck are two circular photo pins from an arcade photograph booth, which put this youngster in a modern context despite several traditional trappings from earlier times. Bama thought the style of paint might have tribal significance, but Indian friends told him otherwise. They said each person has his own individual and creative way of putting it on. In earlier times, Indians made paints from natural materials—black from charcoal, yellow from ground up buffalo gallstones mixed with pine-tree moss and vine roots, red from soil containing oxidized iron, blue from bentonite mud. Before applying the paint they smeared themselves with buffalo fat to prevent the paint from running. This lad, with a broad red band across his eyes, looks fearsome, to say the least. Gossip around the fair indicated that his teachers would agree.

*R*ichard Smith's Arapaho name was Flaming Rainbow. Despite a tough, militant expression, Bama found him to be "the most gentle guy I've ever known," a poet and a highly intelligent letter writer. Bama has painted many young militant Indians. At the time of the Wounded Knee protests in 1973, the town of Cody was shaken by a rumor that militants were going to blow up the Buffalo Bill Dam and the museum. A German tourist group canceled a planned tour. No such violence ever occurred, of course, but the town remained wary. "I like to shake up people by taking a militant-looking Indian to dinner with me," Bama says. Though he formed a friendship with Smith, the young man eventually disappeared. Bama's last letter to him was returned by the postal service years ago, and the artist has not heard from him since. That is life, he says. People drift across our paths, then drift away, leaving little trace except a memory.

QUEST OF QUI—Cover for a Doc Savage Book
MOTHER AND CHILD, GUILIN, CHINA—Children Looked Like "Little Dolls"
RISE WITH FORCE AND SPIRIT—Old Phrase, New Meaning
LOUIS L'AMOUR'S *KIOWA TRAIL*—Lynne Bama Posed for Bantam Books Cover

JAMES BAMA—

THE ARTIST

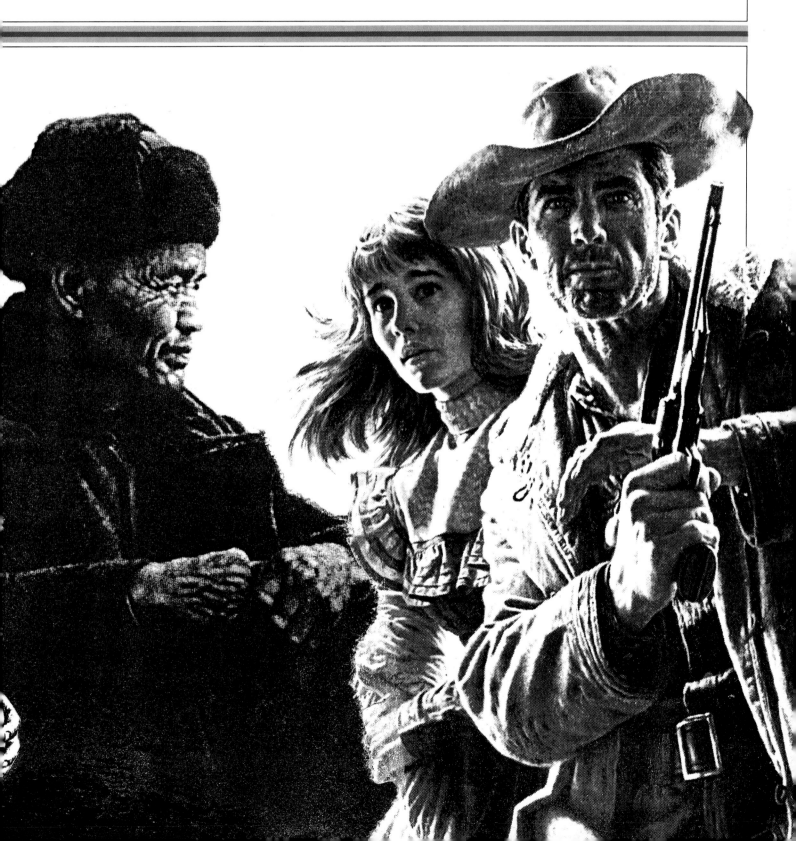

JAMES BAMA- THE ARTIST

James Bama laughs easily at himself, but he is dead serious when it comes to his art.

It was by a series of unpredictable circumstances that the affable, outgoing Bama became a leading interpreter of today's West, for he is a native New Yorker who never saw the West until he was forty years old. "I am the biggest accident that ever happened," he declares.

He was born in 1926 in Manhattan's Washington Heights section. His mother, Selma, suffered a stroke when he was thirteen. A year later his Russian-Jewish immigrant father, Ben, died of a heart attack. Because of his mother's disability, James and his older brother Howard had to assume many of the family responsibilities. Their mother died in 1944, the year James graduated from the High School of Music and Art which New York Mayor Fiorello LaGuardia had founded for gifted children. He had begun drawing as a boy, inspired by the artwork in such comic strips as Flash Gordon and Tarzan.

After seventeen months in the Army Air Corps late in World War II, he enrolled in the Art Students League and became a student of Frank J. Reilly, respected as one of the finest illustrators of his time. Graduating in 1949, he freelanced as an illustrator for a year and a half, then was represented by the prestigious Charles E. Cooper Studios for more than fourteen years before reverting to freelance status for the remainder of his twenty-two-year career as a commercial artist. During that time he worked in such advertising accounts as Ford, General Electric and Coca-Cola. He illustrated stories in such mainstream magazines as *The Saturday Evening Post*, *Argosy* and *Reader's Digest*. He painted movie posters for leading film studios and created hundreds of book covers, including sixty-two in the popular Doc Savage series for Bantam Books.

One of the strongest influences in his life has been a passion for sports. This led him to do seven paintings through the

Bigelow Calendar Company for the Baseball Hall of Fame in Cooperstown, New York. These included portraits of the great right-handed hitter Rogers Hornsby, pitcher Bob Feller and manager Casey Stengel. He painted Ernie Nevers and Johnny Blood for the Football Hall of Fame in Canton, Ohio. For six years he was official artist for the New York Giants football team and designed their victory pennant.

As a child of the Depression era he acquired a Puritan work ethic which even today compels him to his easel early in the morning and keeps him there until night. He balanced as many as a dozen projects at a time, keeping a cot in his studio and sometimes not going to his bachelor apartment all week.

Commissioned to paint a book cover which would feature a nurse, he attended a party to which he was told a number of nurses were invited. There he met beautiful young Lynne Klepfer. She was a weaver, not a nurse, but he persuaded her to pose for the painting. They were married the following year, 1964, at her parents' rural home twelve miles outside of Philadelphia. Lynne had attended Antioch College and New York University, majoring in early Renaissance and medieval art. She was also strongly interested in photography.

His career in commercial art offered volume and a background money could never buy, but it was stressful and was not fulfilling his needs as a serious artist. Because of his admiration for the art of Norman Rockwell, he had long considered moving to New England when he reached a point that he could pull back from his commercial work. But New England was not to be. In 1966 he and Lynne visited the Wyoming guest-ranch home of longtime friend Robert Meyers, an artist with whom he had worked for many years. The Bamas fell in love with the mountains and the isolation of rural Wyoming.

A series of family deaths during the next year changed the direction of their lives. They decided it was time to make their break if they were ever to do it, and they chose Wyoming. Their move to the Meyers ranch in September, 1968, gave him a quiet atmosphere in which to work and Lynne a chance to explore her interests in outdoor photography and writing.

Bama began painting for himself during the day, then doing book covers at night. In two and a half years he finished eigh-

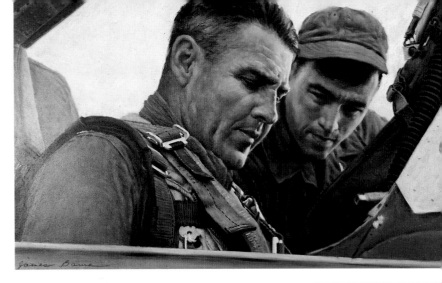

(Top) *TWO AMERICANS—AIR FORCE 1950's:* An aircraft mechanic in WWII, Bama portrays a mechanic and a pilot preparing for take-off.
(Center) *THE GREAT DEMOCRACIES:* For a Bantam cover of this Winston Churchill work, Bama portrayed Lincoln surrounded by Queen Victoria, Thomas Jefferson, Benjamin Disraeli, William Gladstone and Andrew Jackson.
(Bottom) *THE MAN WHO HATED:* For *The Saturday Evening Post's* WWII story, Bama painted a harried infantryman near Italy's battered Monte Cassino monastery.

teen easel paintings. He selected five to carry to New York's Hammer Galleries on speculation. Dubious at first, gallery officials looked, liked what they saw and asked to see the rest. In two months they sold fourteen of the eighteen offered. Deciding it was time to drop commercial art altogether, Bama concentrated on building up enough paintings to support his first one-man show. Hammer Galleries conducted it in 1973 and quickly sold twenty-two of the twenty-seven works.

For twelve years—1975 through 1987—the Coe-Kerr Gallery in New York presented him not as a Western artist but as a 19th- and 20th-century realist painter. That suited him immensely. Even though after moving to Wyoming he had begun to concentrate on subjects that were of the West, he had not considered himself a Western artist in the usual sense. He still does not.

In 1978, three months after the birth of their son Ben, the Bamas moved into their present home on a sagebrush-covered hillside some twenty miles west of Cody, Wyoming, in the village of Wapiti on the highway to Yellowstone National Park. The large north window of his studio serves as a frame for ten-thousand-foot Jim Mountain, named for early mountain man Jim Baker. Down the slope to the south, beyond the North Fork of the Shoshone River, towers the Absaroka Range, an extension of the Rockies named for the Crow Indians. In winter deer often come up to the house, and moose have wandered by. Elk roam the area. Bighorn sheep thrive in the high country above.

Living in the Wyoming mountains awakened in Lynne a strong interest in geology, range management and the complexities involved in protecting the environment while

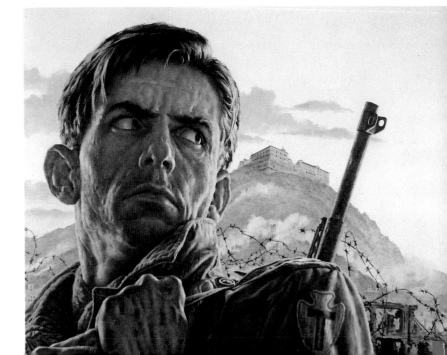

continuing to utilize it for useful purposes. She also found avenues as an outdoor photographer and writer.

Initially, Bama was only dimly aware of the Western art genre that was beginning a strong upswing in popularity. In fact, some of his first easel paintings were of people he had sketched and photographed in distant parts of the world. But as he began to paint those around him—cowboys, Indians, trappers and outfitters—he found himself regarded more as a Western artist though that was never his intention. To him, his subject matter was people, "the ultimate challenge." That those people happened to be Westerners was incidental.

He feels that Western painting has never been accepted as high art, relegated instead to a subculture status more on the basis of subject matter than on its artistic merits. He feels that

critics who sneer even at Frederic Remington's work do so because he painted the West, not because he did not paint well.

"Remington was really a marvelous painter. But just as Norman Rockwell is judged for his subject matter rather than for his incredible ability to draw and paint, I think Remington is judged for *what* he painted, not *how* he painted."

The realism of Bama's art sometimes leads people to mistake his paintings for photographs. He *does* employ photography extensively as a tool. Using a Hasselblad camera, he may photograph a subject as many as fifty times to pick up different looks, to record details of clothing and accessories or alternative lighting. Photographs can capture the moment, freezing a spontaneous attitude or a fleeting change of expression that a live model could not hold for the hours necessary to make

detailed sketches. He does color sketches to guide him in color selection and a tissue drawing to establish the composition. He draws the work in pencil on a gesso-prepared masonite panel, which he then sprays with a fixative and gives a semi-opaque tone to set the mood. He likes masonite because it is smoother than canvas and easier to crate and ship. He does most of his work in oils, using sable brushes to retrace the pencil lines in fairly dark paint. The finished product has a smooth appearance.

He is not concerned about running out of subject matter. When an artist draws upon life, upon real people, the variations are infinite, he declares. Nevertheless, he has recently begun to consider possibilities for moving in new directions once again, as he did when he dropped commercial work for fine art. He has produced a number of paintings out of a recent trip to China, for example. Like his renditions of Western characters, these have concentrated upon people, upon interesting faces and attitudes. In many respects the Chinese faces resemble the Indian faces he has so often painted.

His awareness of mortality, heightened by the deaths of family members at comparatively young ages, has made him careful of his health. He watches his diet. Trim and athletic, he leaves his easel three or four times a day for exercise breaks, hiking, pounding a punching bag, practicing hoop shots.

Bama's paintings today are channeled through the Big Horn Gallery in Cody, Wyoming. The Greenwich Workshop, Inc., in Trumbull, Connecticut, has issued prints of about sixty Bama works. He regards prints as an excellent vehicle for showing an artist's work to a broad audience.

The work habits drilled into him as a child of the Depression keep him drawn to the easel. He has ambivalent feelings about well-meaning fans who interrupt his schedule.

"Ironically," he comments, "the people who love your work most are the ones who take you away from it. They would never think of dropping in on a surgeon while he is in surgery or on a dentist while he is drilling. At my age, time is a luxury I do not have. But I'd rather have visitors than be a failure and ignored." At the top rank in his field, James Bama is neither a failure nor ignored.

[159]

LIST OF PLATES

[160]